ENGAGING THE PAST

ENGAGING THE PAST

Mass Culture and the Production of Historical Knowledge

ALISON LANDSBERG

COLUMBIA UNIVERSITY PRESS
NEW YORK

Columbia University Press
Publishers Since 1893
New York Chichester, West Sussex
cup.columbia.edu
Copyright © 2015 Columbia University Press
All rights reserved

Library of Congress Cataloging-in-Publication Data
Landsberg, Alison.
 Engaging the past : mass culture and the production of historical knowledge /
Alison Landsberg.
 Pages cm
 Includes bibliographical references and index.
 ISBN 978-0-231-16574-7 (cloth : alk. paper) — ISBN 978-0-231-16575-4 (pbk. :
alk. paper) — ISBN 978-0-231-53946-3 (e-book)
 1. Motion pictures and history. 2. Historical films—History and criticism.
3. Television and history. 4. Historical television programs—History and
criticism. 5. Documentary-style television programs—History and
criticism. I. Title.
PN1995.2.L35 2015
791.43'6582—dc23

 2014040180

Jacket Design: Jordan Wannemacher
Jacket Image: © Corbis

References to websites (URLs) were accurate at the time of writing.
Neither the author nor Columbia University Press is responsible for URLs
that may have expired or changed since the manuscript was prepared.

For my parents, Jill and Lewis Landsberg, with love

CONTENTS

ACKNOWLEDGMENTS

I WOULD LIKE to express my gratitude to the various institutions and individuals whose intellectual, moral, and financial support enabled me to complete this book.

The ideas for this book originated from a series of papers I wrote for several groundbreaking international conferences and symposia on memory, media, and history. I thank the following colleagues for providing me the opportunity to present my work and for the insightful feedback I received: Ann Gray and Erin Bell, organizers of the "Televising History" conference at the University of Lincoln in 2009; Leonardo Gandini, organizer of the "Memory and Media" conference in Trento, Italy, in 2009; Michael Rothberg and Stef Craps, who put together the seminar "Creolizing Memory" for the American Comparative Literature Association's annual meeting in 2010; Anne Rigney, organizer of "Memory on the Move" at the University of Utrecht in 2010; Eleanor Ty and Russ Kilbourn, organizers of "Memory, Mediation, Remediation: An International Conference on Memory in Literature and Film" at Wilfrid Laurier University in 2011; and Stephan Jaeger, organizer of "Languages and Cultures of Conflicts and Atrocities" in Winnipeg, Canada, in 2012. I am grateful also to Malgorzata Rymsza-Pawlowska, who as a graduate student at Brown University invited me to a give a talk there in 2011 and to participate in an exciting

Mellon Workshop, "Affect Unbounded," that she and other graduate students organized.

I am eternally grateful to Robert Rosenstone and Alun Munlsow, founding editors of the journal *Rethinking History*. They were early champions of my work, and as this book attests, their own extensive scholarship has been incredibly important to my thinking.

Portions of chapter 1 were first published as "Politics and the Historical Film: *Hotel Rwanda* and the Form of Engagement," in *A Companion to the Historical Film*, edited by Robert Rosenstone and Constantin Parvulescu, 11–29 (Malden, Mass.: Wiley-Blackwell, 2013), and a portion of chapter 2 first appeared as "Waking the Deadwood of History: Listening, Language, and the 'Aural Visceral,'" *Rethinking History* 14, no. 4 (2010): 531–49. I am grateful for the permission to include them in this book.

I owe a significant debt to my colleagues in both the Department of History and Art History and the Cultural Studies Ph.D. program at George Mason University; I have benefited enormously from being around a group of talented and supportive colleagues. Although neither Roy Rosenzweig nor Larry Levine were alive during the writing of this book, their commitments to democratizing history and to examining how history is disseminated, produced, and acquired outside the academy were a true inspiration. Deborah Kaplan, colleague and dear friend, has been a crucial interlocutor for me. I am profoundly grateful for her pointed questions and truly insightful suggestions and for her meticulous reading of the full manuscript.

I could not ask for a better editorial team than the one I worked with at Columbia University Press. My editor, Philip Leventhal, was a supporter of this somewhat unconventional project from the beginning, and Anne McCoy, Whitney Johnson, Annie Barva, and others were consistently patient and helpful. Not all authors are lucky enough to receive thorough, insightful, and, above all, useful readers' reports; I am grateful to the anonymous readers of this manuscript, whose invaluable suggestions certainly made it better. Of course, only I am responsible for the book's shortcomings.

Although my children, Eli and Leah, were until recently only dimly aware that I was writing another book, they nevertheless contributed in important ways to the project. From the time that Eli was little, he has always wanted to understand the big picture. His questions are profound and energizing, and

they provide precisely the kinds of provocations to new thoughts that I take up in this book. Leah, perhaps the most empathetic person I know, always tries to see every situation from the other side. Her lack of cynicism and her ardent desire to see the good in everything are an inspiration to me and are reflected in the way I approach the mass-cultural texts that I analyze.

My colleague, friend, and husband, Matthew B. Karush, was fully aware that I was writing another book! He has been my sounding board and my most tireless reader for nearly two decades. His incisive questions and insights have been instrumental in helping me to develop and refine my ideas. It is to him that I owe my deepest gratitude.

ENGAGING THE PAST

INTRODUCTION

A CENTURY AGO, in 1915, D. W. Griffith famously prophesied that history books would be replaced by movies and that in a not-so-distant future time "the children in the public schools will be taught practically everything by moving pictures. Certainly they will never be obliged to read history again." Instead of "wading laboriously through a host of books, and ending bewildered without a clear idea of what exactly did happen and confused at every point by conflicting opinions about what did happen, you will merely seat yourself at a properly adjusted window, in a scientifically prepared room, press the button, and actually see what happened."[1] His vision imagines a central role for motion pictures, which he understood in scientific terms. The technology of film, he believed, like scientific instruments, would be free of human bias and would therefore offer a perfectly transparent, objective view of the past.

In obvious ways, Griffith's prophesy was wrong. Within a decade, motion pictures were appropriated by the burgeoning entertainment industry, not the public schools. And to this day professional academic history is alive and well. Professional historians in the academy continue to conduct research, engage in intellectual debate, and advance interpretations of the past, which often take the form of peer-reviewed journal articles and scholarly monographs. Students, from elementary school through college, continue to acquire historical knowledge by reading books. Furthermore, Griffith's claim that "there will be no

opinions expressed"[2]—a claim that betrayed his faith in the inherent objectivity of the filmic technology—has been roundly rejected by generations of film scholars who have illustrated the ways in which filmic narratives are always to some extent shaped by the economic logic of the industry and the ideological pressures and concerns of their moment of creation.[3] That film could somehow *reveal* the past in a transparent, unbiased manner—as opposed to creating a representation of it—is itself pure fantasy.

Film did not hold the key to objectivity, as Griffith thought it might, nor did it become first and foremost a pedagogical tool for teaching those in the present about the past. And yet it would be a mistake to ignore the role cinema as an institution and audiovisual media more broadly have played in shaping the way people in the present visualize, come to understand, and ultimately feel invested in history. When one thinks about the past, what does one see? What images does one call up? For those in the "academy," historical knowledge is derived from reading historical monographs and journal articles, from assessing the debates between historians over interpretations of issues in the past—say, the role of women in the new republic, the agency of slaves in the Deep South, or the racialization of immigrants at the turn of the twentieth century. And yet no matter how much academic history one has read, no matter how sophisticated one's understanding of the complexities of the past, one's *image* of it has inevitably been affected by the images and narratives that have circulated in mass culture. Even more, I want to suggest that one's sense of the importance of the past, one's sense that the past matters, that it has value or significance, has been fostered by these popular narratives that touch and move and provoke one, engaging one not only intellectually, but in affective ways as well. There are ways in which the cinematic experience—and other affectively engaged modes of representation of the past—can and do produce new forms of historical knowledge, as this book demonstrates.

In part, this book picks up some of the threads from my earlier publication *Prosthetic Memory: The Transformation of American Remembrance in the Age of Mass Culture,*[4] in which I sought to describe seismic changes to both the practice of memory and its very constitution in the twentieth century. In that book, I argued that as a result of large-scale social changes associated with modernity—on the one hand massive migrations of people and on the other the burgeoning of a commodified mass culture that made possible a widespread

dissemination of images and narratives about the past—it became increasingly possible for people to take on, in a personal way, memories of events through which they did not actually live. These "prosthetic memories" are personally felt public memories that result from the experience of a mediated representation of the past. The current book in its turn explores the ramifications of prosthetic memory for what constitutes *history* and the acquisition of historical knowledge in the contemporary, mass-mediated public sphere. In other words, it explores what an affective personal relationship to the past implies for the project of *history*. Although it builds on some of the theoretical insights of *Prosthetic Memory*, it turns its attention instead to the specific questions raised by the recent turn to affective modes of popular history.

This book thus explores popular modes of engagement with the past in contemporary mediated society and the ramifications of those modes of engagement for the projects of history and politics. It examines the relationship between structures of looking and feeling and the contemporary conditions of knowledge production and acquisition. It describes and examines what might be considered a cultural dominant—the experiential mode of engagement—recognizing its emergence as historically conditioned, a product of the current political and economic conjuncture. The omnipresence of this experiential mode bespeaks a widespread popular desire to bring things close and, in this context, to have a personal, felt connection to the past. The experiential mode is tactile and material in the bodily sense. The experiential is first and foremost an affective mode: when engaged this way, one's body is touched, moved, provoked. Part of the work of this book is to think critically about the relationship between this mode of engagement and the acquisition of knowledge about the past, about the relationship between affect and cognition.

HISTORY AS REENACTMENT

It might seem odd to begin an exploration of new forms of historical knowledge by moving backward to the work of R. G. Collingwood (1889–1943), but his insights on historical consciousness and historical thinking were in many ways prescient. In his foundational work *The Idea of History*, originally published posthumously in 1943, Collingwood calls history "a special form of

thought," "a kind of research or inquiry," the goal of which is to produce human self-knowledge. He emphasizes that the past as we encounter it in history books is one actively *imagined* by the historian. Although we tend to assume that the difference between the historian and the novelist is that the former hangs his imaginative creation or interpretation on "certain fixed points provided by the statements of his authorities," ensuring that "the whole picture is constantly verified by appeal to these data," Collingwood suggests otherwise. In historical thought, he claims, no fixed points are given: "just as there are properly speaking no authorities, so there are properly speaking no data." Collingwood is by no means rejecting the *project* of history but is rather articulating a model of historical interpretation in which the historian must ultimately consider "whether the picture of the past to which the evidence leads him is a coherent and continuous picture, one which makes sense." Despite the similarities he draws between the novelist and the historian, they differ in their goals, for the historian is making truth claims. As a result, he must follow several rules: his representation must be localized geographically and temporally, it must be internally consistent, and it must bear a specific relationship to evidence. But evidence, for Collingwood, is not some "ready-made historical knowledge." In fact, what counts as evidence depends in part on the question being asked, and as the questions change, so too do the contours of evidence. He suggests that the project inevitably entails "using the present as evidence for its own past." And since the present is ever changing, so too is what counts as evidence: writes Collingwood, "The evidence available for solving any given problem changes with every change of historical method and . . . the principles by which this evidence is interpreted change too." What this means of course is that history is written and rewritten by each generation.[5]

For Collingwood, the work of the historian is best understood as historical reenactment: he "must re-enact the past in his own mind."[6] The example Collingwood uses to make this point is instructive, and I thus quote it at length:

> Suppose for example he [the historian] is reading the Theodosian Code, and has before him a certain edict of an emperor. Merely reading the words and being able to translate them does not amount to knowing their historical significance. In order to do that he must envisage the situation with which the

emperor was trying to deal, and he must envisage it as that emperor envisaged it. Then he must see for himself, just as if the emperor's situation were his own, how such a situation might be dealt with; he must see the possible alternatives, and the reasons for choosing one rather than another; and thus he must go through the process which the emperor went through in deciding on this particular course. Thus, he is re-enacting in his own mind the experience of the emperor; and only in so far as he does this has he any historical knowledge, as distinct from a merely philological knowledge, of the meaning of the edict.[7]

Collingwood is here suggesting that the historian must strive to re-create the parameters in which a thought occurred. For a thought from the past to be revived requires context: "it cannot repeat itself *in vacuo*, as the disembodied ghost of a past experience. However often it happens, it must always happen in some context, and the new context must be just as appropriate to it as the old. Thus, the mere fact that someone has expressed his thoughts in writing and that we possess his works does not enable us to understand his thoughts."[8] Simply understanding what the edict says cannot be considered historical knowledge; one can only gain historical understanding by contextualizing the reading in the moment in which it was first pronounced, by putting oneself in the position of the emperor. In other words, there is a strong *experiential* component to this endeavor. For the thoughts to emerge in the way they emerged in the past, the context must be in some ways conducive to that outcome. Historical parameters must inform the reading. In the case of reenactment, the parameters are artificial because they have been constructed for this purpose, yet they nevertheless offer a frame in which an experience occurs. Collingwood underscores the inevitable and necessary difference between these two moments of edict reading—the reenactment can never be identical to the original: "no one experience can be literally identical with another, therefore presumably the relation intended is one of resemblance only,"[9] which is important for the experience to enable what he calls "historical thinking."

Collingwood is here suggesting that there is a meta- or self-reflexive component to the production of historical knowledge. Historical knowledge requires more than immediate consciousness; there must be a self-reflexive component, a reflecting on the process of reenacting the experience. If one is not *conscious*

that one is re-enacting an historical event, then one is not thinking historically. In other words, "Historical thinking is an activity . . . which is a function of self-consciousness, a form of thought possible only to a mind which knows itself to be thinking that way."[10]

Writing before the mid–twentieth century, Collingwood could not have anticipated the widespread popularity of historical reenactment at the current conjuncture, nor was he focused on ordinary laypeople acquiring historical knowledge—he was explicitly theorizing the work of the historian. Nevertheless, his ideas about the acquisition of historical knowledge have particular resonance in a culture where the "experiential mode" is increasingly privileged as a powerful pedagogical tool. Furthermore, his insistence on mental reenactment as crucial to the project of history and the production of historical knowledge offers us a way to think critically about affective modes of historical engagement. What I suggest in the analyses in subsequent chapters is that historical knowledge in the form Collingwood describes is enabled in interesting and provocative ways by a range of popular representations of the past, situations where viewers are not merely being presented with reenactments of the past but are being forced to reflect on their own act of thinking as well. The historical representations I consider in this book provoke the kind of self-conscious historical thinking Collingwood describes and in so doing foster a kind of historical consciousness. Various stylistic and formal devices—interruptions in the visual field, alienating language and sounds, the calling of attention to mediating devices, technologies, and so on—have the effect of provoking the awareness that one is thinking.

This book considers what can be learned from popular, experiential genres of historical representation that cannot be learned from traditional monographs and scholarly articles. And it starts by acknowledging the enormous popularity of these affective experiential modes, as evidenced by the widespread popularity of reenactment, in both its performed and its filmic/televised incarnations. Memory scholar Raphael Samuel has described this preference as a "quest for immediacy, the search for a past which is palpably and visibly present."[11] As U.S. historians Roy Rosenzweig and David Thelen discovered when they conducted an elaborate, large-scale survey project to identify "*how* Americans understood and used the past," the majority of Americans feel most in touch with the past when they believe they have some kind of immediate, direct access to

it: when conversing with older family members who lived through a particular era or event or when visiting relics from the past at museums or historical sites. Rosenzweig and Thelen found that many Americans want to "experience history" in what they believe to be some kind of unmediated way; when faced with authentic objects from the past, individuals felt "transport[ed] . . . straight back to the times when history was being made." These individuals were more compelled by experiential modes of history and tended to view history as an "active and collaborative venture." School-based history, by contrast, according to those surveyed, was dry, the material predigested and disconnected in a profound way from the vital objects, documents, and events of the past.[12] These Americans were more compelled by what might be described as experiential or affective modes of historical engagement. Indeed, this desire for a personal connection to the past, a kind of affective engagement,[13] is fostered by many contemporary popular-history modes—film, television (in both the dramatic and reality TV formats), the experiential museum, and even certain history websites.

The fantasy that one might actually have unmediated access to the past by looking at or touching "authentic" objects recalls D. W. Griffith's belief that the film screen might serve as window through which to view the past as it actually happened. Both speak to a widespread, earnest desire to engage in an intimate and personal way with the events, people, and situations of the past. Although Griffith imagined a visual library, as it were, a place where one could push a button and then see "a certain episode in Napoleon's life,"[14] the more contemporary fantasy voiced by Rosenzweig and Thelen's respondents is quite literally to *experience* the past. Indeed, there are more and more opportunities to "witness," interact with, and reenact the past. One can see this move in culture by the increasing presence of interactive environments, by the development of immersive exhibits in museums, and by the continued popularity of reenactments of all kinds—both "live" and on television in the form of reality history TV.

Vanessa Agnew has aptly termed this move to the experiential the "affective turn" in historical representation. Among other things, this turn reflects increased interest and investment in experiential modes of engagement with the historical past. What concerns Agnew is that those engaged by affective history—film or television viewers or participants in historical reenactments—will misread the past by projecting their own contemporary responses

backward. She worries that the experiential mode fosters an easy identification with the past, one that loses a sense of the past as a "foreign country."[15] Similarly, Joan Scott worries that "when experience is taken as the origin of knowledge, the vision of the individual subject (the person who had the experience or the historian who recounts it) becomes the bedrock of evidence upon which explanation is built" and that "the project of making experience visible precludes analysis of the workings of this system and of its historicity."[16] The fear, in other words, is that treating experience as bedrock creates an illusion of unmediated transparency, obscuring the inevitably mediated nature of the present's relationship to the past.

Furthermore, considering a role for affect in the acquisition of historical knowledge has been anathema to most academic historians, for whom the proper mode of historical engagement is analytical and distanced, cognitive rather than emotional. And yet some historians, in particular those working on histories of the Third Reich and the Holocaust, have begun to articulate a case for the importance of affect in both the production and transmission of historical knowledge. In *The Years of Extermination*, the second volume of his monumental account of the Holocaust, Saul Friedländer describes the importance of the affective quality of Jewish testimony:

> Up to this point the individual voice has been mainly perceived as a trace, a trace left by the Jews that bears witness to and confirms and illustrates their fate. But in the following chapters the voices of diarists will have a further role as well. By its very nature, by dint of its humanness and freedom, an individual voice suddenly arising in the course of an ordinary historical narrative of events such as those presented here can tear through seamless interpretation and piece the (mostly involuntary) smugness of scholarly detachment and "objectivity." Such a disruptive function . . . is essential to the historical representation of mass extermination and other sequences of mass suffering that "business as usual historiography" necessarily domesticates and "flattens."[17]

Not only do these voices bear witness, as others have argued, but they quite literally disrupt the neat and contained parameters of historical represen-

tation in ways Friedländer believes necessary to convey a history of mass exter-
mination and mass suffering. Dominick LaCapra has similarly suggested that
"historiography involves an element of objectification, and objectification may
perhaps be related to the phenomenon of numbing in trauma itself."[18] In other
words, both accounts suggest that for certain kinds of history—history of mass
trauma in particular—the conventions of written academic history and its in-
vestment in objectivity not only are inadequate to the task but actually work
against the production of historical knowledge.

In another vein, some historians, most notably Frank Ankersmit and Hans
Ulrich Gumbrecht, have in different ways attempted to theorize historical ex-
perience as it occurs in an encounter with an object from the past—Ankersmit
for the historian himself or herself and Gumbrecht for the layperson. Like
Collingwood, Ankersmit is here suggesting that "there is also such a thing as
'intellectual experience' and that our minds can function as a receptacle of ex-
perience no less than our eyes, ears or fingers." But he is careful to explain that
this experience is not one of *reliving* the past, but one that "pulls the face of
the past and the present together in a short but ecstatic kiss." Importantly, too,
Ankersmit is interested in the role historical experience plays for the historian,
not for the layperson; "the past comes into being only thanks to and by his-
torical experience. . . . Sublime historical experience is the experience of a past
breaking away from the present. The past is then born from the historian's trau-
matic experience of having entered a new world and from the awareness of ir-
reparably having lost a previous world forever."[19] Gumbrecht, by contrast, is less
focused on the historian's experience, describing instead what he sees as "the
presentification of past worlds" orchestrated by "techniques that produce the
impression (or, rather, the illusion) that worlds of the past can become tangible
again." Importantly, though, presentification, "the desire for presence," as he ar-
ticulates it, is not about locating the "meaning" of historical objects but rather
about "mak[ing] us imagine how we would have related intellectually and with
our bodies, to certain objects (rather than ask what those objects 'mean') if we
had encountered them in their own historical everyday worlds."[20] Those experi-
ences, he suggests, have pedagogical value.

There is a profound popular desire to touch and be touched by history, and,
as Ankersmit and Gumbrecht suggest, this desire need not automatically be

regarded as naive. This book, which focuses on popular, audiovisual representations of the past, explores the complexity of being *touched* by history. It is here that I see Collingwood's insights as particularly useful. His account of the historian's method as a kind of mental historical reenactment that entails self-consciousness about that endeavor provides a model for an experiential or embodied engagement with the past that is something other than an actual unmediated experience of it. In other words, reenactment as a mode or, in Collingwood's case, as a methodology does not inevitably foster the illusion that one is actually inhabiting the past. For Collingwood, historical knowledge is the result of conscious activity, "a form of thought possible only to a mind *which knows itself to be thinking that way*" (emphasis added here). The popular history formats that I consider here exploit the experiential component in ways that foster a cognitive or intellectual *awareness* that one is engaged in this kind of inquiry.

This book is meant as neither a celebration nor a critique of "affective historiography," but it does insist that the experiential or affective mode, in conjunction with more explicitly cognitive modes, can play a role in the acquisition of historical knowledge. For Collingwood, reenactment is an act of imagination, but I suggest that by describing it as experiential, he betrays the inevitably affective quality of the *experience* of mental reenactment, which becomes the grounds for the self-reflective historical thinking that it induces. In the cases I describe, I attempt to theorize the range of ways affect is mobilized: at times fostering closeness with characters and scenarios depicted and at others doing the opposite. Moreover, I argue that in order for real historical knowledge to be produced, the affective engagements that draw the viewer in must be coupled with other modes that assert the alien nature of the past and the viewer's fundamental distance from it. Considering a wide range of history texts—historical fiction films, TV historical dramas, reality history TV, virtual history exhibits—this book engages with the dynamics of the experiential to explain both what it makes possible for people and what it obscures or refuses. It suggests not only that these popular engagements pose some fundamental challenges for our sense of what constitutes history in the twenty-first century but also that academic historians need to take more seriously the kind of work popular media can do in the production of historical knowledge. This shift in

approach requires in part a much more self-reflexive look at the specific limitations posed by traditional academic historiography.

FORM: THE SHAPE OF HISTORY

In considering popular genres of historical representation, I begin with the premise that form is crucial in the production of knowledge and meaning: new or nontraditional forms and formats make new kinds of knowledge possible. All written history—even that written by academic historians—is inherently narrative, carefully plotted, fundamentally an imaginative construction on the part of the historian. Historians such as Hayden White, Alun Munslow, Frank Ankersmit, Jerome de Groot, and Robert Rosenstone have been at the forefront of rethinking history's epistemological basis, in part through a careful consideration of form. Indeed, the journal *Rethinking History* was itself created to address these issues: "Re-thinking history," Alan Munslow argues in the journal's first volume, "requires us not only to question empirical foundationalism along with the cognitive functioning of history's literary form, but then to ask: do new models, theories, methods, constructions/deconstructions add to our historical understanding of why events or actions occurred?" From the outset, the journal was committed to asserting that form is instrumental in making history legible in the present. Of the journal's agenda, Munslow writes, "By Re-thinking history I mean expanding the study of the nature of history in all its forms and conceptualization. Rethinking it must mean questioning the boundaries of how we study the past."[21]

An important first step is to recognize historical writing as itself a genre with certain established rules and conventions, which opens it up for potentially productive textual analysis. Munslow, for instance, has described in detail the way in which the "author-historian" constructs "story-space," which greatly affects the truth claims the narrative is able to make. Munslow here draws on the concept of diegesis, which in film theory refers to the world created in the film. He explains the difference between "extradiegetic" and "intradiegetic" narration in terms of how visible the "author-historian" makes him- or herself within the narrative. In extradiegetic narration, the author-historian "exist[s] outside the story and telling," which produces the illusion of objectivity, whereas in

intradiegetic narration he or she is "a part of both the story and its telling,"[22] thus coming clean about the narrative's constructed nature. What I would like to emphasize is that these different forms of narration and the different form of "story-space" each produces also have ramifications for the *reader's* position in relation to the unfolding narrative; in other words, the extent to which the reader is invited into that diegetic space—or held out of it—has ramifications for the reader's sense of connection to or intimacy with the past. Furthermore, recognizing historical writing as itself a genre with certain established rules and conventions makes it possible to imagine that there might be other genres of historical representation that have different sets of rules and conventions. These other genres might offer different avenues to or forms of knowledge about the past.

The privileging of form, what one might even call aesthetics, is not necessarily reactionary—especially if one is mindful of the historical, social, political, and economic context in which particular forms emerge and come to dominance. Form is indeed material, connected to larger social processes; new emergent social formations, or what Raymond Williams called "structures of feeling," are first palpable through cultural or artistic forms. Furthermore, the form a text takes has ramifications for its mode of address to viewers. Different formal choices can also disorient or provoke or wake up the audience, as Berthold Brecht suggested with his account of the "alienation effect" in drama.[23]

Formal innovations, I am thus suggesting, have both epistemological and political ramifications. In *The Politics of Aesthetics*, Jacques Rancière insists that the artistic or aesthetic sphere is intimately connected to politics in that it conditions or shapes the realm of what is thinkable. Within any given society at a particular historical moment, there is what he calls a "distribution of the sensible" "that determines a mode of articulation between forms of action, production, perception, and thought." The aesthetic realm is important to Rancière because he understands it to set the terms for what can be said and understood within a particular society at a particular historical moment. Aesthetics, here, is "a delimitation of spaces and times, of the visible and the invisible, of speech and noise, that simultaneously determines the place and the stakes of politics as a form of experience."[24] It is thus first within the realm of the aesthetic, through "aesthetic practices," that new formal arrangements in the social world more broadly can be represented and made thinkable.

Artistic practices—which of course would include filmic, televisual, and digital productions—are important to Rancière in that they represent "ways of doing and making" that intervene in the general ways of doing and making within a society, beyond the aesthetic realm: they have the potential, in other words, to intervene in and challenge or reconfigure the prevailing "distribution of the sensible." To illustrate this point, Rancière describes what he identifies as the three main regimes of art in the Western tradition: the ethical regime of images, the representative regime of arts, and the aesthetic regime of arts.[25] In the first, artistic practice is tied to the community's ethos. The representative regime, in contrast, is not tied to moral, religious, or social criteria, but rather to specific, mainly mimetic, functions, adhering to conventions regarding acceptable subject matter. The third and by far most radical is the aesthetic regime, which occurs at the beginning of the nineteenth century and calls into question the implicit hierarchies and valuations of the representative regime in terms of genre, subject matter, and so forth. By challenging the hierarchization of the representative regime, the aesthetic regime necessarily asserts the fundamental equality of represented subjects. Rancière thus suggests that art literalizes the concept of equality in a way that makes it available for politics. But his claims have ramifications beyond politics; in a fundamental way, he is talking about how form and formal innovations can produce new thoughts.

Walter Benjamin's classic writings on photography and film also help demonstrate how aesthetic practices can intervene in the "distribution of the sensible"—to define, in Rancière's words, "what is visible or not in a common space, endowed with a common language."[26] Benjamin, writing in the 1930s in response to modernity and its new technologies as well as to the rise of fascism in Germany, believed that new visual technologies—and their attendant practices and conventions—produced new kinds of perception, new ways of seeing. Human perception, he suggests, is neither static nor natural but rather conditioned by history and thus changeable over time: "Just as the entire mode of existence of human collectives changes over long historical periods, so too does their mode of perception. The way in which human perception is organized—the medium in which it occurs—is conditioned not only by nature, but by history."[27]

For Benjamin, then, photography fundamentally alters human perception. The camera, he writes, "furthers insight into the necessities governing our lives

by its use of close-ups, by its accentuation of hidden details in familiar objects, and by its exploration of commonplace milieu through the ingenious guidance of the camera." The camera offers unprecedented access to that which remains invisible to the naked eye. The technology itself thus enables a new kind of inquiry: "With the close-up, space expands; with slow motion, movement is extended. And just as enlargement not merely clarifies what we see indistinctly 'in any case' but brings to light entirely new structures of matter, slow motion not only reveals familiar aspects of movements, but discloses quite unknown aspects within them.... Clearly it is another nature which speaks to the camera as compared to the eye."[28] For Benjamin, this bringing into visibility is both literal and metaphoric: the close-up reveals heretofore unseen details of the world we inhabit, but photography also more broadly offers access to the "way things are," enabling its viewers to see through the reified structures of society that amount to a prison world. The detritus of capitalism and its oppressive structures are offered up visually for all to see in a way not possible without the mediation of the photograph.[29]

Recognizing that the new technology initiated new modes of engagement with art, Benjamin posits the notion of "distraction" to understand how the "masses" engaged with cultural artifacts. He writes, "The greatly increased mass of participants has produced a different kind of participation." Whereas the bourgeois mode of engagement with art was characterized by deep concentration, the masses were often criticized for their distracted mode of reception, treating the artwork as entertainment. Benjamin, however, challenges this characterization, recognizing that both modes involve a kind of absorption: whereas the contemplator is absorbed by the work of art, a member of the distracted mass "absorbs the work of art" into him or herself. Because Benjamin is acutely aware of the relationship between perception and technology, he posits film as the form of art that mobilizes the masses and can thus tackle the most difficult tasks: "Reception in distraction—the sort of reception which is increasingly noticeable in all areas of art and is a symptom of profound changes in apperception—finds in film its true training ground."[30] He was able to make this claim because the film he was interested in was Soviet, not Hollywood. The American studio system was then developing the conventions of what would be called "classical Hollywood cinema," a style that attempted to situate the viewer in a predetermined, fixed spectatorial position, incorporating him or

her into the film's narrative. The Hollywood style sought to produce a seamless viewing experience, minimizing the shock of cuts in order to pull the viewer into the film and into identification with the characters on screen. By contrast, Dziga Vertov's and Sergei Eisenstein's films were created with an overtly political agenda and used a variety of techniques to shock and disorient rather than to pacify or lull the viewer. Benjamin is particularly interested in the potentially revolutionary impact of montage, the piecing together of film so as to create a jarring or shocking experience for the viewer. Furthermore, he writes, "Film, by virtue of its shock effects, is predisposed to this form of reception."[31] It is very important to understand that Benjamin is not rejecting this mode of reception. He sees distraction as a potentially useful mode of engagement, suggesting that "the relation of distraction to absorption must be reexamined."[32]

Gilles Deleuze's essay "Image of Thought" provides a way to understand the potential power of distraction. Deleuze argues that a sensuous encounter, any encounter in which one has a physical embodied response to a sensuous stimulus, can be a productive catalyst to new thought. He suggests that recognition promotes complacency: if one recognizes something in the world, there is no need to think. But a sensuous encounter, he suggests, is different: "Something in the world forces us to think. This something is an object not of recognition but of a fundamental encounter. . . . It may be grasped in a range of affective tones. . . . In whichever tone, its primary characteristic is that it can only be sensed. In this sense it is opposed to recognition."[33] Because audiovisual texts' and virtual spaces' modes of address are often multisensuous—tactile, aural, visceral, visual—one can be provoked in ways one does not immediately recognize, ways that need to be processed, examined, in order to be understood. The encounter that can only be sensed forces the viewer into an active interpretive mode, a distracted state, which can be a critical first step toward the production of new knowledge or critical political consciousness. In other words, these encounters are triggered sensuously but demand cognitive processing, forcing the viewer to make sense of a particular affective bodily response. Such interruptions sometimes happen on the level of the sensible, taking the form of shock, perplexing the senses, and ultimately provoking cognitive processing.

When we are moved or touched or made to feel uncomfortable, we are prodded to think and make sense of that experience. When such affective engagements occur within a historical frame, new historical insights can be

produced. Indeed, this is itself a way of theorizing the work of reenactment. Rather than dismissing the affective as an easier, more crowd-pleasing alternative to the cognitive, this work explores the relays that move between the affective and the cognitive, the way that affective or bodily provocations can lead to new thoughts, ideas, or historical insights. When those affective provocations occur within a historical narrative—whether in a film or a museum exhibit or a television series—the affective experiences are shaped by that frame so that the knowledge produced is contextualized, case specific, historical.

This book examines the ramifications of the distracted mode of engagement—one that never fully slips into absorption or identification—as an embodied and powerful mode of engagement that might be conducive to the acquisition of historical knowledge. I explore a particular mode of engagement solicited by a range of contemporary mass-cultural texts that uses affect to move viewers between absorption and distraction, an oscillation that I argue is particularly conducive to the acquisition of historical knowledge and even to the fostering of historical consciousness in the mass-mediated public sphere. These powerfully affective audiovisual texts have the power to draw viewers in through the logic of absorption, making the circumstances seem personally important, but their effectiveness as catalysts to historical thinking is predicated on the logic of distraction, where the viewer is forced out of the absorption, alienated from the material represented, the experience of which demarcates a sense of distance from the situation or circumstances represented. The assertion of distance pushes the viewer back into his or her own shoes, forcing him or her to reckon with or become conscious of his or her own thinking about the audiovisual material. Contemporary modes of historical representation change the way ordinary people understand history and acquire historical knowledge in our distracted age.

THE POLITICS OF AFFECTIVE HISTORY

Throughout this introduction, I have been describing affective forms of engagement, in particular the experiential mode and sensuous encounters. The pervasiveness of the experiential mode, a mode that is fundamentally affective, has drawn the attention of scholars and theorists in a range of disciplines from

philosophy, English, anthropology, and history to cognitive and behavioral sciences and psychology. For some theorists, the attention to affect is part of the larger turn to a "new materialism," which has called for a refocusing on material processes and the bodily as a corrective to the "linguistic" or "discursive turn" of the 1970s. The privileging of a discursively constituted subject occluded the materiality of the body, often with detrimental political effects. In their introduction to *New Materialisms: Ontology, Agency, and Politics*, Diane Coole and Samantha Frost identify as an "urgent reason" for turning to materialism "the emergence of pressing ethical and political concerns that accompany the scientific and technological advances predicated on new scientific models of matter and, in particular, of living matter." Furthermore, they argue that the "dominant constructivist orientation to social analysis is inadequate for thinking about matter, materiality and politics in ways that do justice to the contemporary context of biopolitics and political economy."[34] Affect theory might be considered a branch of the new materialism, but it is one that focuses extensively on the bodily. Here, too, the insistence on the materiality of the body and the realness of one's experience no matter how mediated might be read as a reaction to post-structuralism and theorists such as Jean Baudrillard, who insist that in the contemporary, media-saturated world "the real" has been replaced by simulation. The popularity of the affective or experiential mode is a reaction and a rebuke to postmodern and post-structuralist accounts that describe the contemporary world as immaterial, the play of simulations and signs. What is needed, then, and what I hope this book in part provides, is a more sophisticated account of experience in the contemporary media landscape where one engages with or "experiences" mediated representations all the time.

Much of the current scholarship on affect—and the strain most relevant to theorizing its role in the production of knowledge—takes its lead from Baruch Spinoza. This line of thought proposes that any attempt to understand subject formation, knowledge production and acquisition, or political engagement must take into account our status as sentient, embodied beings. Proclaiming that "no one has yet determined what the body can do,"[35] Spinoza likens affect to potential, suggesting that it has an intimate and even causal relationship to the body's potential to act. Because the body is fundamentally embedded in its social world, external provocations compel it to act or think or process or question. Affect is ongoing, mobile, and therefore inherently unfinished or

unfinishable. Spinoza's conviction that affect functions like potential, the "not yet," renders it as a catalyst to action and a crucial component of political activation, which along with ethics is central to his project. My interest in affect, like that of many other scholars, arises from the conviction that it is a catalyst to new thought or to action, pressing the individual to process a particular experience intellectually, to grapple with that which has previously been unthought. This, of course, is what Deleuze attempts to theorize as a kind of encounter that produces new thought.

Affect is by definition amorphous, which makes defining or providing an account of it quite difficult. As Melissa Gregg and Gregory Seigworth describe, there is no originary state for affect: "Affect arises in the midst of *in-betweenness*: in the capacities to act and be acted upon . . . in those intensities that pass body to body."[36] But those interested in affect's relationship to politics have chosen to emphasize not so much what it *is* as what it *does*. It moves the individual in a bodily and or cognitive way and is also that experience of being moved. Because it does not reside in a body but rather passes through it, affect is profoundly social.[37] Unlike the more familiar term *emotion*, the term *affect* describes something less fixed, less shaped and determined by cultural norms and valuations. It is the experience of being touched or moved before that sensation is recognized or codified into a particular emotion or feeling. Sara Ahmed registers affect's dynamic and generative quality, saying, "We are moved by things. And in being moved we make things."[38] For Ahmed, the things "made" are crucial to subjectivity and social belonging, taking the form of new insights or a sense of political connectedness. Proximity, she argues, plays a crucial role in the production and dissemination of affect in that the closer one gets to something, the greater its capacity to move or affect one. Importantly, the affect that moves one to political engagement or political consciousness is not always positive. In this case, affect is a crucial precursor to politics. Both Lawrence Grossberg and Deborah Gould emphasize the centrality of affect to political projects.[39] People are most motivated to action by those issues in which they feel a personal stake.

I share these scholars' appreciation for the political significance of affect, and I hope to inscribe my analysis of history within this frame. The importance of affect to history has emerged at the margins of many important texts. Indeed, many historians embrace the political project of making visible the agency of

everyday people. Jerome de Groot as well as Rosenzweig and Thelen have documented the widespread desire to *feel* a connection to the past.[40] There can be a political dimension to feeling connected to history—to feeling that the past matters in an intimate individual way. This book is most directly concerned with the ways in which affective engagements within the context of a historical representation can be a strategy for activating one's own personal stake in that knowledge, for making the past matter. A personal stake in knowledge about the past can in turn catalyze one's desire to engage in politics, to work against injustices in the present.

In this book, I consider the various ways in which affect is mobilized, solicited, and produced within and by popular representations of the past in a range of media. In other words, I consider the effects of affective provocations within a historical frame. As I suggested previously, many academics, with the important exception of those mentioned in my discussion here, tend to be wary of the use of affect in historical representation. A commonly voiced concern about the mobilization of affect or experiential modes of address in historical films, at museums, or at historic sites is that its goal is simply to engender thrills or fears, much like a theme park or Disney World aims primarily to entertain the consumer and generate profit for the studio or institution. In this way, these texts and sites often oversimplify complicated historical events into facile stories of good versus evil, ultimately working to make the consumer feel good about the experience so that he or she will come back or do it again. In other words, the concern is that if emotions are being played upon, the resulting historical representation will necessarily be reductive and manipulative. Many popular historical reenactments, historic sites,[41] and audiovisual texts produced by the Hollywood film and television industries do indeed bear out these concerns. However, it seems similarly reductive to dismiss out of hand all mass-cultural attempts at historical representation that invoke affective engagement on the part of their spectators or participants. As this book demonstrates, affect can be engendered in complicated, contradictory, and unexpected ways to produce *both* historical knowledge *and* what I describe as a historical consciousness more broadly.

There are obvious and qualitative differences between the experience of living through an event and experiencing a mediated representation of it. Nevertheless, when the individual is brought into contact with a mediated

representation, the body responds. Even in the presence of a mediated representation, the body can be moved, touched, affected. The experience of the mediated representation is itself lived; it is a real experience. In my analysis of specific texts in the following chapters, I treat moments of engagement with mass-cultural representations of the past—both virtual and on screens—as moments of encounter, where one's body is provoked and addressed. In these cases, an affective response is elicited when one is brought into proximity to a historical event. Although one is not reenacting the event per se, one is forced into an encounter with the situation and its logics. Importantly, the moments of affective engagement that I describe take place within a narrative frame or a set of narrative conditions established by the film, television show, or website. The affect, in other words, is not free floating but reverberates in a context that is shaped by parameters that the narrative sets. In other words, affect operates within constraints determined by the formal properties of a given text—from generic conventions to mise-en-scène and sound. The meanings produced by the affective engagement are shaped by the parameters—historical and formal—that shape the narrative. And yet because this engagement is played out on one's own body, it moves and resonates in ways unique to that body and its own historical specificity. In other words, even as the historical frame orients one's affective response, the fact that it takes place *within* the individual means that the experience is not the same for everyone.

As I argue more extensively in chapter 1, most critiques of history on film and of popular history more broadly focus on the problem of identification: locked into an identification with a particular character, spectators are lulled into a sense that they can easily understand what life was like for that historical protagonist. That illusion of understanding often takes the form of identifying with the other's victimization, which, instead of provoking further inquiry into the social conditions that produced the victimization, turns one's gaze inward on the self. In the chapters that follow, I examine strategies that produce affect, but not in the service of facile identification. I consider situations where one is forced into an affective experience—a kind of encounter with a historical predicament—but, again, not in the context of identifying with a character. Rather, in these moments one's body is provoked or challenged into some kind of analysis; through a sensuous provocation, one is forced into self-conscious

reflection on the situation represented, the experience of which is akin to Collingwood's historical thinking.

There is, of course, a political dimension to this kind of historical thinking, as I discussed earlier. In "Theses on the Philosophy of History," Benjamin writes, "There is no document of civilization which is not at the same time a document of barbarism," making the task of the historical materialist "to brush history against the grain." For Benjamin, knowledge begins with a critique of historicism's claims for "enduring truths." Moreover, Benjamin asserts that history as such exists only in the present, in the connecting of the present moment to a moment in the past; the historian "grasps the constellation which his own era has formed with a definite earlier one." History, as here imagined, offers a glimmer of hope for redemption in a barbarous world. The past, says Benjamin, "can be seized only as an image which flashes up at the instant when it can be recognized," and it is the historian's task "to seize hold of a memory as it flashes up at a moment of danger."[42] To treat the representations of the past in the mass-cultural texts that I am analyzing in this book as memories that "flash up in a moment of danger" is to recognize the urgency of history for the present.

The first chapter, "Theorizing Affective Engagement in the Historical Film," argues that some historical films with strong affective components engage the viewer in ways that are not captured by the standard notion of identification. I here propose the idea of "affective engagement," which unlike identification is not premised on abandoning oneself or one's subject position; with affective engagement, I suggest, the viewer is encouraged to feel himself or herself while encountering up close something foreign. Historical texts with an affective mode of address invite viewers not so much to put themselves in the protagonist's place but rather to see the protagonist's world up close; they are positioned not to *be* the protagonist but to listen to him or her. I explain how this is enabled on the one hand by the complicated mode of address staged by experiential museums and audiovisual texts and on the other by the expectations or "rules" or truth claims that accompany any representation of the past as history. In this chapter, I analyze the films *Milk* (Gus Van Sant, 2008),

Hotel Rwanda (Terry George, 2004), and *Good Night and Good Luck* (George Clooney, 2005)—all of which make visible the mediations that are part of the story. In both cases, we as viewers are forced to be listeners, and our act of listening produces a new understanding of the historical situations represented.

The second chapter, "Waking the Past: The Historically Conscious Television Drama," focuses on the television historical drama, arguing that it has the capacity to produce knowledge about the past that eludes more traditional, written history. By attending to the form of these shows—their serial nature, their resistance to closure, their complicated use of sound, images, and dialogue—I make claims about what role form plays in the production of historical knowledge and historical consciousness. I look at the television series *Deadwood* (HBO, 2004–2006), *Mad Men* (AMC, 2007–2015), and *Rome* (HBO, 2005–2007) to assess the kinds of historical knowledge that are produced and to track the relays between affective and cognitive knowledge. But I also consider the ways in which these shows rely on *style* to convey a sense of the past. Style, which is formal and atmospheric, can provoke a range of affective responses from nostalgia to disgust and thus can help position viewers to understand the historical period represented in unexpected ways.

Chapter 3, "Encountering Contradiction: Reality History TV," explores the contemporary desire to experience or feel the past, as manifested by the popularity of experiential museums, reenactments, and historical television and film. This popular desire to bring things close, enabled by mass-cultural technologies of representation and the Internet, challenges the epistemological premise of history as primarily a distanced intellectual engagement with past events. The new experiential modes often have an affective dimension, offering up history as something that can be lived or at least imported into one's life. This chapter explores the contours of affective history by considering the controversial though popular television genre of reality history TV, in which individuals from the present are cast into the past: the participants are made to abandon all aspects of the present, from clothing and personal effects to dispositions, and then placed in a setting from the past where they must live as their historical predecessors did. The chapter explores the way participants and viewers encounter the past in these shows and the range of ways affect functions for both groups. I argue here that because participants are unwilling to

reenact certain unsavory aspects of the past, the shows in some ways share the logic of alternative history.

The fourth chapter, "Digital Translations of the Past: Virtual History Exhibits," explores the political dimensions of an affective engagement with the past or, more specifically, under what circumstances history in this format has the potential to politicize viewers. This chapter considers some affective engagements with history on the Internet to assess the way in which they intend not only to teach history but to provoke a kind of progressive political consciousness. I look, for instance, at the virtual exhibit *The Secret Annex Online* on the Anne Frank Museum website; the Kristallnacht exhibit designed by the United States Holocaust Memorial Museum and hosted on the virtual world *Second Life*; and the Embodying Empathy project at the University of Manitoba Media Lab.

This book is by no means an exhaustive study of popular representations of the past, nor does it offer any kind of comprehensive analysis of the historical film as a genre. It is not a thorough-going study of history in popular media. Instead, my project is at once more modest and more ambitious. I am attempting to take seriously and theorize what has emerged as a new cultural dominant in popular representations of the past and, by looking closely at a handful of specific cases, to identify specific instances where these logics work to produce historical thinking and to foster historical consciousness. This book looks in earnest at what this turn to the experiential—as it is activated by film, television, and experiential history websites—means for people's sense of the past and its relevance to the present and to politics as well as what it means for the project of history more broadly conceived.

In contrast to arguments that dismiss mediated bodily engagement with the past as purely presentist, lacking the sense of distance considered necessary to historical engagement, this book asks what such a mode of engagement with the past makes visible to viewers and what forms of knowledge or historical consciousness it makes possible. It theorizes the complicated question of whether one's own body can be a site of knowledge about the past. Experiences, whether they are mediated or not, are felt and interpreted by the body and thus feel real. Understanding this mode of engagement is crucial to understanding how history works in the contemporary mediated public sphere. My

point is neither to criticize academic history nor to suggest that it be replaced with popular history; clearly, they serve different audiences. Nevertheless, to treat all popular engagements with the past as watered-down, oversimplified melodrama misses an opportunity to think productively about how ordinary people use the past and how contemporary technologies and modes of perception have the potential to provoke historical thinking. I am suggesting that even these mass-media representations of the past have the capacity to produce historical knowledge and to foster the historian's mindset, a kind of historical consciousness. As the chapters suggest, this kind of historical thinking can be fostered by popular mass-cultural texts that take advantage of each medium's formal properties to orchestrate complicated modes of engagement with the past. Understanding these modes of engagement is crucial to understanding how history works in the contemporary mediated public sphere.

1

THEORIZING AFFECTIVE ENGAGEMENT IN THE HISTORICAL FILM

In a post-literate world, it is possible that visual culture will once again change the nature of our relationship to the past. This does not mean giving up on attempts at truth but somehow recognizing that there may be more than one sort of historical truth, or that the truths conveyed in the visual media may be different from, but not necessarily in conflict with, truths conveyed in words.

ROBERT ROSENSTONE, "HISTORY IN IMAGES/HISTORY IN WORDS"

IT IS NOT wrong to say that the development of the Hollywood feature film went hand in hand with the development of the historical film. Even before D. W. Griffith's notorious *Birth of a Nation*, filmmakers both in the United States and in Europe were picturing history on film, as Robert Burgoyne has chronicled.[1] So powerful did the cinema seem as a medium for depicting the past that Woodrow Wilson is purported to have said upon screening *Birth of a Nation* in 1915, "It's like writing history with lightning."[2] And although Griffith is perhaps the most remembered in his cohort of filmmakers, he was by no means alone in his desire to use film to write history. Cecil B. DeMille was also committed to the historical film; in his autobiography, he reflects on the significance of his 1916 film about Joan of Arc, entitled *Joan the Woman*: "More important than its financial return, however, was the fact that this was my first big historical picture." Understanding the power of the medium to elicit an

emotional connection to the historical past, DeMille writes, "The audience is interested in people, not masses of anonymous people, but individuals whom they can love or hate, in whose fortunes they can feel personally involved." His professed method was "to tell an absorbing personal story against a background of great historical events. The story gives the historical events a more vivid meaning than most of the audience will have found in their history books."[3] DeMille's notion that film brings the past to life in a way that is impossible in a written history book is a claim still made in defense of the historical film.

DeMille ends his discussion of *Joan the Woman* with what he sees as its "greatest dramatic flaw"—the use of the "historical flashback," a narrative and editing device whereby characters in the present are flashed back to their lives at an earlier historical moment. The problem with this filmic technique, according to DeMille, is that "if you put an audience back into the fifteenth century, or any other distant time, and then at the end snap them back to the present with modern scenes, you are likely to lose the emotional impact of the main story. The audience may think it was just a dream. They will certainly be forcibly made aware that it happened a long, long time ago. Its actuality, which is the heart of the drama, is weakened if not destroyed."[4] I am particularly interested in this final, insightful observation. DeMille worries that "snap[ping] them back" to the present will weaken the drama and make the audience "forcibly . . . aware that it happened a long, long time ago." I, however, see this formal technique, which asserts a rupture between the past and the present, as crucial to the project of writing history or producing historical knowledge on film. In other words, those filmic devices and strategies that break or interfere with a kind of seamless identification with characters of the past are quite literally what make rigorous and complex history on film possible.

DeMille believed that affect, or emotional engagement, is what the cinema has to offer history, and, indeed, those who see the potential for film to teach viewers about the past usually understand emotional involvement in the form of identification as a powerful tool for transporting the viewer back in time. Academic historians, in contrast, would insist that such engagement necessitates oversimplification and collapses the distance between past and present, fostering the illusion that one can really know what the past was like. In this chapter, I explore the possibility that film can produce historical knowledge when it takes advantage of its ability to draw viewers in viscerally and make

the past matter and seem meaningful while also calling attention to both its distance from the present and to the impossibility of ever actually getting back to the past. Insisting on this sense of distance from the past is a crucial step in producing historical consciousness, the historian's critical disposition. The medium itself, I argue, with its multisensuous mode of address, can solicit complicated forms of engagement. In particular, cinema can address the viewer in a range of contradictory ways within a single text—drawing the viewer in and holding the viewer out, making the past seem palpable even as it reveals the inevitable mediation involved in any representation of the past. I begin by discussing the historical film as a genre before considering what film's earliest theorists had to say about the affective quality of the medium. I then explore the idea of "affective engagement," which is qualitatively different from identification in that it explains how a film draws the viewer into proximity to an event or person in the past, fostering a sense of intimacy or closeness but not straightforwardly through the eyes of someone living at that time. I also show how affect can work to disorient the viewer, "forcibly" pushing him or her out of the narrative and back into his or her own body. I attempt to illustrate this complex mode of address and to locate the moments where particular kinds of historical knowledge are being produced by analyzing three very different films that can be considered "historical": *Milk* (Gus Van Sant, 2008), *Hotel Rwanda* (Terry George, 1994), and *Good Night and Good Luck* (George Clooney, 2005).

Rather than rehearsing the well-known critiques of filmic history—that it inevitably "dumbs down" historical accounts, reduces the complexity of the past, and lacks the rigor of written history—I would like to theorize what history on film might do and *how* as a visual and aural and tactile medium it might do that. In a groundbreaking article for the *American Historical Review* in 1988, Robert Rosenstone made a case for the value of film for the project of history. Though written nearly a quarter of a century ago, his claims still seem radical, which only suggests how resistant academic historians have been to thinking through the potential of film as a vehicle for the production of historical knowledge:

> The amount of traditional data that can be presented on the screen in a two-hour film (or even an eight-hour mini-series) will always be so skimpy compared to a written version covering the same ground that a professional historian may feel intellectually starved. Yet the inevitable thinning of data

on the screen does not of itself make for poor history. . . . If short on tradi-
tional data, film does easily capture elements of life that we might wish to
designate as another kind of data. Film lets us see landscapes, hear sounds,
witness strong emotions as they are expressed with body and face, or view
physical conflict between individuals and groups. Without denigrating the
power of the written word, one can claim for each medium unique pow-
ers of representation. It seems, indeed, no exaggeration to insist that for a
mass audience (and I suspect for an academic elite as well) film can most
directly render the look and feel of all sorts of historical particulars and situ-
ations—farm workers dwarfed by immense western prairies and mountains,
or miners struggling in the darkness of their pits, or millworkers moving to
the rhythms of their machines, or civilians sitting hopelessly in the bombed-
out streets of cities. Film can plunge us into the drama of confrontations in
courtroom or legislature, the simultaneous, overlapping realities of war and
revolution, the intense confusion of men in battle.[5]

No one has argued more convincingly for taking the historical film seri-
ously than Rosenstone. His work has inspired a generation of scholars who in
a range of ways have attempted to theorize the possibilities opened up by film
for both the representation of the past and that representation's wide dissemi-
nation.[6] Perhaps the most important claim in that early essay, the one I used as
an epigraph for this chapter, is that "the truths conveyed in the visual media
may be different from, but not necessarily in conflict with, truths conveyed in
words."[7] In part this is to say film can create and convey something like period
truths, a sense of the different texture and contours of life at a specific mo-
ment in the past. That kind of knowledge fosters a historical consciousness, by
which I mean a particular intellectual predisposition. Similar to Collingwood's
emphasis on historical thought as self-conscious, Ludmilla Jordanova has em-
phasized that the historian's path lies between objectivity and subjectivity: "it
combines open recognition that we are interested parties in our studies with a
clear sense of how to make the resulting knowledge as judicious as possible."[8]
Like Collingwood, Jordanova recognizes the importance of acknowledging
one's own position as historian. In other words, for history on film to produce
historical knowledge, it must make viewers aware that they are engaging in his-
torical inquiry; it must make them conscious of what they are doing.

In his more recent work on the "history film,"[9] Rosenstone has borrowed Alun Munslow's concept of "historying"[10] to underscore the fundamentally constructed nature of history. Whether presented in text or on screen, history is the result of putting the past into a narrative. Rosenstone concludes that "in order to understand the historying done by the history film, we need to analyze it as a visual, aural, and dramatic presentation that engages—as any work of history does—with the past, present and future."[11] This analysis needs to pay careful attention to the generic conventions and technical practices that are specific to the cinema. For example, film editing can be a powerful way to position the viewer in relation to the unfolding narrative and, as such, has important ramifications for the audience's sense of connection to or intimacy with the past. Like Rosenstone, I do not mean to dismiss written history or the purposes it serves but rather to suggest the specific power of a sensuous, experiential medium such as film to disseminate alternative but no less instructive forms of knowledge about the past. What I want to call attention to is the potential in an audiovisual text for a more complicated mode of address than most theorists allow. Affect is crucially important both for making the story matter to the viewer on an individual level and in an embodied way and for catalyzing jarring moments of disorientation and alienation from it. Those visceral experiences— the oscillation between proximity and distance, alienation and intimacy—provoke analytical or cognitive processing and meaning making. In other words, the affective engagements I am describing do much more than simply add flesh and bones to the story. They facilitate both the historical reenactment *and* the self-conscious reflection on that process that Collingwood sees as fundamental to historical analysis.

Even the most biting critiques of historical film, those most unwilling to consider it serious history, will recognize that its greatest power is its capacity to bring the past literally into view, to make it feel real, to flesh it out. And yet this is also its greatest weakness: in some cases it offers the illusory promise that the viewer can slip back into the past and "know what it was like" by means of a simplistic, facile identification with an onscreen character. For history on film to be considered history, for it to be recognizable as history by academic historians, it needs at the very least to complicate the kind of simple identification that tends to be encouraged by filmic technologies and the stylistic and narrative conventions of classical Hollywood cinema. It must, through either

narrative or stylistic details, assert again and again a sense of difference between viewer and protagonist—a sense that the past is foreign and cannot be definitively or conclusively grasped or understood—but also an awareness that any account of the past is a mediation, a representation, and not the past itself. The film cannot, in other words, foster the illusion of what Joan Scott calls "unmediated transparency,"[12] that one is somehow experiencing the actual past. Nevertheless, it behooves us to take quite seriously the way film both elicits and transmits affect, what makes it effective and affecting. I propose that bringing viewers close to the past in ways other than through identification is part of the constructive work a historical film can accomplish.

The potential of film to represent and produce knowledge about the past has primarily to do with the ways in which the medium produces and transmits affect. Film engages us in a bodily way: haptically, aurally, visually. Yet affect in this context is *generated within a frame*—that is, the parameters of cinema as well as the structure and conventions of filmic narrative shape the way viewers cognitively process the affect they experience. In the case of the historical film, the frame within which affect is generated is historically specific. Finally, the particular kind of historical knowledge produced in film has a potentially political edge. History is made productive and meaningful if, despite its difference from the present, it informs how people think about their world. Certain kinds of affective engagements fostered by a historical film might function to produce new knowledge that is useful in the present and that raises political consciousness.

"WITH SKIN AND HAIR"

The notion that films affect the spectator's body and thereby influence his or her thoughts dates back to cinema's first decades. In 1916, Hugo Münsterberg authored a psychological study of film concerned primarily with the power of this new medium to affect viewers. "The intensity with which the plays take hold of the audience cannot remain without strong social effects," he wrote. "It has even been reported that sensory hallucinations and illusions have crept in; neurasthenic persons are especially inclined to experience touch or temperature or smell or sound impressions from what they see on the screen.

The associations become as vivid as realities, because the mind is so completely given up to the moving pictures."[13]

For Münsterberg, film's power to shape consciousness derives from its sensuous and tactile mode of address; the sense experiences it generates in its spectators "become as vivid as realities." German cultural critics in the early twentieth century were acutely aware of the power of cinema to affect viewers in a bodily way as well. In the 1930s, Walter Benjamin and Siegfried Kracauer began to theorize the experiential nature of the cinema. For Kracauer, film "seizes the 'human being with skin and hair'" as "the material elements that present themselves in film directly stimulate the *material layers* of the human being: his nerves, his senses, his entire *physiological substance*."[14]

In part, these theorists are describing cinematic images' ability to provoke a kind of mimetic response in viewers. In the words of anthropologist Michael Taussig, mimesis means "to get hold of something by means of its likeness," which for him implies both "a copying or imitation, and a palpable, sensuous, connection between the very body of the perceiver and the perceived." Mimesis entails what he calls a "corporeal understanding."[15] This relationship between viewer and filmic text, often theorized under the category "spectatorship," has long been of interest to film scholars, though how that relationship is understood has changed rather dramatically over time. Nevertheless, spectatorship has been understood to be shaped, at least in part, by certain strategies developed by filmmakers to position the viewer in very specific ways to understand the narrative. Specific techniques of both filming and editing powerfully elicit mimesis and thus aim to foster identification with a particular character or point of view. One such technique is the close-up: with the camera locked on a person's face as it registers pleasure or pain or humiliation or anger, the viewer cannot help but feel his or her own body respond in kind. Another is the point-of-view shot, which creates the impression that the viewer is seeing the unfolding events through a character's eyes. A point-of-view shot is constructed by the joining of two different shots. In the first shot, we see a character looking, which is immediately followed by another shot of what he or she is seeing, as if the camera were placed in the position of his or her eyes. This editing convention attempts to place the viewer in the character's position. Point-of-view shots force the viewer to look at the world quite literally from another's perspective, the effect of which can be to bring the viewer into the diegesis,

the film's action, as well as into the protagonist's mental and emotional life. Cinema, in other words, authorizes its viewers to inhabit subject positions to which they have no "natural" connection. It offers spectators access to another person's mind and motivations, and that person might have very different life experiences, convictions, and commitments.

This can be a particularly powerful device in the case of the historical film, where the events depicted are supposed to have actually happened. Linking individuals in the audience with characters in the film has the effect of immersing the former in historical events and in foreign geopolitical logics, which can be a powerful strategy for drawing them in and making them care about and even feel that they have a stake in the temporally and often geographically distant events depicted. The cinema, then, might be imagined as a site in which people experience a particularly intense bodily encounter with lives and contexts at great temporal and spatial remove from their own lived experiences—which of course is central to the acquisition of what I have called prosthetic memories.

The scholarship on cinematic spectatorship that gained currency in the 1970s focused on the cinema as an ideological apparatus,[16] emphasizing its ability to lock viewers into a specific viewing position and, as a result, to induce them to take on specific ideologies. In more recent film theory, spectatorship has been theorized as a more fluid experience, where the viewer moves in and out of identifications with different characters and scenarios even over the course of a single film.[17] It seems to me that the issue of identification itself is somewhat of a red herring. Surely, the apparatus theorists were right to suggest that filmic texts—and the whole viewing apparatus (viewers sitting passively in the dark at the mercy of the tempo and logic of images projected from behind their heads onto the large screen before them)—attempt to position the viewer and that both the filmic narrative and editing conventions encourage preferred vantage points and viewing positions. And yet the critiques of apparatus theory, claiming that identification is more fluid and that a viewer may move in and out of identifications with characters over the course of a film, seem correct, too. In either case, though, to think about spectatorship solely in terms of identification is unsatisfactory because to do so is to imply that the primary way a spectator engages with a filmic text is to leave himself or herself behind.[18] My point is not, of course, that something like identification does not happen, but rather that it is not the only dynamic in spectatorship, and, for the

purposes of producing historical knowledge, it is neither the most productive nor the most important.

A more useful approach would entail moving beyond identification in order to consider a wider range of affective engagements between spectator and film. As I suggested in the introduction, Walter Benjamin's notion of distraction offers a way of understanding how film might induce a more complex response from viewers. Benjamin argues that unlike the traditional artwork that solicits a form of deep concentration, film fosters instead a distracted mode of reception.[19] The distracted viewer moves between a sense of closeness or proximity to the scenarios depicted and a sense of alienation from them, a feeling of being snapped out of the narrative. This assertion of distance pushes us back into our own shoes, forcing us to account for what we see. It is in the reckoning with this oscillation that the possibility for the production of historical knowledge lies.

Considering the parameters of such engagements requires a refocusing of attention on the way in which the viewer's body is addressed or provoked, and, of course, this refocusing is largely a product of the film's formal aspects—the use of sound, close-up, camera movements, and editing. Film has the capacity to bring us into proximity with distant events of the past, which is part of the reason it can be such a powerful transmitter of affect. Forcing viewers to confront historical events can be a powerful strategy for making them feel that they have a stake in the events depicted, but we need to theorize this encounter in a way that does not reduce it to identification. Viewers do not automatically lose themselves in a film simply because they feel their own bodies being activated. In fact, some historical films are particularly effective in returning individuals to their own bodies—achieving precisely the effect that DeMille regretted having achieved in *Joan the Woman*. The cinema, then, might be imagined as a site in which people experience an intense affective encounter with lives and contexts at great temporal and spatial remove from their own lived experiences. Yet they do so as themselves.

Because a single filmic text addresses its viewer in multiple ways—visually, cognitively, affectively—the viewer can be brought into proximity with events and characters, but not necessarily *into* the diegesis, the world constructed by the film. This complicated mode of engagement, I believe, is essential for the production of historical knowledge because it preserves the distance between viewer and historical event or character. The viewer is brought close to a person

or event of the past, but not necessarily through identification; the viewer does not lose himself or herself in the story. In fact, the potential for the production of useful historical knowledge is at its greatest when the viewer does *not* identify with the characters on the screen, when he or she is aware of the response in his or her own body and is forced to make sense of it in a self-conscious way.[20]

An increasing number of film theorists have turned their attention to the bodily aspect of spectatorship. They tend to emphasize the tactile, haptic, or sensuous quality of film and argue that a large part of the power of the cinema derives precisely from the fact that it addresses the spectator's body, making her or him feel and then think about things she or he might not otherwise encounter. Vivian Sobchack has been a pioneer in the phenomenology of film, arguing that "the film experience is meaningful *not to the side of our bodies but because of our bodies.* . . . Movies provoke in us the 'carnal thoughts' that ground and inform more conscious analysis."[21] She is particularly interested in the relationship between the viewer and what she calls the film's body.[22] Laura Marks has also emphasized cinema's tactile mode of address, asserting that "film is grasped not solely by an intellectual act but by the complex perception of the body as a whole."[23] Jennifer Barker similarly insists that "meaning and significance emerge in and are articulated through the fleshy, muscular, and visceral engagement that occurs between films and viewers' bodies" and that film "comes close to us, and . . . literally occupies our sphere."[24]

Nevertheless, Barker writes, "we do not 'lose ourselves' in the film, so much as we exist—emerge, really—in the contact between our body and the film's body."[25] I am more interested in the relationship between the viewer and the body or situation *represented* than in the *film's* body. But the point remains: we engage with films deeply, but we do so as ourselves. We can be brought into a film *but not necessarily or only through identification with the characters*. At certain moments, the film speaks to us in our own bodies—we are touched, moved, perplexed, but not simply through a mimetic encounter with a character. Lisa Cartwright has theorized a model of "empathetic spectatorship" in which "you move me to have feelings, but the feelings may not match your own."[26] In *Trauma Culture*, E. Ann Kaplan is interested in trauma narratives that construct what Dori Laub has called a witnessing position, which entails a "deliberate distancing from the subject" to prevent identification. As Kaplan writes, "When a film constructs this sort of position for the spectator, it enables

attention to the situation, as against attention merely to the subject's individual suffering, and this positioning thus opens the text out to larger social and political meanings."[27] In these theorists' formulations and mine, what is crucially important is a recognition of a sense of difference between oneself and the person figured on the screen. And in the case of historical film what can emerge from such an experience, I think, can be a distinctly empathicohistorical disposition: a desire to come to understand something foreign and fundamentally ungraspable, to care about and be interested in the past while acknowledging that it is never fully recoverable, that attempts at understanding it are necessarily partial. To engage in this way, though, depends on the film's ability to draw the viewer into the historical past, to immerse him or her in its logics, no matter how foreign they seem, and this immersion is predicated in large part on the film's ability to affectively engage the viewer.

What I hope to emphasize here is that that there is a difference between touching the spectator and bringing him or her into a kind of seamless, immersive identification with a character on the screen. The danger of the dramatic film as a vehicle for history is precisely its virtuosic capacity to lure the viewer into a deep identification with the characters and events of the past, fostering an illusory sense that the viewer truly understands another person's position or how the past felt to those who lived then. In this intense identification—what I would call "overidentification"—the viewer is not challenged. The viewer, here, gets to try out being someone else without having to grapple with or even understand the distance that separates him or her from that other person. Identification alone, in other words, is quite easy and does not necessarily produce cognition and new thought. In fact, historical films have often induced viewers to identify with the victims in a way that produces resignation and incapacitation, emotion over cognition. As I show later in this chapter, films that deploy formal and narrative strategies that force the viewer out of easy identification and back into his or her own body, outside of and yet connected to the constructed, diegetic world, are most able to avoid the pitfalls of immersive identification. I examine filmic strategies that produce affect, but not in the service of facile identification. I am thinking of a situation where a cinematic spectator has an affective experience—a kind of encounter—but, again, not in the context of identifying with a character. In these moments, affect is generated by a represented proximity to a historical event, but though this affect is

conditioned by the film, the register is the spectator's body—where it moves and resonates in ways unique to that body and its own historical specificity. An affective experience catalyzed by the movie takes place in the individual and as such feels real for that individual.

STAGING ENCOUNTERS

Most films attempt to foster identification through narrative. Through the story the film tells, we come to know and relate to or take a particular interest in one or more characters. Yet even narrative films have moments of affective encounter, strong bodily engagement, that work against the forward pull of the narrative. I propose that even within a narrative film there can be powerful moments of interruption that break the illusion of connection with a character or a sense of understanding exactly what their experience was like, thus prompting questions and critiques and compelling self-evaluation. I see the potential for the production of critical thought and meaning making following from these moments of interruption, moments in which an encounter occurs between viewer and film. These moments of encounter break the concentration and foster what Benjamin describes as a distracted mode of engagement. These encounters are in excess of the narrative and as such disrupt its seamless flow. They work against simple, immersive identification. They often shock or provoke the viewer in a bodily way. Theorists of early cinema have debated the relationship between spectacle and narrative in film, arguing about the extent to which spectacle disrupts narrative.[28] In this sense, I see these moments of affective encounter as analogous to spectacle. Within the context of strongly narrative films, affective encounters interrupt the narrative flow. These encounters between viewer and film occur on the level of affect and are only later processed cognitively. Nevertheless, narrative and affective interruption work together: the viewer's affective engagement takes place through his or her own body, outside the narrative, yet the content of that engagement is conditioned by the historical narrative. Affective encounters are unexpected and open-ended, but the cognitive processing of those moments is conditioned by the film's narrative.

This logic of encounter or interruption permeates all the texts I consider in this chapter and in future chapters. At times, these encounters are triggered sensuously but demand cognitive processing, snapping the viewer out of the narrative and forcing him or her to make sense of a particular affective bodily response. Because these encounters are in some way in excess of the narrative, they cannot simply be assimilated into the narrative's forward movement. At other times, they force the viewer to recognize his or her own position as viewer or listener (as opposed to active participant), again situating the viewer in a place different from identification. These encounters work by positioning us, the viewers, beyond the frame of the film, as if the film is speaking to us directly and we are thus aware of our distance from the diegetic world.

Among other things, historical films attempt to re-create the conditions of what life was like in a particular time and place and the parameters within which people lived. Some expose how individual lives were circumscribed by laws, customs, values, social mores, political and economic circumstances. Most seek to make visible the material culture of the period—where people slept, what they ate, what they wore. Because the moments of affective encounter occur within the context of specific historical conditions, the way the viewer processes those encounters is inevitably shaped *by* those conditions—by what was possible and impossible in that historical moment. Even when the viewer does not identify with one of the characters, his or her body is activated, brought into proximity to the conditions of existence for a person in the historical past, and affected by the conditions of possibility at that moment. It is in precisely this conjuncture that film can produce real and useful knowledge about the past. The viewer is in his or her own body, his or her own space, but the body and its experience have been altered by its engagement within the diegesis, which in the case of a historical film is structured by the political, economic, social, and cultural conditions that governed the life of a person or community in the past.

Other senses beyond the visual are invoked by the cinema. As Sobchack has suggested, "Vision may be the most privileged in the culture and the cinema, with hearing a close second; nonetheless, I do not leave my capacity to touch or to smell or to taste at the door, nor, once in the theater, do I devote these senses only to my popcorn."[29] In addressing senses other than vision, cinema's

capacity to provoke is at its highest level because these stimuli are not as easily legible or intelligible as things we see. My point here is similar to Deleuze's critique of recognition, which I discussed in the introduction: when we encounter something we recognize, no thought is required; nothing is provoked or perplexed. Because it is often easier to recognize what we see, sonic and other nonvisual stimuli can provide a more effective provocation to new thoughts. As we "watch" a film, we are less likely to recognize immediately things we cannot see but can only sense in other ways. We often must work to discern these things and to understand what they might mean.

These sensuously provoked encounters can be alienating, as in the tradition of Eisenstein and Vertov. For them, part of the power of the cinema is its ability to disrupt reality visually—to draw the world differently, to break through reified consciousness by denaturalizing the world. Each, albeit differently, sought, in Vertov's words, "the sensory exploration of the world through film."[30] Mainstream narrative films, by contrast, do not rely on montage or other non-continuity techniques. For these films to work in the way that I see them working, they cannot simply operate through alienation and shock; they must rely also on the other power of cinema that I described first—its power to draw viewers in and make them care. This oscillation between putting viewers in emotional and physical proximity to others and then returning them to their own bodies and minds is the dynamic that fosters the kind of historical consciousness I am articulating here. In what remains of this chapter, I look at three films that provoke such historical consciousness in distinct ways: *Milk* (Gus Van Sant, 2008), *Hotel Rwanda* (Terry George, 1994), and *Good Night and Good Luck* (George Clooney, 2005). I engage not so much with the specific historical interpretations that the films advance, but rather with *how* they advance those interpretations.

MILK

Gus Van Sant's 2008 film *Milk* depicts a period in the life of gay rights activist Harvey Milk (Sean Penn). Instead of tracing the arc of his whole life, childhood through death, Van Sant's film begins on the night of Milk's fortieth birthday and follows him through his assassination eight years later by

fellow San Francisco Board of Supervisors member Dan White (Josh Brolin); the film, in other words, chronicles the years during which Milk was a public figure. The narrative begins and ends with Milk's own recording of his story, as he composed it, into a tape recorder nine days before his death in anticipation of a possible assassination attempt. This film was critically acclaimed and modestly successful at the box office. And yet even as it was praised, it was often treated as inferior to Robert Epstein's 1984 Academy Award–winning documentary about Milk, *The Times of Harvey Milk*. Michael Bronski, writing for *Cineaste*, asserted that "while it is unfair to Van Sant's considerable talents as a filmmaker to compare these two works, the comparison is inevitable. *Milk* feels artistically weak—even flabby—politically naïve and, while not exactly dishonest, certainly ahistorical enough to be deeply misleading."[31] For Bronski, this was in part a critique of the genre: the dramatic film, he suggested, is not as effective at making the political case as the documentary. What Bronski found misleading is the elevation of the individual—Harvey Milk—over and above the hard work of many unnamed individuals involved in political organizing of the time: "*Milk* fails politically because it sacrifices and substitutes the communal work of political organizing with the false image of a gay political savior and martyr. . . . It's easy for the media and the popular imagination to reduce the complexities and contradictions of a political movement to the public image of one dynamic person."[32] James Burns, by contrast, in a review in the *Journal of American History* wrote, "For those who have seen *The Times of Harvey Milk*, *Milk* will seem familiar, as it integrates a good deal of material from the earlier film. Some broadcast footage is reshot with actors reciting the original dialogue verbatim, and several scenes in *Milk* are dramatizations of anecdotes related by Milk's associates in the documentary. Because it hews so closely to this public transcript, *Milk* is fairly scrupulous in its reconstruction of events."[33] For Burns, the fact of the documentary and Van Sant's reliance on it as a kind of public record actually enhance the film's veracity.

Burns did concede, though, that "it is in the nature of the biopic to simplify events and amplify the importance of its subject,"[34] echoing Bronski's criticism that the film downplays the work of the activists who laid the groundwork for Milk. Labeling the film a "biopic" is itself meant as critique; biopics are commonly considered puff pieces or vehicles for stars rather than sustained inquiries into the complexities that make up an historical figure's life. As Dennis

Bingham has pointed out, "'If it's a bad movie it's a "biopic" but if it's doing something interesting or different, it's something else': this is an almost universal attitude."[35] *Milk* has also been criticized for implying that White's actions were homophobic, growing out of his own repressed homosexuality.[36] This critique, though, seems like a critique of interpretation—and, indeed, if we are treating *Milk* as an historical account, then it is incumbent upon us to recognize that, like all historical accounts, it represents an interpretation by an author. In a style popularized by Oliver Stone,[37] this film intersperses archival footage with re-creations made to look like archival footage in an attempt to lend authority to or legitimate the story being told. Rather than condemn the epistemological uncertainty created by this move, I argue that it actually invites a more critical gaze at the film and the attendant construction of historical knowledge.

I want to use this film to articulate some of the key points I am trying to make about the possibilities for the production of historical knowledge on film. In this section, I first argue that the history film, because of its wide dissemination relative to other history formats, is able to popularize and to bring into representation those aspects of the past that have heretofore been unrepresented or underrepresented and therefore largely unknown outside of academic history circles. Second, I explain the cognitive work engendered in viewers by the appearance, in Jean-Louis Comolli's words, of a "body too many" in the biopic. Finally, I illustrate the film's veritable obsession with the issue of mediation; within the diegesis, characters are continually documenting their world: the film is orchestrated around Milk's tape recording of his memoir and relies heavily on TV news reports and so forth. The presence of mediating devices has the perhaps unintended effect of calling attention to the very process of mediation at work in any dissemination of the past, reminding the viewer that the film itself is a mediation, a representation, an interpretation of what happened as opposed to a transparent window onto the earlier moment. In the end, my point is not that this film is better or worse history than the acclaimed Epstein documentary but that it produces a different and also useful form of historical knowledge.

Although much of the radicalism of the 1960s and 1970s has found its way into U.S. history survey courses—the civil rights movement and the women's movement tend to be staples of twentieth-century U.S. history—the gay rights

movement has not, at least not to the same degree. Certainly, queer theory has taken up aspects of gay activism, but the history of the gay rights movement has been an underrepresented aspect of the 1970s. In that regard, a mainstream film such as *Milk*, because of its topic alone, has the potential to produce historical knowledge simply because it makes visible a largely unknown chapter in the larger struggle for equal rights in this country. And knowledge about this historical moment has the potential to awaken political consciousness in a generation that did not live through the events depicted. Furthermore, as an account of individuals working through an oppressive system to change it, the film produces knowledge that is transportable to other contexts. It offers an example of a disempowered and invisible minority becoming visible, which is the first grounds for political recognition. In this case, the importance of visibility is actually thematized in the film itself in that part of Milk's agenda was to get gay people to come out of the closet. Film is and has been from its first days a medium for making things visible and as such is well suited to this politico-historical task.

It is also essential to consider specifically what a narrative film might be able to do that a documentary—even a documentary as effective as *The Times of Harvey Milk*—cannot. Although the documentary can also make the past visible in a literal sense, what exactly it can make visible is limited by the kinds of archival footage that actually exists. The narrative film, however, is not bound in the same way. Most of the narrative in *Milk* is rendered in flashback, but the chronological starting point is Harvey Milk's fortieth birthday, a pivotal day in his life and yet one that not surprisingly was not captured on film. It is on this day that he meets Scott (Milk calls him "Scottie") Smith (James Franco), flirts with him very sweetly in a New York City subway station, and ultimately ends up sharing birthday cake with him in bed. The scene in Milk's apartment is intimate, artfully shot, and edited as a montage of close-ups of the two men's faces: a nose, cheeks, eyes, lips almost in a kiss (see figure 1.1). Because of the way the film is shot, we are not looking exactly through one character's eyes at the other, and yet we are brought right into the two characters' midst. The scene does not exactly encourage the audience to identify with either of these two men; rather, it brings viewers close to the characters' intimacy, thereby legitimizing and familiarizing it. There is an affective charge in this scene in that

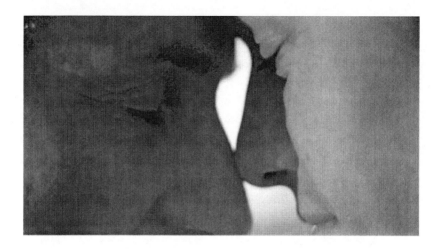

FIGURE 1.1 Harvey Milk and "Scottie" Smith. From *Milk*.

we experience something of their attraction for each other, but not *as* one or the other of them. The intensity of this moment, its erotic quality, is followed by a scene of the two of them sitting up, shirtless, in bed, Milk feeding Scottie cake with a spoon.

They have the following playful exchange:

SCOTT: Man, you're forty now.

HARVEY: Forty years old and I haven't done a thing that I'm proud of.

SCOTT: You keep eating this cake, and you're gonna be fat by the time you're fifty.

HARVEY: That's if I ever get to fifty.

SCOTT: [Takes frosting on his fingers and smears it on Harvey's face.] Happy birthday, old man.

HARVEY: Why don't we run away together?

SCOTT: Where to? [They kiss, frosting and all.]³⁸

The film, in a way that is largely impossible in the documentary, offers us access to their affection for one another, their playfulness, their intimacy. It offers the audience a way into this story; it fosters feeling for and interest in the characters' plight, making their lives and what they stand for seem important and meaningful. The audience is offered a way into this story, a way to care

about and be invested in gay characters in order to understand the contours of their existence within the parameters placed on them by the political and social culture of the United States in the not so distant past. The "way in," however, is not through some simple identification, but through being brought into the characters' world and being made aware of their priorities and the kind of work they are engaged in to bring about social change. For some viewers, this film might be their first moment of proximity to the gay community, and that experience is meant to be inviting and humanizing. The viewer's relationship to the characters is not identification. A heterosexual viewer does not suddenly feel gay, but he or she nevertheless has an affective engagement with the characters' desires for one another. This engagement makes their lives, dreams, and hopes seem meaningful and worth fighting for.

On a more theoretical level, the very form of the biopic actually works against the common claim that viewers accept the cinematic illusion as truth, that they slip into the past and believe they are seeing the world as it actually was. The premise of the biopic—in which a person who really lived is played by an actor everyone knows and recognizes—works against the kind of immersive engagement upon which identification is predicated and thus enables the distance necessary to produce historical knowledge. In discussing the biopic, Bingham cites Jean-Louis Comolli's important 1978 essay "Historical Fiction: A Body Too Much" to make the point that "the two bodies—the body of the actor and the body of the actual person as the spectator knows him or her—compete for the spectator's belief" and that, paradoxically, "the strength of the performance lies in its ability to make us believe that this could be Picasso or Kahlo, while never letting us forget, either, that these are Hopkins and Hayek creating their art, interpreting."[39] Bingham here is suggesting that the biopic produces a kind of cognitive dissonance in the viewer as he or she is asked to hold two contradictory ideas simultaneously. According to Comolli, "the historical character, filmed, has at least two bodies, that of the imagery and that of the actor who represents him for us. There are at least two bodies in competition, one body too much." Here, Comolli gets at a kind of oscillation that takes place between belief in what we see and knowledge that what we see is not the thing itself. He writes, "We know, but we want something else: to believe. We want to be fooled, without ever quite ceasing to know that we are." In watching Sean Penn play Harvey Milk, the viewer is, in Comolli's words, "summoned

to the delicate exercise of a double game: it is him and it is not, always and at the same time; we believe in it and we do not, at the same time."[40] This kind of oscillation between belief and disbelief does an important kind of epistemological work: it undermines the simple illusion that we are seeing the past as it was. The body of the actor at once evokes the historical figure he or she represents and at the same time disavows him or her. In interfering with the illusion, the actor's performance reminds us that it is a re-creation, an interpretation, a representation of the past—and not the past itself. This is crucial in that it reasserts a sense of difference between the present and the past. It also prevents a kind of immersion in the narrative because the viewer at various points will remember that what he or she is viewing is an actor, not the historical figure. Those moments—often initiated by the re-created archival footage that has the actor instead of the historical figure—calls the viewer to himself or herself. Part of the cognitive work done in those moments is the searching for clues—Is this footage real or re-created?—and this self-conscious critical engagement is itself a form of historical thinking.

Milk has a veritable obsession with the idea of mediation. The narrative begins with and is punctuated by the recording Harvey Milk made nine days before his assassination. We see him sitting at his kitchen table, speaking into a small microphone attached to a tape recorder (see figure 1.2). He begins, "This is Harvey Milk, speaking on Friday, November 18. This is only to be played in the event of my death by assassination." Although the recording in the film is based on the recording Milk did in fact make for that purpose, by foregrounding it here, privileging it as the opening scene, the film makes the audience acutely aware that Milk is consciously constructing a narrative. The story we are watching unfold in the film is being mediated through him, a mediation that is signaled and made explicit by the interposition of the tape recorder.

Although Milk's narration into the tape recorder begins the film's narrative, the very first images we see, upon which the titles are superimposed, are archival video images of gay men being led out of bars by police. The video images are black and white and are interspersed with newspapers, whose headlines read, "Police and Homosexuals Clash" and "Tavern Charges Police Brutality." Some of these men look away from the camera, hiding their heads in shame. This footage is followed by the kitchen table scene described earlier. Milk's narrative continues, "During one of my early campaigns I began to open speeches with

FIGURE 1.2 Harvey Milk sitting at a table, speaking into a tape recorder. From *Milk*.

a line that became a kind of signature," and here there is a cut to Milk with a megaphone speaking before an audience, "My name is Harvey Milk, and I want to recruit you." Another cut returns us to the present as Milk continues into his tape recorder, "I fully realize that a person who stands for what I stand for, an activist, a gay activist, makes themselves the target for someone who is insecure, terrified, afraid, or disturbed themselves. It's a very real possibility, see, because in San Francisco we have broken the dam of major prejudice in this country." Here there is another cut, and we are aware of the scratchy sound of police walkie-talkies or radio. We see archival footage of police moving inside the county building as they and we are trying to understand what has happened. As the stage directions in Dustin Lance Black's screenplay describe, "Police officers and press race through the halls of City Hall, their walkie-talkies squawking. Something terrible has happened. It's chaos. A stretcher is wheeled out of an office. On it, a filled body bag with a white sheet draped over it. The press rush to get a photo. The police officers quickly load the body onto the elevator and disappear from sight."[41] Then there is a cut to another piece of archival footage, a distraught-looking Dianne Feinstein, then chair of the county board, speaking into a microphone: "As president of the board of supervisors, it's my duty to make this announcement. Both Mayor Moscone and Supervisor Harvey Milk have been shot . . . and killed." There is a cut to Milk with the tape recorder: "Knowing that I could be assassinated at any moment, I feel it's important that

some people should understand my thoughts. I think that—I wish I had time to explain everything I did. Almost everything that was done was done with an eye on the gay movement." And explain he attempts to do, with a cut to a younger Milk on the New York City subway on his fortieth birthday, where he meets and picks up Scottie, the man who will become his boyfriend.

By describing the cuts in the film's opening moments, I hope to make clear that there are many different types of film layered here—archival reconstructions of the film's present and reconstructions of the past that are supposed to look archival. This layering or joining of film that is supposed to represent different temporal moments invites a skeptical or questioning gaze. Rather than passively absorbing the narrative, viewers are positioned to look critically at the footage. Is it archival, or was it made for this film? This kind of intellectual work reinforces the idea that the film is a constructed product, an interpretation. The oscillation between real archival footage (the first scene where gay men are being escorted by police out of a bar) and re-created, artificially grainy footage asks us as viewers to try to discern what is authentic and what is re-created. That we engage in that kind of questioning prevents us from passively accepting the story as truth so that we see it instead as a mediation, a representation, an interpretation of the past. The use of archival footage works, as it does in a documentary, to serve as evidence for the veracity of the story being told. However, by interspersing real archival footage with footage created to look archival but containing the actors and actresses, the audience is asked to recognize the artificial and interpretive aspects of the film as a whole.

Many other instances in the film call attention to mediated representations. Immediately following Milk's proposal to Scottie that they run away together, we see footage that is clearly supposed to be made from a hand-held video camera. We see Milk with long hair behind the wheel of the car. He turns to look at the passenger seat, from where we assume Scottie is filming him, and makes faces into the camera, goofing around. In the early scenes set in San Francisco's Castro neighborhood, Milk has a camera; we see him photograph Scottie and the neighborhood. We see the photos being taken and then the photos themselves. The shop Milk opens up in the Castro, which ultimately becomes his headquarters, is literally a camera store. Later in the film, we see playing on a television archival news footage of Walter Cronkite and other television news anchors along with archival footage of Anita Bryant (figure 1.3); these scenes

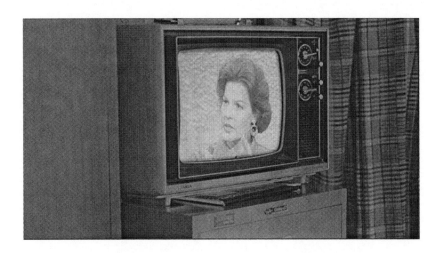

FIGURE 1.3 Anita Bryant on TV. From *Milk*.

are meant to teach both the characters in the film and the audience about various anti–gay rights initiatives, such as the one in Miami "to repeal the four month old ordinance which prohibits job and housing discrimination against homosexuals." The frame narration that punctuates the film—Milk speaking into his tape recorder—also works against immersion in the narrative, reminding viewers that we are hearing an account of a life, not seeing it lived.

What I hope to have suggested here is that this film gives viewers a stake in the historical knowledge produced. The concept of identification, I believe, misdescribes this process. Furthermore, the conscious calling attention to the mediating devices—the camera, the video camera, the tape recorder—has the effect of calling attention to the narrative as just that, a mediated construction. This kind of metaconsciousness is precisely what Collingwood finds necessary for historical thinking, and it is in this way that the film has the potential to create what I am calling a "historical consciousness" in the viewer.

HOTEL RWANDA: REACHING THROUGH THE PHONE

Although I want to acknowledge that one can never predict how any individual will respond to or read a film, it would be equally naive to dismiss the

many formal strategies filmmakers deploy in an attempt to position viewers to understand events in a particular way. Terry George's 1994 film *Hotel Rwanda* uses a range of such strategies as mechanisms with the potential to provoke historical thinking. Through subtle sensuous interruptions to the narrative, interruptions that occur not on the visual register but on the aural or haptic register, the film positions viewers to process and bring the historical narrative into intelligibility. It engages the viewer's body, but not in the service of a facile identification with onscreen characters. There are ways in which the film actively grabs us, not to bring us into the story so much as to position us as listeners. Viewers are made to feel like outsiders who nevertheless have an obligation to make sense of the historical circumstances and use that knowledge to inform the way they will act in the future when confronted with similar situations.

Hotel Rwanda professes to tell the "true story" of Paul Rusesabagina, the Hutu manager of a fancy, Belgian-owned hotel in Kigali, Rwanda, in 1994. I have put the term *true story* in quotation marks here to signal that although details of the story might not be historically verifiable in a way that would be comforting to historians, the film is aiming to depict a historical truth about the dispossession of the Tutsis and the world's neglect of them. This is not to deny that there has been some controversy over the historical interpretation advanced by the film.[42]

The film dramatizes the story of how Rusesabagina, a Hutu who was married to a Tutsi, housed 1,268 Tutsi refugees in the hotel when Tutsis were being hunted down and killed by Hutu militias. The film is not just the story of Rusesabagina's humanity, but also of the Western world's failure in the face of a humanitarian crisis. The film critiques the actions of nations, appealing to the viewer not as a national subject, but as a caring humanitarian, a citizen of the world. In many ways, *Hotel Rwanda* is a formulaic film that borrows heavily from Hollywood, in particular from *Schindler's List* (Steven Spielberg, 1993). Nevertheless, there is a politics to the form the film takes. I focus here on the particular ways in which the film engages, speaks to, challenges, and provokes its viewers, attempting to produce historical knowledge in a way that might awaken political consciousness.

Despite the fact that *Hotel Rwanda* is a mainstream film in the dramatic tradition, there are powerful interruptions in the narrative in which encounters of different kinds occur. These interruptions are often aural or caused by

the disjuncture between visual and aural information. These aural interruptions work to reposition the viewer as listener or receiver of historical evidence. The strategy begins at the very beginning of the film, which opens with a black screen. The accompanying noise on the soundtrack is unclear at first and then is gradually discernible as static. Someone, it seems, is turning a radio dial. When finally a station is tuned in, we hear, as diegetic voice-over, "We will squash their infestation." We soon learn that this is RTLM Hutu Power Radio railing against the Tutsis. The film's audience is being asked, first and foremost, to listen—and to process or make sense intellectually of what is heard.

Hotel Rwanda mobilizes and engages our senses—beyond the visual—with the effect of producing a different kind of historical knowledge about the events in Rwanda, in particular knowledge about the way the events were or were not mediated to the rest of the world. It also produces knowledge about the modern condition of being far away from an ongoing historical trauma, forcing the viewer to think about his or her own complicity in the circumstances and the subsequent obligation to respond in some way. Two scenes in particular produce affective engagements that ultimately foster the kinds of knowledges I just described. Despite the differences between them, both scenes demonstrate that interruptions in the narrative can produce a type of affective engagement that contrasts sharply with simple identification.

In a particularly powerful scene, viewers are forced into an encounter that is destabilizing precisely because it does not occur primarily on the visual register. In this scene, Paul and his employee Gregoire have left the hotel to procure more supplies from a corrupt Hutu, George Rutugundas. It is a dangerous mission. From their car windows, they see chaos on the streets and buildings burning. Upon arriving, they learn from George that all supplies and food are now double the price. Nevertheless, they buy what they can. Following George's suggestion, they take the river route back. The visual field is quite dark, obscured by fog. Viewers are positioned as if in the backseat of the car, sitting behind Paul and Gregoire. We hear the loud thumping noise of the tires going over bumps and through the shakiness of the camera feel in our own bodies the van's jerkiness. Paul and Gregoire are confused, and Paul asks, "Gregoire, what is going on? . . . You've driven off the road. . . . Stop the car, stop the car."[43] Like them, we feel the unevenness of the road but don't know what has caused it. When the car stops, Paul opens the door and literally falls to the ground.

Through dense fog, we can just barely make out piles of dead bodies around him. At that moment, the film provokes—largely on the sensuous register— a traumatic encounter that, I would argue, forces us to process the situation intellectually. Paul reels back in horror, gasping, slowly realizing that the road is littered with dead bodies—the bumps in the road are actually bodies under the tires. We are aware of the dead bodies, but because of the darkness and fog we can see only their outlines, no gratuitous blood or mutilation. We see Paul's visceral reaction: his body crumples, he gags. The scene is profoundly disturbing, but not so much because of what we see. The bumping of the camera as the van literally drives over the dead bodies implicates both Rusesabagina and us, for both he and we are in the car that runs over the dead Tutsis. Forcing us to feel this through a somatic engagement, the film pushes us to consider our own complicity in these deaths. The agitation and queasiness we feel—those affective responses—occur within a historical frame and narrative produced by the film: that innocent people were brutally murdered in Rwanda. This experience activates our own personal stake in that knowledge.

Part of the work of the film—and part of the knowledge that gets produced here—has to do with the viewer's being forced to grapple with his or her own relationship to historical events in Rwanda. These events are at two removes: they are in the past, have already happened, and thus cannot be changed, and they are geographically distant, not witnessed firsthand. As I have already suggested, historical inquiry and the production of historical knowledge require an assertion of the unbridgeable distance between past and present. The past is irretrievably lost. No one who was not there at the time, not even the historian, can ever go back or know exactly what it was like. Our relation to the past is always mediated through sources, artifacts, interpretations, and representations. Interestingly, this film foregrounds the issue of mediation. Even for the characters in the film, the events transpiring around them are mediated through the radio, video clips, and television; that mediation both stands in for the viewers mediated relationship to the historical events in Rwanda and illustrates the way in which those mediations invite, even require, active participation on the part of viewers to make intellectual meaning of what they sense. In many instances, the narrative flow is interrupted by radio or television broadcasts. The effect of these interruptions is simultaneously to put viewers in the position of Rwandans listening to the radio but also to snap them out of the filmic narrative. In

other words, we listen to these reports as the Rwandans do in their cars and homes, but also as ourselves—listening to the way these events from the past are being mediated.

In one scene, after Paul departs the hotel at night, there is a cut to him in his car. He is surrounded by darkness. Eerie, scratching sounds emanate from the radio. Because these sounds are disembodied, they have no visual corollary; viewers must actively attempt to decipher and discern. He reaches down to tune in a station. As the camera follows Paul's hand to the dial in close-up, it seems to call attention to the radio and to signal its significance. The noises coming through are still unintelligible, neither he nor we can make sense of it. There is no possibility for recognition. Instead, there is a startling crash of glass outside the car. Paul is nervous, on edge, disturbed by the rioting on the streets. His house is dark, too, because the power has been turned off. With his flashlight, he moves from room to room, empty bed to empty bed, until he finds all his neighbors crowded into a single room. There are rumors that a Tutsi rebel assassinated the president. The next day, the Tutsis in his neighborhood are listening to a handheld radio: "Listen to me, good people of Rwanda, terrible news, horrible news. Our great president is murdered by the Tutsi cockroaches. . . . They shot his plane from the sky. . . . We must cut the tall trees. Cut the tall trees now!" "Cut the trees" is the code Paul had been warned about that would initiate the Hutu militias to go after the Tutsis.

The radio newscasts foreground the issue of precisely how these unfolding events were mediated both to the people of Rwanda and to the rest of the world in 1994—and reminds us that they are also being mediated to us through the film. In particular, the film consistently draws attention to the mediation through which the characters gradually come to apprehend the horror of the situation. In one scene, Paul visits newsman David Fleming (David O'Hara) in his hotel room; David needs Paul to fix his air conditioner. We hear the sound of a videocassette being rewound, foregrounding once again the mediated nature of what we are about to see. The videocassette is a filmed interview with Colonel Oliver (Nick Nolte) of the United Nations (UN) peacekeeping force. First, we see a shot of the small television set through which the video is playing. Then there is a cut to Paul, who looks up from his task, listening to the words spoken by Colonel Oliver: "The elements in the government are following the example of what happened in the Americas and Somalia. I think they

intend to intimidate us, trying to attack us and hope that the West will pull all its troops out." "Do you think they'll succeed?" the interviewer asks. "No, they won't. The UN is here to stay." Here, early on in the film, our expectations of our own role and commitment are confirmed: the UN peacekeeping force will remain. Nevertheless, the film positions us not as active participants in the drama, but as part of an international media audience, distant from the events on the ground.

As I have suggested, information about the Hutu massacres of Tutsis often comes in the film as interruptions to the narrative flow and is usually mediated—either by a radio broadcast or by a television newscast. In these moments, the film carefully avoids any visual shock. In one scene early on, before anyone is aware of the scale of the massacres taking place, the cameraman Jack Daglish (Joaquin Phoenix) bursts into the room designated as news headquarters at the hotel. His superior, David Fleming, begins to reprimand him for disobeying protocol and shooting footage outside of the hotel, exclaiming, "What the hell do you think you're doing? I'm responsible for the safety of this crew!" There is a close-up of the VCR as Jack inserts the videotape (see figure 1.4). "What is this?" David asks. Before we see any images, we hear little noises that we eventually understand to be the sound of women crying and voices yelling. But they sound small, far away, as they would on a TV set at low volume. Furthermore, the TV set we are watching is tiny, with a screen not more than ten inches wide, frustrating our curiosity. This is not at all an immersive experience. Nevertheless, the sounds pique Paul's interest. We see him looking at the screen before we see it ourselves. He stands up. Then we see the small screen at which he is staring. It is a scene of a village, many bodies lying on the ground, and others swinging machetes and dancing (see figure 1.5). Although the scene is ultimately legible as the scene of a massacre, the way it is presented prevents us from getting too close, prevents any kind of voyeuristic engagement. It is not a scene that we are *in* as anything other than distant viewers. Because the massacre is shot from long view and shown on a small screen there are no gory details to be seen. Rather, the scene emphasizes the way in which the event is being mediated, hailing us as distant observers, not as participants.

A scene that I find to be emblematic of this element of the film's agenda—to position the viewers in such a way that they recognize their distance and difference from the Tutsis but come to feel that the Tutsis' story is important and

FIGURE 1.4 Putting a tape into the VCR. From *Hotel Rwanda*.

FIGURE 1.5 Watching the massacre on TV. From *Hotel Rwanda*.

can in some way affect their own view of the world—follows an exchange Paul has with Mr. Tillins (Jean Reno), the president of the hotel's parent company, Sabena, in Belgium. Mr. Tillins tells Paul that he asked the French to rescue the refugees in the hotel, but they refused. Mr. Tillins says, "I pleaded with the French and Belgians to go back and get you all. I'm afraid this is not going to happen; they are cowards, Paul. Rwanda is not worth a single vote to any of them, the French, the British, the Americans. I am sorry, Paul." The point here is that the nations of the world will not help. If there will be aid, it will not come through national channels: it will be the work of a multitude of concerned individuals. The subsequent call for help, as dramatized by the film, is an individual address from one person to another—a spoken plea, over the phone.

There is a cut to Paul addressing his people: "There will be no rescue. No intervention force. We can only save ourselves. Many of you know influential people abroad. You must call these people. You must tell them what will happen to us. Say good-bye. But when you say good-bye, say it as though you are reaching through the phone and holding their hand. Let them know that if they let go of that hand, you will die." Part of this speech functions as voice-over to another cut to images of the Tutsis in his hotel speaking on the telephone.

Notice that despite the fact that the scene foregrounds the mediation—images of the Tutsis on the phone—Paul quite literally urges the group to *touch* the people to whom they are speaking: "When you say good-bye, say it as though you are reaching through the phone and holding their hand." Paul is suggesting that to get foreigners—and the West in particular—to commit to help, they must be touched, they must be grabbed, they must be made to feel something. But importantly in this film the audience is not made to feel *like* the Tutsis, not positioned simply to identify with or wallow in the Tutsis' pain. We are positioned to listen to them: our own individual bodies are addressed. Politics, as I have suggested, are premised on *feeling* connected to a people or a cause or a nation. To mobilize those political commitments, however, we must feel, too.

Furthermore, this "reaching through the phone" moment, I think, underscores the film's insistence that we must care and respond but also know that it is not our tragedy and that we are not allowed to occupy the victims' position. We cannot overidentify with the victims because they are speaking to us. The call for help as dramatized by the film—the reaching out to the world—is literally mediated by the telephone. The phone as mediator here posits a distance between the Rwandans and the rest of the world and, by extension, between the Rwandans and us, the viewers of the film. This layer of mediation, of distance, is crucial for understanding the contours of our relationship to the crisis. We are positioned as listeners, as part of an international community of those at a distance who have been asked to listen. We have a relationship of obligation to these others precisely because they can speak to us, precisely because—despite our geographic and cultural difference from them—they are literally asking us for help. We are addressed in our own bodies, but not simply through identification with the main characters in the film.

GOOD NIGHT AND GOOD LUCK:
HISTORY OF THE PRESENT

I want to make one final point about historical film: that film is particularly well suited to history with a political dimension because it can offer viewers a useful archive of past episodes and actions that might be called upon to inform decisions or engagements in the present or that can in some fundamental way shed light on aspects of the present that have been intentionally or unintentionally obscured. Toward that end, I want to consider very briefly George Clooney's 2008 film about Edward R. Murrow, *Good Night and Good Luck*. This film is meant to be historical fiction, meant to make visible the role journalists once had in challenging the government by standing up and exposing what they saw as wrong or unjust, even in the face of potential retribution. Some have argued, most famously Siegfried Kracauer,[44] that historical films teach us more about the historical moment in which they were created than about the historical moment depicted. In that light, this film is particularly interesting in that it very consciously depicts an earlier moment that might offer direction or motivation for the present. One cannot watch this film—and certainly Clooney would feel he had failed if one did—without considering how different the state of journalism is in the present conjuncture from how it was in the 1950s.[45] I see this film as a history intentionally meant to intervene in the present. It seeks to wake up audiences, to have them ask for more from the news media. And as such, it serves as an example of how a history film and the kinds of historical knowledge produced therein can be politically useful.

It would be disingenuous to deny that this film produces nostalgia for the 1950s—the earnestness of the newsmen, the intensity of the job—a mood that is enhanced by the film's attention to style and the cool jazz on the soundtrack. But the film also resists the temptation to indulge the viewer with an abundance of visual pleasure: it is a black-and-white film with very little action, a very circumscribed set (shot largely in the newsroom), and no development of a love relationship. In fact, the only "fun" in this film occurs in the opening titles, at the awards dinner, before Edward R. Murrow comes to the podium with a speech intended to serve as a wake-up call to the journalists in the room.

And yet the film is engaging. On the most superficial level, it takes pleasure in the style of the 1950s in a way that is similar to but less dramatic than the pleasure in the early 1960s of *Mad Men* (AMC, 2007–2015), which I discuss at length in the next chapter. The camera lingers over hairstyles, clothing, glasses, and, of course, smoking. But it revels in the old technology, too: in the opening sequence, the men line up for a photo to be taken with a twin lens reflex camera (the kind one looks down into), and the newsroom hums with the sound of the film projector. Curiosity is elicited here, an invitation to have a look, and the old technologies create a kind of visual fascination even as they remind viewers of the material and social differences between then and now. The black-and-whiteness, the film's austere style, its obsession with the 1950s (smoking, jazz, old technology) are about fostering a kind of affective engagement with this historical period that enables viewers to critique the colorful spectacle of journalism in the present. The style is seductive, and in its journalistic earnestness it seems better than what we have now.

As in *Milk*, here, too, the fact that many of the characters are played by well-known actors, including Clooney himself, means that the audience is able to suspend disbelief, to be fully engrossed in the narrative, for only short stretches without remembering that they are watching Clooney or Robert Downey Jr. Likewise, the film incorporates archival footage of Joseph McCarthy and others testifying before the House Un-American Activities Committee. This footage is often projected in the newsroom, and the newsmen discuss it. We find ourselves studying this footage to try to determine if it is in fact archival, for the film actively invites a skeptical gaze in its viewers. As in *Milk*, the archival footage in *Good Night* works on the one hand to lend credibility to the story being told—it functions as a primary source—but on the other to call attention to the fact that historical narrative is a construction. The inclusion of archival footage, in perhaps a counterintuitive way, works against the illusion of immediacy, preventing the viewer from being lost in or absorbed by the narrative.

Finally, because the movie begins with an address to both those attendees at the Radio and Television News Directors' Association Annual Meeting and to us, the film's audience, we are not presumed to be in the film but rather are being spoken to by it—as is the case with *Hotel Rwanda*. Furthermore, when Murrow takes the podium, he warns that he is going to speak with candor about what is happening to radio and television. What he criticizes at this very

first moment in the film is precisely the problem with the news media at the film's moment of creation, in 2005, in the context of the war on terror and the wars in Afghanistan and Iraq. He says to the audience before him, an audience not expecting the cautionary tale he is about to tell,

> This might just do nobody any good. At the end of this discourse a few people may accuse this reporter of fouling his own comfortable nest, and your organization may be accused of having given hospitality to heretical and even dangerous ideas. But the elaborate structure of networks, advertising agencies, and sponsors will not be shaken or altered. It is my desire, if not my duty, to try to talk to you journeymen with some candor about what is happening to radio and television.... Our history will be what we make of it. And if there are any historians about fifty or a hundred years from now, and there should be preserved the Kinescopes for one week of all three networks, they will there find recorded in black and white and in color evidence of decadence, escapism, and insulation from the realities of the world in which we live. We are currently wealthy, fat, comfortable, and complacent. We have a built-in allergy to unpleasant or disturbing information. Our mass media reflect this. But unless we get up off our fat surpluses and recognize that television in the main is being used to distract, delude, amuse, and insulate us, then television and those who finance it, those who look at it, and those who work at it may see a totally different picture tonight.[46]

Part of the movie's mission is to make visible the way in which the TV news, referred to in the film as "editorial," is increasingly being policed by corporate interests and sponsors. Very early on in the film, Murrow is pushing to cover the story of Milo Radulovich, a young man who was kicked out of the air force as a security risk because his father reads a Serbian newspaper. Murrow's colleague Sig Mickelson (Jeff Daniels) points out that they have sponsors who support the military, that Alcoa won't pay for the ads. This point is made at several points over the course of the film but most explicitly when Murrow is called into his boss's office and told that Alcoa is pulling its ads from his show. The film, in other words, is using this historical case to make visible to contemporary viewers the way in which the press's freedom—supposedly protected by the Constitution—is compromised by the corporate structure of television.

Furthermore, Murrow's sketch of a "wealthy, fat, comfortable, and complacent" populace seems a more apt description of people in the viewer's present. It thus forces viewers to negotiate the distance between now and then and thereby makes a critique of the present.

But the film also takes on the question of the media's impartiality or neutrality. When Murrow says he wants to take this case, his superior, Mickelson, asks if he really wants to abandon the standard they have set for covering both sides of a story. Murrow replies, "We all editorialize, it's just to what degree. . . . I've searched my conscience, and I can't for the life of me find any justification for this. I simply cannot accept that there are on every story two equal and logical sides to an argument. Call it editorializing, then call it that. . . . They're going to have equal time to defend themselves." The film is suggesting in a rather pointed way that the journalistic ideal was not originally considered to be equal time to all positions; not every story has two equal sides. Sometimes to advance social justice a journalist must take a side.

As I suggested at the outset, this film has very little action, and if I have quoted at length from monologues, it is because the film itself is very talky. It is trying to address its viewers, to speak to them in a way that points out how a particular interpretation can produce historical knowledge about the past, can be a model for the present, or can make visible the problems or shortcomings of the present.

None of these films is without flaws. But that is true of all history. All histories, written and otherwise, get some things right and other things wrong, end up emphasizing one aspect or detail to the exclusion of others, and so on. Furthermore, I do not mean to endorse the specific interpretations advanced by each of these films. What I have tried to show is *how* they advance these interpretations and how they produce historical knowledge. If anything, the power of film to do this means that we need to take them seriously, so that we do not leave their perhaps erroneous or misleading interpretations uncontested. The constructive moments of affective engagement that I have described here work in ways different from identification as it is commonly understood; in these moments, viewers are engaged in complex and sometimes contradictory ways

that require reflection and thus have the potential to provoke historical think-ing and historical consciousness. Because of film's complex mode of address and the fact, for example, that one can be pulled in by the cinematography but pushed out by the editing, a film does not need to be a "work of art" to initiate the kind of thinking I have described here. In other words, the films with the greatest potential to produce historical knowledge are not necessarily the most acclaimed ones, but rather those that foreground mediation, that produce epis-temological uncertainty through the layering of different types of footage, and that in a range of ways prevent us from losing ourselves in the illusion.

2

WAKING THE PAST
THE HISTORICALLY CONSCIOUS
TELEVISION DRAMA

Television has become the most important means of communication and education of our time. Do historians, who boast about the widening of their horizons and the opening of new fields of research, realize that it is television that has broadened our view of the world? . . . What I would like to suggest is that, when teaching history, when writing books, we adopt a style profoundly affected by the techniques of television.

PIERRE SORLIN, "TELEVISION AND OUR UNDERSTANDING OF HISTORY"

PIERRE SORLIN MAKES a radical claim for the impact television has had not just on the dissemination of historical knowledge but on the writing of academic history as well: "I am convinced that television is going to transform our comprehension and that the historiography of tomorrow will be fairly different from the one we have been used to. Cinema changed our vision but did not influence our intelligence of the past. On the other hand, it is our very conception of history that will be modified by television."[1] Such claims are particularly unexpected given the overall academic contempt for popular history on television and given the conventional privileging of film over television as "higher brow." Following Sorlin's suggestion, I hope to show in this chapter that certain television genres might have structural and formal properties that enable them to produce historical knowledge in a way that is distinct from the

way film produces such knowledge, ultimately forcing us to reconsider what the project of history looks like in the contemporary media landscape.

I begin this chapter by engaging some of the thoughtful and important recent work on historical representation on television. Much of this work focuses on either the documentary or the docudrama or the miniseries, texts concerned primarily with *re-creating* a specific historical event. Ann Gray and Erin Bell have labeled these sorts of television programs "factual history."[2] Factual history as they describe it encompasses not only documentary and historical reconstructions, but some more experimental genres as well, such as reality history TV (which is the focus of the next chapter) and even splashy programs such as *Who Do You Think You Are?* (BBC One), where celebrities trace their genealogies. By contrast, the type of shows I consider in this chapter, which might be dubbed "historically conscious dramas," are not "factual history" because they do not aim first and foremost to re-create historical events. Rather, they aim to reconstruct the lived contours of a particular historical moment and, in so doing, to provoke a historical consciousness in their viewers.

The study of history on television has blossomed as a field in its own right, attracting scholars from a range of disciplines. Gray and Bell's groundbreaking and extensive work in the context of their long-term research project Televising History, 1995–2010, has done much to shape the field. Their research project, funded by the Arts and Humanities Research Council, led to the publication of two volumes: a collection of essays entitled *Televising History: Mediating the Past in Postwar Europe*[3] and the monograph *History on Television*. Their research was motivated by the veritable explosion of history programming in the United Kingdom in the 1990s, a phenomenon that occurred on a slightly smaller scale in the United States, although, as their research suggests, historical programming on British TV is more weighted toward genres other than drama.[4] Part of what they argue in the monograph is that history on television can properly be considered public history. This argument is in some ways resonant with the work by Jerome de Groot, who concludes his book *Consuming History* with the claim that "history is always a mediated experience, but the movement away from text toward virtual or material or physical history presents us with a new and developing historiography. The physical consumption of the historical—economic or otherwise—has been revolutionized."[5] De Groot explores the commodification of history but recognizes the way in which those

processes also work to make history accessible and public in new ways. Gray and Bell use as a working definition of public history those "representation[s] of the past provided for and/or by people who are not university based historians."[6] They consider the kinds of responses that ordinary people post and the discussions they engage in as a form of public history. They also interviewed scholars to track the range of opinions about history on television. Although some scholars categorically refused to consider any of this alternative or experimental programming as history, others were more open-minded. One scholar, for instance, insisted that the opposition between academic history and public history is false, arguing that "television [is] not the poor step-sibling to academic dissemination; rather, as a form of public history it offer[s] the opportunity to reach different audiences and see scholarship represented in different ways, appropriate to the topics discussed."[7] Without downplaying television's ability to reach an audience that academic history cannot, I also hope to show that history on television can offer a kind of complexity that, although different from the complexity of a monograph, produces a kind of historical knowledge that even an academic historian would recognize as having value.

Perhaps the most controversial aspect of history on television is its perceived lack of historical accuracy. Indeed, most critical attention to historical miniseries or biographies takes the form of fact checking: Did that scene actually occur in real life? Did the protagonist say those words? Was he or she actually at the place as depicted? Although such questions are understandable, even legitimate, they miss the point that audiovisual representations of the past do not necessarily adhere to the same rules as historical monographs and that they produce historical knowledge in different ways. Robert Rosenstone's discussion of the historical film is relevant to the case of historical drama on television. As he explains in *Visions of the Past*, film can never provide a "literal" truth because the past no longer exists, nor can it be represented in real time. He writes, "Of course, historical recounting has to be based on what literally happened, but the recounting itself can never be literal. Not on the screen and not, in fact, in the written word." Rather, audiovisual texts *create* specific scenarios and dialogue that can produce knowledge about the past that resonates with more conventional written accounts; even if the scenario depicted did not literally happen, a fidelity to the spirit of the moment can foster historical understanding. Filmic depictions, Rosenstone asserts, "will always include images

that are at once invented and true; true in that they symbolize, condense, or summarize larger amounts of data; true in that they impart an overall meaning of the past that can be verified, documented, or reasonably argued."[8] Gary Edgerton has similarly suggested that "any constructive evaluation of 'television as historian' also needs to start with the assumption that it is an entirely new and different kind of history altogether. Unlike written discourse, the language of TV is highly stylized, elliptical (rather than linear) in structure, and associational or metaphoric in the ways in which it portrays images and ideas." Edgerton also underscores the idea that the pasts most often taken up by television are those that are most relevant to viewers in the present: "'Television as historian,' in general, is less committed to rendering a factually accurate depiction as its highest priority than to animating the past for millions by accentuating those matters that are most relevant and engaging to audiences in the present. On the most elementary level, this preference is commercially motivated and often results in an increasing number of viewers, but in a deeper vein the more fundamental goal of most popular historians is to utilize aspects of the historical account as their way of making better sense out of the current social and cultural conditions."[9]

What I want to emphasize here is not only history's broader reach in this format, but also a particular conception of the kind of historical understanding produced; it is more a consciousness of an ethos of a period or era than an attempted reconstruction of events. By looking at dramatic series that do not call themselves history but nevertheless have a historical sensibility and are the result of historical research about the period represented, I have selected an archive that enjoys even more license to experiment with the production of a kind of "period truth." Even as I say that, though, I am wary of the very idea of historical "truth." The notion of historical truth is problematic because history only ever exists as a representation of the past: it is never the past itself. In Frank Ankersmit's words, "The relationship between (a historical) representation and what it represents cannot be reduced to or explained in terms of truth." His point is not completely nihilistic because he suggests the importance of considering the "adequacy of historical representations of the past."[10] Furthermore, as any historian will admit, history is an interpretation of the past and as such is not static but changes over time. All history makes an argument, emphasizes certain details over others.[11] The analytical focus, despite the media or format

of the representation, should be on what kind of historical argument is being advanced and toward what end.

Although film and television as audiovisual media share many conventions, there are important differences. Pierre Sorlin has suggested, for instance, that close-ups are the "standard format" on television versus the knee-up shot that dominates film. This stylistic convention "frames a part of the human body, head and shoulders or just a face[,] . . . introduces a radical change in the representation of living beings," and has ramifications for the kinds of engagement solicited by television. As Sorlin notes, "The camera operators do their best to catch a face and keep it within the frame. This kind of inquisitive glance gives spectators a special feeling; the larger the image, the more they believe themselves to be directly involved."[12] Indeed, much scholarship has emphasized television's ability to "add flesh and bones to history," to add an emotional component, to draw viewers in. Part of the reason television is a formidable disseminator of ideas about the past clearly has to do with its power to make the past seem real, palpable, and meaningful, but that power alone is not enough to produce historical knowledge. Such knowledge is predicated on a recognition that the past is a "foreign country." On some fundamental level, the past is gone, inaccessible. Accepting this claim is epistemologically important to the project of history, for it is the first step in acknowledging that any attempt to represent the past is inevitably imaginative work, a construction. Any television show that attempts to produce historical knowledge must *also* convey that fact. In other words, the production of historical knowledge requires an understanding on the viewer's part that the past really is distant and that it looked and felt different.

The type of engagement that televised or filmic historical representations might foster—of feeling connected to but different from some other person or historical situation, of feeling both compassion and distance—is the structural condition for empathy. Empathy is a modality quite different from, though often confused with, sympathy. Sympathy assumes similarity, a preexisting connection. In sympathy, one *shares* the feelings of another person. And most notably, when one person sympathizes with another, she focuses on herself, on how *she* would feel in the other's situation. Empathy, a much more modern concept, also seems the more complicated of the two in that it requires the person to imagine the other's situation and what it *might* feel like

while simultaneously recognizing her difference from the other. With empathy there is a leap, a projection, from the empathizer to the object of contemplation, which implies that a distance exists between the two. The experience of empathy requires an act of imagination—one must leave oneself and attempt to imagine what it was like for that other person given what he or she went through. Empathy, unlike sympathy, requires mental, cognitive activity; it entails an intellectual engagement with the plight of the other. When one talks about empathy, one is not talking simply about emotion, but about contemplation as well. Empathy takes work and is much harder to achieve than sympathy because it entails negotiating distance and difference.[13] Having an empathetic relationship to the past can be a constructive mode of engagement because it discourages individuals from reading the present back into the past even as it creates a sense of emotional investment, and it will stay with the viewer, affecting and perhaps even orienting his or her future ideas and beliefs. In her book *Empathic Vision*, Jill Bennett is interested in the way that art, "by virtue of its specific affective capacities, is able to exploit forms of embodied perception" in ways that create "critical awareness." Art that fosters "affective and critical operations might constitute the basis for something we call empathic vision."[14] Theorists of trauma have begun to consider the relationship between narrative representation and empathy. E. Ann Kaplan, for instance, has considered the ways in which "telling stories about trauma" creates the conditions for what she calls "empathic sharing."[15] Dominick LaCapra has used the term "empathic unsettlement" to describe "being responsive to the traumatic experience of others" without appropriating their experience. It involves, he suggests, "a kind of virtual experience through which one puts oneself in the other's position while recognizing the difference of that position," fostering "a desirable affective dimension of inquiry which complements and supplements empirical research and analysis." Furthermore, LaCapra suggests, by resisting uplifting accounts of trauma, empathic unsettlement "poses a barrier to closure in discourse."[16] These theorists have made a compelling case for how certain high-cultural texts might produce empathy. I suggest in this chapter and the next two that the formal properties of certain kinds of popular texts also have the potential to orchestrate and foster this particular mode of engagement.

The format of the serial drama—ongoing and meandering rather than closure oriented—opens up possibilities for the representation of history that are

quite impossible in a film or even a history monograph. Glen Creeber begins his book *Serial Television* by challenging the belief commonly held by British television critics that the film or "single play" was politically progressive, "somehow epitomising quality television's golden age," whereas the long-form drama—the series or serial—is "commercially standardised and aesthetically conservative." He then proceeds to delineate the ways in which long-form drama can allow for narrative complexity that cannot be realized in a single play, largely through an analysis of TV miniseries such as *Roots* (ABC, 1977), *Holocaust* (NBC, 1978), and *Heimat* (WDR, 1984). Although series and serials have often been pejoratively likened to soap operas, Creeber argues that "soap opera techniques (generally derided by so-called 'serious' television writers, directors and producers of the 1960s and 70s) have now become the very means by which 'radical' and 'progressive' drama is frequently conceived and constructed for a contemporary audience."[17] Although Creeber's analysis focuses on these particular miniseries, many of his insights about the value and complexity of drama in "long form" are useful in thinking through the dramatic series I consider in this chapter.

The notion that there is a potentially progressive quality to serial drama also comes through in Alexander Dhoest's analysis of television in Flanders. Period serials were very popular in Flanders in the 1980s. What is particularly interesting to Dhoest is these serials' class consciousness as they "portray[] a rural world of simple people, not the higher classes." For Dhoest, *Wij, Heren van Zichem* (BRT, 1969), the show on which he focuses and which he sees as a precursor to the shows of the 1980s, fits most comfortably under the umbrella of popular history, which he sets in opposition to official history. Although in some ways what the show represents seems mythological, he asks what it has to offer from a historical point of view, positing that, "clearly, it's not intent on creating accurate pictures of 'the past,' although 'surface realism' through the use of accurate period details is important. Costumes, settings, buildings, objects: every detail is selected to effectively and accurately evoke a particular episode from the past. . . . on the whole, *Wij, Heren van Zichem* does not offer much in terms of 'proper' history, but to dismiss it as completely historically irrelevant would underestimate its impact."[18] This history, he ultimately suggests, has a kind of use value in the present by becoming part of popular memory and is thus available for various uses in the present. It is a

politically charged history in that it focuses on poverty and the poorer classes rather than on the elite.

As this brief historiography suggests, much of the work on "factual history" has focused on European or Australasian television largely because there is simply more of it there than in the United States. As I have indicated, the specific genre I examine here might be called the "historically conscious drama," whose emergence can be traced to some of the fundamental changes to the U.S. television industry brought about by the advent of cable TV. In fact, the economic structure of cable was instrumental in creating the conditions of possibility for the historically conscious drama. As Gary Edgerton suggests in his introduction to *The Essential HBO Reader*, the advent of cable led to a departure from the existing economic model wherein the three major networks "sold specific audiences (most recently targeting young urban professional viewers above all others) to sponsors"; this "[s]hifting [of] the center of gravity in this sector of the television industry away from advertisers and more toward serving the needs and desires of their monthly customers" had a dramatic effect on the kind of programming produced by HBO.[19] The freedom from sponsors and from the Federal Communications Commission broadcasting guidelines, which banned the broadcasting of "obscene, indecent, or profane programming,"[20] had a dramatic effect on the content distributed. HBO tried several business models—offering first-run movies and sporting events—before landing on one in the 1990s that would be financially successful: the creation of original productions. HBO was the first cable network to produce an original series. As Edgerton has suggested, HBO became an idea or an identity brand and was "marketed with the tagline, 'It's not TV, It's HBO,'" which in effect promised that "series and specials produced by and presented on HBO are a qualitative cut above your usual run-of-the-mill television programming."[21] This production and marketing context gave HBO and the other cable networks that followed its example greater license to experiment with both form and content. These networks invested not only in writing but also in research, some of them hiring historical consultants; the effort to produce prestigious shows led HBO and its competitors to invest energy and resources in their efforts at historical reconstruction.

Three claims can be made for this genre of historically conscious television drama, some demonstrated to a greater and some to a lesser extent in the

shows under consideration. First, these cable shows are marketed as drama, and yet they have a historical consciousness in that they are set in a distinct, researched, historical moment in the past. But rather than re-creating a pivotal event from the past or tracing the life of a famous person as the primary plot motivation—which has been the form of much of the factual television in the United Kingdom and Australasia—these shows, I argue, function more like an experiment in social history[22] because they make visible the contours of life for everyday people as they were shaped or circumscribed by historical parameters and conditions. Second, their serial nature enables them to have a much more complex and nuanced narrative, to follow smaller side plots than would be possible in a film, and to be less motivated toward closure, thus acknowledging the messiness of the past itself. And third, as audiovisual texts, they have the capacity to orchestrate a complex mode of address (visual, aural, even tactile) and can, as I suggested about the films I discussed in the previous chapter, move the viewer through affective engagement from a position of proximity to the story to one of alienation from it, the effect of which is to provoke historical thinking along the lines Collingwood describes. I illustrate these points by means of the particular kinds of knowledge I see being produced in the television shows *Deadwood* (HBO, 2004–2006), *Mad Men* (AMC, 2007–2015), and *Rome* (HBO, 2005–2007). I am by no means suggesting that *all* history-conscious dramas are equally able to produce something we can legitimately call historical knowledge. Nor am I suggesting that these shows are uniformly "accurate" or constructive or even the only or best examples available. Rather, I am using these particular texts to highlight the ways in which the format and the specificities of the audiovisual medium itself have the potential to produce historical knowledge, even if that potential has only occasionally been realized. To see the potential requires us to think more expansively about the range of different kinds of historical knowledge and to examine moments of complex historical engagement even within shows that are otherwise considered mere entertainment.

None of the long-form series I interrogate here is aimed primarily at reconstructing a particular historical event, and yet all of them are set within a clearly discernable historical frame against the backdrop of real-world historical events. None of them calls itself history, and yet they all have aspirations beyond the "costume drama."[23] Although *Deadwood*, *Mad Men*, and *Rome* are

not equally successful at producing historical knowledge or provoking a historical consciousness, they all aspire to depict an era, promising something more than mere soap opera. Insofar as these shows are effective, it is in their capacity to function like social history experiments. For the most part, these shows do not teach people about the world historical events that occur in the background or even about the lives of any world historical figures. Instead, viewers watch a group of people—a particular class or community or social entity within a specific socioeconomic milieu—live. These shows makes visible the horizons of possibility, the possible courses of action, the way public and private spheres are defined, the expectations of gender—in short, how individual lives are circumscribed by the political, economic, and social constraints of a given historical moment.

The long form enables viewers to detect change over time and, importantly, that change does not always mean progress. It enables viewers to see the complexity of characters as well as the many different and countervailing forces that affect which possibilities are open to a particular character and which are not. The long form also challenges the formal constraints of short-form drama, such as film, particularly under the dominance of classical Hollywood cinema, a film style heavily invested in closure. In the historically conscious drama on cable TV, struggle and conflict take central stage without the reassurance that there will be closure. There is a messiness here seldom allowed in either classical Hollywood cinema or academic monographs. As a result, these shows are particularly well suited to reveal contradictions in that neither a given character nor a given situation can be drawn as simply "good" or "bad."

DEADWOOD

I start with *Deadwood* because it seems to me the most effective of the three in producing the kinds of historical knowledge I have discussed. David Milch's critically acclaimed dramatic series on HBO fosters in viewers a kind of empathetic engagement with the past. As a long-form drama, it offers a more complicated engagement with time and exploits the potential afforded by the form to see how historical conditions were worn by people and shaped their

existences. The series aired for three seasons, from 2004 to 2006, and was based on the lives of real people and documented events. The setting is the Black Hills of South Dakota in the gold-rush town of Deadwood in July 1876. Because the Black Hills belonged to the Oglala Sioux then, Deadwood was outside the sovereignty of the U.S. government and thus, as the show insistently reminds viewers, beyond the reach of U.S. law. The show begins with the arrival in town of former Montana sheriff Seth Bullock (Timothy Olyphant) and his partner, a Jewish immigrant named Sol Starr (John Hawkes). They plan to start a hardware business. But first Bullock and Starr must purchase land from Al Swearengen (Ian McShane), owner of the Gem Saloon and the most powerful man in town. Also arriving in Deadwood are the notorious Wild Bill Hickok (Keith Carradine) and Calamity Jane (Robin Weigert), and the show follows the ways in which all of these characters' lives intersect. Although based on the lives of historical figures and circumstances, the show makes no documentary claims for itself, adamantly resisting the label *docudrama*. As Milch has declared, "I've had my ass bored off by many things that are historically accurate."[24] Nevertheless, Milch himself is no stranger to academia or historical research; he graduated from Yale University and was then employed there as a lecturer in English. In preparation for writing the show, Milch conducted extensive primary research over the course of two years on the town of Deadwood and its inhabitants, relying quite heavily on the local newspaper, the *Black Hills Pioneer*. But Milch claims that, rather than write in documentary fashion, he "learned as much as he could and then threw out most of what he knew when he began writing the show," as Nancy Franklin of the *New Yorker* puts it. "'Deadwood,'" she continues, "draws on history without being slavishly beholden to the facts."[25] By acknowledging its own createdness and boldly asserting its status as imaginative reconstruction, the show abandons claims to a kind of literal "truth" on the level of fact for truths about the contours of experience at that historical moment.

In an exchange that is certainly meant to have resonance beyond the diegetic world of the show, E. B. Farnum (William Sanderson), the local hotel proprietor, converses with the recently arrived Francis Wolcott (Garrett Dillahunt), an agent for mining mogul George Hearst (father of William Randolph Hearst):

FARNUM:	Some ancient Italian maxim fits our situation, whose particu-
	lars escape me.
WOLCOTT:	Is the gist that I'm shit out of luck?
FARNUM:	Did they speak that way then?[26]

This question of whether people really "sp[o]ke that way then" has dominated much discussion about the show and is at the heart of my analysis of *Deadwood*. Neither journalistic nor academic appraisals fail to mention the show's language. As Alessandra Stanley writes in the *New York Times*, "Black hat or white, everyone in Deadwood uses the kind of crude language more commonly associated with 'The Sopranos.' "[27] But as she and others have noted, the pervasive use of obscenity is paired with a stylized, poetic form of language. Writes Franklin of the dialogue, "It is ornate and profane—far beyond on both counts, anything that's ever been on television." Interestingly, Franklin moves directly from describing the show's language to the brutality of its depiction of bodies: "What I find more brutal than the language is seeing freshly dead bodies fed to the pigs."[28] The way she moves seamlessly from the issue of the sound of the language to the brutality of the depiction of bodies unwittingly betrays something deeper about the show. It gets at how powerfully human sounds function in this text in a visceral, affective, bodily way. And yet there are other elements of the show's sound—the dialogue in particular—that work in the opposite way: to hold spectators off and outside of the show. The various sound strategies, in other words, move spectators between spectatorial identification and alienation.

I think the way language is used in the series has important ramifications for both the way the show engages and holds off viewers on the one hand and engages with and transmits a sense of the past on the other. The show makes visible two distinct kinds of knowledge about the past. The first is more structural. It is the point that history is only ever representation and constructed narrative and that we can only ever get so close to events of the past. The other kind of knowledge is more specific to the period depicted. However, it is not the "what-really-happened" kind of knowledge—not that that is possible anyway—but more knowledge of what the conditions of existence might have been like, how masculinity was worn or experienced, where power resided, how and where the lines between public and private were drawn, and so forth.

As a television series or long-form drama, *Deadwood* has the luxury of time. Unlike a film, where everything must happen within two hours, a television series allows viewers to grow acquainted with characters slowly, to gradually develop a sense of place and time, by witnessing and listening to more aspects of daily life than would be possible to depict in a single play.

In his book *How Early America Sounded*, historian Richard Cullen Rath begins the daunting task of reconstructing how the world sounded to people in the seventeenth- and eighteenth-century United States. Rath makes two claims: first, that sound used to be more important—or, rather, that it had more immediate power than it does now—and, second, that acquiring knowledge through reading written words is a learned and by no means natural process. By way of introduction, he writes:

> The subject of this book—how people heard their worlds in early America—requires an ability or at least a willingness on your part to be repeatedly decentered. It requires you to think about the process of taking in knowledge through the eyes from a black and white two dimensional page and to think of that act as a socially learned rather than natural way of coming to know things, one that has had profound effects on how one perceives worlds beyond the printed page. This denaturalization, this historical situating of one's own reading and its cognitive effects, is a necessary starting point for coming to grips with a sometimes alien world of powerful sounds.[29]

Rath reminds us of how powerful sound can be in producing social meanings and, in particular, how powerful it can be in transmitting certain kinds of knowledge about the past. He calls attention both to the power of sound to provoke response—even cognitive response—and to the possibility that certain aspects of life, or lived experience, are more effectively conveyed through sound than through the written (and then read) word. His point about the unnaturalness of learning about the past through reading about it resonates with some of the important claims made by historians interested in thinking about film and television as powerful and effective vehicles for the transmission of certain forms of historical knowledge.

I would like to emphasize here the way sound and language can elicit particular kinds of spectatorial responses. It is worth noting that the body of literature

that addresses itself to the relationship between cinemagoer and film—tellingly called "spectatorship"—unwittingly privileges vision as the primary sense experience of the cinema. This is *not* to say that film sound has not been studied. The study of sound in film has a long and, some might say, vexed history. In a recent review essay in *American Quarterly* aptly titled "Is There a Field Called Sound Culture Studies? And Does It Matter?" Michele Hilmes notes that the study of sound is "always emerging, never emerged." She attributes this quality—as have others—to sound's subordinate position vis-à-vis the visual, as "fundamentally secondary to our relationship to the world and to dominant ways of understanding it."[30] Furthermore, although we think of cinema as an experiential medium, we tend to pay less attention to sound experience than we do to visual experience. This insight is at the heart of the groundbreaking work by Rick Altman and others who have painstakingly analyzed the complexity of film soundtracks.[31] Michel Chion, in his elaborate discussion of how sound works in cinema, argues that "there is always something about sound that overwhelms and surprises us, no matter what—especially when we refuse to lend it our conscious attention; and thus, sound interferes with our perception, affects it. Surely, our conscious perception can valiantly work at submitting everything to its control, but, in the present cultural state of things, sound more than image has the ability to saturate and short-circuit our perception."[32] For Chion, our response to sound is more reflexive, less mediated by cognition, than our response to images. In this way, hearing is a profoundly sensuous, bodily experience. Sound thus has extraordinary—and often unappreciated—power to shape the way viewers see the images before them. Furthermore, Chion writes, film sound can be far more complicated than film image; sounds can be piled up one on top of the other and are not bounded by the frame in the way that visual images are.[33] Furthermore, sound can actually work against images, complicating or challenging the visual narrative. What I would like to emphasize here is that sound produces specific kinds of cognition and knowledge, and although cinema is a multisensory experience, sound by itself can work in complicated and varied ways, even within a single show. One of the ways in which *Deadwood* is different from other shows of its kind is that it largely resists nondiegetic music—that is, music that is heard by the audience as opposed to the characters and that often works to cue specific emotional responses in viewers. For most of each episode, we hear only dialogue and diegetic sounds; not

until the end of an episode, when we hear either the show's theme or another song chosen for its feel and lyrics, are we presented with nondiegetic sound, and then it really serves the purpose of initiating closure. For that reason, I have chosen to focus on the soundscape within the town of Deadwood; as I demonstrate, these diegetic sounds and dialogue structure the conditions of audience engagement in a way that fosters empathetic engagement with the past.

As I have suggested, it is on the level of language—and other human sounds—that this show both invites and holds off spectatorial investment. In a powerful scene from a second-season episode of *Deadwood*, sound compels affective response—we are drawn in by the sound of another's cry of pain. I call this particular form of connection achieved by sound the "aural visceral." In this scene, Al Swearengen, proprietor of the Gem Saloon (and whorehouse) and the most powerful player in the town of Deadwood, is suffering from a kidney stone. He is upstairs in his room, and his henchmen are there with him, along with the camp doctor. He is lying in bed, visibly in pain. The doctor says, "All right, Al, I'm in your bladder, I can hear the fucking stone. I'm gonna try now to move the stone to release your water—so you push now if you can, son." Swearengen responds with heavy breathing and low guttural groans. He cries out, "Mother of God!" (see figure 2.1). His cries are so loud that Trixie (Paula Malcomson), a favored prostitute with whom he often shares his bed, hears him from the street below. What we are hearing is clearly a man's cry, a cry to which we are rather unaccustomed. The visuals cut here from Swearengen's room to other locations in Deadwood, where characters look up, listening to Swearengen's cries of anguish (see figure 2.2). In other words, while the visuals cut from character to character in the town, the soundtrack, dominated by Swearengen's cries of pain, plays uninterrupted.

This combination of image and sound underscores that this is a *heard* and not seen event in Deadwood. I find it almost impossible to listen to this scene without feeling my own body tense. The scene is challenging for the viewer: enduring Swearengen's cries of agony, witnessing a man reduced to no language. Listening to and watching his guttural moans and wails beg a response, invite mimesis. As noted in chapter 1, according to anthropologist Michael Taussig mimesis means "to get hold of something by means of its likeness," which for him implies both "a copying or imitation, and a palpable, sensuous, connection between the very body of the perceiver and the perceived."[34] This response has

FIGURE 2.1 Al Swearengen screaming in pain. From *Deadwood*.

FIGURE 2.2 Town residents looking up in response to
Swearengen's cries. From *Deadwood*.

both social and physiological components. The aural visceral makes an indel-
ible impression by affectively engaging the listener; as a result, the content of
that entreaty stays with him or her. Similarly, much recent work on cinematic
spectatorship has focused on just this phenomenon; eschewing older, psycho-
analytic models of spectatorship, these theorists have moved toward more

phenomenological and cognitive-perceptual models. A key tenet of this approach is a conviction that affect matters—that, in the words of film theorist Carl Plantinga, "the viewer's affective experience in part determines meaning, and a lack of attention to, or an inability to understand, affective experience could well lead one to misunderstand and mischaracterize the thematic workings of a film, and perhaps even to misunderstand the story itself." He calls "affective mimicry" the spectator's response to human forms; it "depends on the fact that viewers *see* the bodies of film actors/characters and *hear* their voices."[35] Plantinga, in other words, attempts to theorize the specific kinds of scenarios that produce affect in spectators and the constitutive role that affect plays in constructing the film's meaning. And yet, despite his inclusion of sound as an important stimulus, he offers very little analysis of the aural sensorium.

I want to underscore here that this scene from *Deadwood* is meant to be heard. We are quite literally shown what Chion refers to as the "point of audition"[36]—the people listening. We *see* people hearing Al suffer. We see shots of townspeople looking up to the balcony of the Gem Saloon; we see the uncertainty on their faces. We watch them react affectively. Their bodies respond, and so do ours. We might say that sound works here to transmit affect from character to viewer. But what kind of knowledges does this sound produce? We have to begin by acknowledging that sound works primarily here to draw viewers in, to elicit compassion for the sufferer. And yet even as we are drawn in and prodded to feel something, we have a cognitive response. We literally cannot imagine what it would be like to endure this sort of medical procedure without anesthetics. There is something profoundly foreign about what we watch him endure. As viewers, I believe, we oscillate between these two poles of mimesis and difference, moving back and forth across the bridge.

But another kind of knowledge about the past also gets disseminated here. In a superficial sense, the scene makes visible the vulnerability of the body and the unreliability of nineteenth-century medicine. But there is more to it than that. People in Deadwood are unmoored by Swearengen's condition, which he unsuccessfully tries to hide from them by locking himself in his room. Although he is the most powerful person in town, he is not invulnerable—he is still fundamentally at the mercy of his body. In Deadwood, there is a very fine line between life and death, and what is riding on Swearengen's condition is nothing less than the entire social order. There is no law in Deadwood and

therefore no official positions of power. The order in the town, as contingent as it seems, hinges on Al Swearengen, who commands respect (and fear) in part because he is the wealthiest man and can thus influence who can buy land and where. His power is *not* a vested social power, nor does he occupy a preexisting position of authority, but rather power seems to reside in his body, in his person. Thus, a threat to his body means a threat to the social order—and the townspeople know it. This is a powerful form of knowledge about sovereignty on the frontier at the margins of the nation.

The scene also makes visible a radically different drawing of public and private spheres—or, more precisely, the profound lack of what we now think of as the private sphere. This lack of privacy comes across in many ways in the show: characters urinating into chamberpots or on the street, prostitutes out and about with their breasts and other anatomical parts uncovered, the sounds of characters—even the more well-to-do—engaged in intimate sexual acts. In this scene, though, Swearengen does not want to be heard or seen. He has barricaded himself in his room and is chewing on a piece of cloth to suppress his cries. Nevertheless, he is heard, and the camera shows us the town reacting to this aural event.

If those human sounds that address us viscerally work primarily to engage us affectively, to evoke a mimetic response, to mark us, other sounds in Deadwood—in particular the verbal—work to hold us off. Most of the show's dialogue is ornate and intricate. According to Jesse McKinley of the *New York Times*, "More than anything however characters in Deadwood are addicted to words: big looping passages of quasi-Elizabethan prose that immediately set the show apart from the usual western repertory of variations on the word 'pardner.' "[37] Milch believed that through re-creating the turns of speech of the period, listeners would be invited into a foreign aural field. "Many of them [those who lived in the historical Deadwood] might have been illiterate," Milch notes, "but they knew the King James Bible and Shakespeare, and that's what shaped the way they thought and the way they expressed themselves."[38] The creation of voices with their own particularities transports viewers to a different time and place and at the same time reminds them that it is not their place.

Another scene from season 2 shows language functioning in precisely this way—by conjuring a world to which we have only limited access. Mining mo-

gul George Hearst intends to buy up all of the "claims" in Deadwood—that is, the plots people have purchased to pan for gold. Toward that end and to expedite the process, his agent, Wolcott, is spreading a rumor that the claims will be overturned by Yankton (the Dakota territorial capital) if they are not sold immediately, and the rumors are working the town into a frenzy, encouraging a sell-off. In one scene, Alma Garrett (Molly Parker), owner of a particularly successful claim, and Mr. Whitney Ellsworth (Jim Beaver), the man who is managing the claim for her, discuss how to proceed in the face of the rumors:

ELLSWORTH: Mornin', ma'am.

GARRETT: Good morning, Mr. Ellsworth.

ELLSWORTH: I'm sorry I'm late. I hope you spent a restful night.

GARRETT: I did. And you're forgiven. But this morning I note an amount of confusion and anxiety abound and words of panic about Yankton's disposition of the claims.

ELLSWORTH: Panic's easier on the back than the short handle of the shovel.

GARRETT: I see.

ELLSWORTH: The Creator in his infinite wisdom, Miz Garrett, salted his works so that where gold was, there also you'd find rumor, though he decreed just as firm that the opposite wouldn't always hold.

GARRETT: You understand I needn't be comforted at the expense of the truth.

ELLSWORTH: I'm late, ma'am, over shooing a man away from your diggings named Francis Wolcott that scouts for George Hearst that wouldn't spare attention for a camp or the sun itself if he didn't think it likely to fill his coffers. Nor the sort who'd shrink from a lie or more than one to advance his purpose or be ignorant of how to circulate his falsehoods without anyone knowin' their source. And now I come to camp to hear the waters called muddy and the current quickened, though I see no change in the creek. And the Hooples [slang for foolish, ridiculous, people], certain sure the flood crisp fast approaches, have begun to think keenly, "I'll get ahead of the event, maybe

I'll sell my claim at discount," anything to unharness so they can head for the higher ground. Myself, ma'am, I'd be betting that the levee will hold.

Ellsworth is explaining that the rumors were starting to scare people into selling and that Garrett should ride out the storm. And yet notice the involved, allusive—and elusive—language. Viewers are not lulled passively into the story, both because the language calls attention to itself and because they must work to make sense of what is being said. Interestingly, the dialogue, which is clearly part of the diegesis, actually forces viewers out of the diegesis. The distancing effect of the language and the cognitive work required to keep up with the plot prevent viewers from slipping into an easy identification with the characters or their situations.

At other moments, the stylized language works to convey notions of propriety and social mores and to highlight the range and complexity of social relations in Deadwood. Following the death of his brother, Bullock marries his brother's widow, Martha (Anna Gunn), to take care of her and her son. In a scene that takes place after they have shared a bed for the first time, they awake awkwardly and sit on either side of the bed with their backs to each other:

MARTHA: Let me light the lamp.

BULLOCK: I've misplaced my boots.

MARTHA: I put them downstairs, by the kitchen door.

BULLOCK: I was asleep when you took 'em and did that.

MARTHA: Yes. Would you rather I not?

BULLOCK: No. No. Only I'd intended to be awake last night so we could talk, which what with how it's been we have not done in the peace of the evening as I would like since your arrival.

MARTHA: I would enjoy to converse in the stillness after the day like that.

BULLOCK: Tonight I will have two cups of coffee, and I will not fall asleep.

MARTHA: In the morning, in the quiet before we each take up our work, is also a pleasant occasion for such intercourse.

BULLOCK: Yes.

MARTHA: Would you like to start a discussion this morning?

BULLOCK: I wouldn't want to . . . disturb the boy.

MARTHA: William sleeps sound. If you will see to the bedroom door,
 Mr. Bullock.

And with that Bullock rises from the bed, walks toward us, and closes
the door, as if right in our faces. In this scene, the language not only holds us
outside of their relationship and room but also registers the characters' discom-
fort with one another and their clumsy attempt to navigate the social mores.
This scene, like the one with Swearengen's kidney stone, also tells us about the
operative lines between public and private by illustrating what can be spoken
of and how. Unlike the scene with the stone in which Swearengen cannot have
privacy, here viewers are denied access to Mr. and Mrs. Bullock's emotions. In
part, the scene registers the awkwardness of the moment. The language the
characters use avoids emotion and refuses easy conclusions about what they are
feeling, the stilted nature of their conversation conveying something of their
discomfort with one another. Voyeuristic pleasure is thwarted as viewers are
ultimately pushed out of the room. But that, too, is a form of knowledge about
public and private, the sayable and the unsayable. In *Deadwood*, then, a range
of strategies is at play for creating the kind of estrangement necessary to work
against a simple identification with historical characters and situations.

Most discussions of language in *Deadwood*, though, have revolved around
the pervasiveness of profanity. Says Milch, "Profanity, I've come to believe, was
the *lingua franca* of the time and place, which is to say that anyone, no mat-
ter what his or her background, could connect with almost anyone else on the
frontier through the use of profanity."[39] In the following exchange, Trixie, who
has recently become enamored of Bullock's Jewish business partner, discusses
Swearengen's kidney stone and his character with Calamity Jane. The scene
opens with the women out on a porch, paired symmetrically on either side of
the screen, each taking swigs from huge whiskey bottles.

JANE: [Burps.] Now that's fucking progress.
TRIXIE: Cocksucker upstairs, across the way, whorehouse where I work.
JANE: He *is* a fucking cocksucker.
TRIXIE: Locks the fucking door so people can't get to help him. Fuck-
 ing ashamed to be sick.
JANE: You know he had a design to murder that little one.

TRIXIE:	No, I didn't.
JANE:	Hell yes. He had a design. Charlie and me spirited her from camp, forced him to a second victim more suitable to his cocksucker's purpose.
TRIXIE:	Think they're any different if they've had their fuckin' dicks cut on? They ain't no fuckin' different. You got to like their friends or they won't teach ya numbers or every other fuckin' regulation they set.
JANE:	Anyway.
TRIXIE:	Far as it fuckin' goes, he also brought the cripple from that orphanage.
JANE:	What orphanage?
TRIXIE:	Don't buy his bullshit about the nine-cent trick.
JANE:	What cripple?
TRIXIE:	Jewel. That he says he's got around against some Hooplehead only having nine cents and wanting a piece of pussy. That ain't it. Why she's around is, it's his sick fuckin' way of protectin' her.
JANE:	I'm gonna get whisky.
TRIXIE:	There's entries on both side of the fuckin' ledger is the fuckin' point, as I already talk like a fuckin' Jew.
JANE:	It's shaping up to be a nice cool evening. Maybe he has a good side to him too that I entirely fuckin' missed. It's always fuckin' possible, drunk as I am fuckin' continuously. It's nice to see you.

Trixie and Jane are debating whether Al Swearengen has any redeeming features or not—"entries on both sides of the ledger," because the man is sometimes a monster and at other times a saint—but the women speak as if in code, with veiled references and allusions. Their dialogue is punctuated with profanity. Again, as in the dialogue between Mr. Ellsworth and Alma Garrett, viewers must struggle to understand the content of the conversation, which stands in the way of any simple identification with them. Michel Chion distinguishes "theatrical speech" from "emanation speech." In "theatrical speech," the more common of the two, "the dialogue heard has a dramatic, psychological, informative, and affective function" and is "perceived as dialogue issuing from characters in the action," whereas "emanation speech" "is not necessarily heard and

understood fully, and in any case is not intimately tied to the heart of what might be called the narrative action."[40] As this exchange demonstrates, the writers of *Deadwood* seem to move back and forth between these two modes of speech; clearly, some dialogue functions as much to create a mood or round out a character as to advance important plot information. I would even suggest that the use of profanity in particular functions as emanation speech in that it is more about affect and creating a mood than about advancing narrative action. On first viewing *Deadwood*, I was troubled by its use of profanity because it seemed to me that it broke the illusion of historical reconstruction, that it was anachronistic, presentist. Even though Milch claims that profanity was omnipresent on the frontier, its contemporary feel seems to me to work against realism. I now believe that this lack of realism is productive. Frequent obscenity does break the illusion of verisimilitude or historical accuracy, forcing us to consider whether people really did, in E. B. Farnum's words, "speak like that back then." In fact, it invites the kind of skeptical questioning gaze encouraged by the intermingling of archival and re-created footage that I described in the previous chapter. But the profanity also, perhaps even simultaneously, has the opposite effect of drawing us in because it is the only really familiar aspect of the show (as many have noted, *Deadwood* sounds like *The Sopranos*). In that complicated moment, viewers are both drawn in and held off. Elements of the diegesis, in this case the dialogue, seem to push viewers out of the diegesis and in so doing to preserve the distance between the viewer and the past depicted.

Through these strategies—the simultaneously familiar and anachronistic feel of profanity on the one hand and the affective engagement coupled with formal, ornate language on the other—*Deadwood* oscillates between drawing viewers in and holding them off, and this oscillation, I think, can be a very constructive way to engage viewers with the past in a more complex fashion. The notion that filmic or televisual history can effectively draw people in and promote interest in the historical past has been borne out by the popularity of affective modes of historical representation. Furthermore, as film scholars have shown, the filmic or televisual narrative and editing conventions that are associated with classical Hollywood cinema are powerful tools for promoting identification or eliciting "affective mimicry." What requires more investigation—what I hope I have at least gestured toward here—is how such texts can work in the opposite direction to hold viewers outside of the story, in this case through

the use of sound. It does not so much matter if the series reproduces how people actually spoke back then or not—there is no way to verify that anyway. Milch and the writers of *Deadwood* have used letters, diaries, and other primary sources in their effort to reconstruct the kinds of language and the particular turns of phrase used at the time. And yet what is more important is that the language works to alienate us, to conjure up a foreign place—a place where we do not really belong. Because we are not allowed to feel that we live there, our own emotions are not elevated to evidentiary status in the way that concerns Vanessa Agnew in her critique of affective history (see the introduction).

I think, though, that *Deadwood* does something more interesting than simply force the viewer to recognize that the past was different from the present. Viewers are called by *Deadwood*, compelled to listen or, as Kaplan would say, to witness in a way not so different from what happens when they are watching *Hotel Rwanda*. The viscerality of the aural experiences calls us to our bodies and in so doing produces certain kinds of knowledge about the past. It is not that we literally know what it feels like to have lived then but rather that we learn something more general about the vulnerability of the body and its lack of privacy as well as about the nearness of death in a nineteenth-century frontier town. This knowledge is not transhistorical. Rather, it is tied to the experience of a particular place at a particular, definable historical moment.

MAD MEN

In part because *Mad Men* (2007–2013), the AMC series created by Matthew Weiner, is set in the not so distant past, it does not cry out "history." Nor does it lay claim to "history" in the way that even *Deadwood* does. Nowhere in the promotional material is it claimed that the show is history—at least in the sense of academic written history. Its aim is not primarily to highlight the major historical events of the period it depicts, though they do appear with varying degrees of prominence in certain episodes. And yet the show aspires, as creator Matt Weiner says again and again, to the highest verisimilitude in terms of mise-en-scène. Costumes, props, and sets are meticulously researched to create a visual impression—a historically specific style—of the 1960s. But the show also attempts fidelity to the modes of behavior and the social norms of a par-

ticular class of people in a clearly drawn socioeconomic milieu: ad men, office workers, and their families in New York City in the 1960s. In other words, the show attempts to create the parameters (both tangible and intangible) within which a historically specific group of people in a particular geographical environment once lived.

In writing on *Mad Men*, many critics have pointed, rightly I think, to the way in which the series undermines the "sheen of nostalgia" that has been endemic to most popular depictions of this period, such as *Happy Days* (ABC, 1974–1984) and *American Graffiti* (George Lucas, 1973).[41] One of the ways in which it undercuts nostalgia is by registering how precarious, perhaps even untenable, was the image of the ideal nuclear family both popularized and endorsed in the postwar years. As the promotional material on the show's website suggests, the show aims to "depict[] authentically the roles of men and women in this era while exploring the true human nature beneath the guise of 1960s traditional family values."[42] The show, in other words, challenges the myth of the idyllic suburban home that was created and disseminated in popular culture and official discourse beginning in the 1950s. Although this historical insight is a cornerstone of Elaine Tyler May's important monograph *Homeward Bound*,[43] the myth of the ideal 1950s family has been quite tenacious in popular culture. *Mad Men* gives the lie to that representation by exposing its fault lines: the gendered division of labor, the boredom women endured, the complexity of having "colored" help, and so forth.

The evolution of the fictional ad agency at the center of the show, first called Sterling Cooper after its executives Roger Sterling (John Slattery) and Bertram Cooper (Robert Morse), unfolds over the course of the 1960s. The enigmatic Don Draper (John Hamm), head of "creative," is the show's central protagonist; Peggy Olson (Elisabeth Moss) is hired as a secretary for Draper in the show's pilot and eventually works her way up to copywriter. Alongside these characters is a group of junior executives jockeying for position within the agency. Don Draper's wife, Betty (January Jones), stays home with their children, Sally (Kiernan Shipka) and Bobby (Mason Vale Cotton), in Ossining, New York. Unlike in *Deadwood*, the characters Weiner has created are not people who actually existed; he has not gone through the books or employee rolls at the large Madison Avenue advertising companies to identify actual people. But they are people who *could have existed*, given what can be known about

the advertising workplace, gender norms and gender roles, and race and racial ideologies in New York at this historical moment. The show aims to construct the specific parameters and constraints under which such people would have lived if they were of this particular class at this particular historical moment. It is not a story about the big events of the 1960s; instead, like a social history experiment, it opens up a window onto the contours of daily life *as it would have been lived* by a particular subset of the population. In so doing, it makes palpable the social norms and expectations within that socioeconomic milieu in the early 1960s.

In this section, I consider the particular types of historical knowledge the show produces for viewers, the strategies deployed to position viewers vis-à-vis that historical narrative, and the effect of the serial format on historical understanding more generally. The show privileges a social history of everyday life, a history closer to the ground, which attends to ordinary people and how they lived against the backdrop of the tumultuous 1960s. Within each season, well-known historical events intrude on the characters' lives, but, interestingly and perhaps accurately, they do so in a peripheral way. *Mad Men* thus resists imposing any explanatory, cause-and-effect narrative, focusing instead on how people of the time *experienced* or came to understand those events. In *Mad Men*, we are not offered an account of the political machinations that led to the Cuban Missile Crisis, but we do witness how it was received by people in their daily lives in the midst of the other mundane events that made up their lives. When world historical events occur—the death of a president, a natural or man-made disaster, or even war—people's lives do not grind to a halt. Rather, those events compel attention for a short time and then are assimilated into otherwise full lives, and yet they cast shadows, subtly affecting people's ideas about the future and its possibilities and foreclosures. In *Mad Men*, we gain access to the way those events were mediated to the people at the time and how the effects were felt at the local level, something we rarely see in academic history.

In *Mad Men*, world historical events interrupt the characters' lives via television or radio reports and newscasts, much as they do in *Hotel Rwanda*. Aside from the fact that those media were in fact the primary mechanism by which individuals encountered traumatic national and international events, calling attention to the media technologies underscores the fact that such events, even for people at the time, were mediated—experienced not directly, but

indirectly—as news. Each season correlates with a specific calendar year, and I focus my analysis on the first few seasons.[44] Late in season 1, the Kennedy–Nixon presidential campaign culminates in election day. The episode begins with grainy black-and-white archival footage filling our screen. A voice-over declares, "America is still going to the polls at four o'clock with some precincts opening as early as twelve this morning. Voters across the country are deciding who will hold the most important office in the free. . . ."[45] The camera slowly pulls back to reveal that the footage we are watching is actually being broadcast on what looks to us like an old-fashioned, wood-paneled television. Depicting a television within a television, the show foregrounds the televisual reception of historical events and by extension their mediated quality. Later, the junior executives roll in a TV set and gather around it. A reporter announces: "With early returns just coming in, our NBC computer is putting Senator Kennedy's odds for a win at a grim-sounding twenty-two to one." Cheers erupt from the office. Shortly thereafter, in the Drapers' family room, the television set is also tuned to election coverage. Draper's daughter, Sally, sits on the floor inches from the TV screen. Again, we watch as she does, her screen within our screen. A reporter announces, "Senator Kennedy seems to be closing the gap on the vice president's early lead—state by state."

We are both watching the election unfold over time as people at the time did and reminded of the act of mediation, which is also between us and the historical moment conjured up by the series. Furthermore, the stylistic device employed here—cutting between different groups of characters in different places, all watching television—is used every time a major historical event occurs within the show's diegesis. In addition to making the case that the event compelled the American public's attention, it also underscores the historical importance of television itself as a medium for the dissemination of live news. This was in fact television's golden age, a moment when live news constructed a public sphere of sorts wherein Americans all over the country could watch the same news report simultaneously. In other words, the particular situation depicted—a group of people gathered around a set watching the news as it unfolded—was a historically specific phenomenon (see figure 2.3). Although of course people still watch television today, it no longer promises the simultaneous reception of news; now there are many more news outlets, including the Internet, and therefore much less shared reception.

FIGURE 2.3 Group in the office watching the news of the
Kennedy assassination on TV. From *Mad Men*.

In season 3, several major historical events punctuate the show's drama:
the Cuban Missile Crisis, the assassination of John Kennedy, and the murder
of four African American girls in Birmingham. The inclusion of these events
lends credibility to the smaller, more local, social history work the show per-
forms, but they also function as an eruption of the "real" into what appears to
be a stylized, fictional environment. What is powerful about this format is not
only that we are gaining access to how people in 1963 came to learn about these
events but also that the *experience* of learning about it is replayed to a certain
extent for us because we, too, are watching these historical events unfold over
time. We, in the present, encounter the actual news footage from the past that
brought world historical events into popular consciousness; this situation is
thus a version of what Ankersmit describes as historical experience.[46]

The episode "Grown-Ups" in season 3 is set during and in the immediate
aftermath of the Kennedy assassination. Unlike the characters in the show, we
in the audience know that Kennedy was assassinated, and most of us know that
Lee Harvey Oswald was the primary suspect.[47] What we are learning, then,
is less about the event itself than about *how* it was mediated, how that event
interrupted daily life, and how it unfolded over time for those people living
through it. As the episode opens, two of the junior executives are discussing of-

fice politics, a TV playing in the background. On that screen, we see and hear a news bulletin, which is barely audible over their conversation, announcing, "In Dallas three shots were fired on Kennedy's motorcade." The executives seem not to have heard the announcement or taken note. For the rest of the episode, newscasts, from which the characters are increasingly unable to pull their eyes, punctuate the flow of action. These news broadcasts are archival footage, replete with well-known newscasters: "This is Walter Cronkite in our newsroom, and there has been an attempt, as perhaps you know now, on the life of president Kennedy. He was wounded in an automobile driving from Dallas airport into downtown Dallas, along with Governor Connally of Texas. They've been taken to Parkland Hospital there, where their condition is as yet. . . ."

This stylistic decision—to allow the news coverage to tell the story as it would have unfolded in time—has enormous affective potential. We both experience the unfolding of the news story, literally watching it on our screen, and witness the characters responding to it. This strategy makes palpable the sense of shock and bewilderment (as shown in figure 2.3), how profoundly destabilizing the news was. Don's wife, Betty, is at home watching television. A point-of-view shot positions us to look at her TV screen as if through her eyes. A newscaster declares, "Excuse me, Chet, here is a flash from the Associated Press, dateline Dallas. Two priests who were with President Kennedy say . . . ," Betty sits up straighter and stares at the set, alarmed, "he is dead of bullet wounds. There is no further confirmation, but this is what we have on a flash basis." The Drapers' African American housekeeper, Carla (Deborah Lacey), comes rushing in, and when she sees Betty in front of the television, she asks, "Is he okay?" Betty responds, "They just said he died." Carla's hands go to cover her mouth in disbelief. The voice on the television continues: "This is the only word we have indicating that the president may in fact have lost his life." When the Draper children, Sally and Bobby, come into the room, they look at the shell-shocked women. Sally puts her arm around her mother to comfort her. They all are still fixated on the television set when Don returns home much later and asks in disbelief, "Why are the kids watching this?" He turns to Betty and says patronizingly: "Take a pill and lie down. I can handle the kids." He tells the kids to turn the TV off, but they cannot look away (see figure 2.4). We hear the report in the background as eyewitnesses are describing what they saw and heard. Don tells the kids to look at him, "Everything's gonna be okay," and

FIGURE 2.4 The Draper family watching Cronkite reporting
on the Kennedy assassination. From *Mad Men*.

in the background we hear a voice saying, " . . . fell over on him and said, 'Oh
my God, he's shot.' " Don continues, "There's a new president, and there's going
to be a funeral." Bobby asks, "Are we going to the funeral?" Don looks at them
and then sinks back into the couch, and they all continue watching. This scene
is affecting because it brings us into proximity with the unfolding situation, but
not exactly as one of the characters. And yet the way in which we are forced to
encounter not only the realization of the assassination but its effect on people
at that time makes palpable the profound sense of social instability that was
fundamental to the structure of feeling of the 1960s.

However, even as we are brought into the emotional drama, offered access to
the shock, confusion, and fear wrought by the uncertain historical times as well
as to the tempo at which information was revealed—much slower than in the
present moment with the Internet—we are held at a distance. I have asserted
that for popular texts to produce historical knowledge requires both that they
invite viewers in, encourage them to engage affectively with the material and
conditions of the past, and that they hold viewers out, reminding them that
the past was substantially different from the present. *Mad Men* achieves this
distancing effect in various ways. The television sets that the characters watch
look and feel different, reminding us even as we watch the news that the very

material conditions of existence were different. For many viewers, even those well aware of these historical events, watching archival news reports is a novel experience. And yet because the news reporters look and speak differently, because the footage is grainy, because the TV sets have a curved glass front, the viewer's distance from the moment is continually reasserted. Our relationship to these events is experiential but mediated, once removed. We are not allowed simply to slip into the past.

This sense of distance or difference from the past is also asserted by the show's representation of the social mores and values of the period. In fact, *Mad Men* revels in moments that reveal how much daily life has changed since the 1960s. As many commentators have noted, characters smoke incessantly in buildings and cars and in the course of all activities (Peggy's gynecologist smokes during her examination). They ride in cars without seatbelts, and they allow children to play with plastic bags over their heads. And they casually espouse prejudices that are no longer acceptable—anti-Semitism (when Roger asks if the company has ever hired any Jews, Don responds, "Not on my watch"), racism (in response to the violence provoked by the civil rights movement, Betty suggests that "maybe it's not the right time"), and, of course, sexism, which I talk about at length later. These moments of alterity work on the viewer in a variety of ways. Most importantly, they tend to work against immersion in the narrative. Instead, by shocking or outraging—or even titillating—the viewer, they break the narrative illusion, forcing him or her to consider the difference between now and then. A self-consciousness is awakened here. At first, the viewer is led to critique and to a kind of smug knowingness and superiority: They let their children do that? But the fact that the viewer is positioned in other ways and at other moments to *like* these characters complicates the reception and the analysis required to make sense of the events. Instead of simply looking down on these characters, the viewer is compelled to look more closely at, say, the sexism and to assess to what extent it is actually gone, as opposed to gone from view. As creator Matt Weiner describes, "There are a lot of things you can't talk about now that you can talk about in this world. . . . You can look at these men and say, my God, how sexist they are, how racist they are, how anti-Semitic they are. And the darker point is that we haven't changed that much. We're just better at being polite."[48] The dialectic emerges once again between difference and sameness, the oscillation that enables a distinctly historical consciousness. It is

worth noting that style here, even the style of the 1960s, does not necessarily cut one way. In *Good Night and Good Luck*, for instance, the same stylistic gesture that marks a break with the past offers the past as a model for the present. In *Mad Men*, the past that is marked as different through style is scrutinized. Once marked as different from the present, the past can be mobilized in a range of ways and toward a range of ends—even within a single show, as is the case with *Mad Men*.

This oscillation is literally orchestrated on the level of mise-en-scène. Much has been made of the show's distinctive style, but one cannot talk about style apart from mise-en-scène—ranging from clothing and body type to furniture, décor, and setting—which is the mechanism through which the style is expressed. Because form is instrumental in the production of meaning, we must attend to the role such details play in the construction of specifically *historical* meanings. Style, which is formal and atmospheric, can provoke a range of affective responses from nostalgia to disgust and thus can be usefully explored to get a clearer sense of how viewers are being positioned to understand the historical period represented. It is important to state the obvious: there is something seductive about the show's style—the sleekness, the emphasis on clean lines and modern design in the office—even the clothing and hairstyles are appealing. One might even posit that the show's depiction of the period is *stylized*, that it calls attention to itself and thereby calls attention to the distinctness of the historical moment represented. Instead of flattening time, it visually conjures a different time. The show, in other words, visually, aurally, and even sensually evokes a distinct historical moment, and in asking us to look critically at it even as we are seduced by it, it provokes a distinctly historical consciousness. In an essay on *Mad Men*, Jeremy Butler posits that "visual style has been called upon to signify the historical."[49] Indeed, Weiner and his production crew take great pride in their re-creation of an era through stylistic details and period objects. As Amy Wells, the set decorator explains, "Authenticity is everything. It's really important to us that it looks like they're really there at that place and that time."[50] Butler draws on C. S. Tashiro's claim that "the most consistent means to achieve a convincing image of history is through the saturated frame" to argue that the mise-en-scène "showcases historical specificity and urges us to engage with it," which it does by "saturat[ing] its small-scale frames with 'exotic apprehensible details.'" The painstakingly chosen props for *Mad Men*, from clothing

to food packages, Butler writes, "urge us to acquiesce to its signification of the past. . . . 1960 speaks to us through these details. They construct a picture of domesticity, work and leisure at that time."[51] This fidelity to chronologically accurate detail is the logic that undergirds historical reenactment more broadly, as evidenced by historic sites such as colonial Williamsburg or Plymouth Plantation. The assumption underlying both the show's mise-en-scène and these historic sites is that authentic historical objects, or props, transport the modern viewer into the past. But the inverse is also true: those objects, the dated clothing and hairstyles, construct a world that looks different, and thus they also have the effect of reminding viewers that the past *was* different. It is in part through style that our relationship to the past is managed.

In a long-form drama, the mise-en-scène has the capacity to work in a range of ways, some of which are complicated and even contradictory. The sense of duration, which is different from short-form drama such as a movie, which lasts only two hours, enables the construction of a place that feels enduring, to which one returns again and again across the span of several years. It also offers the viewers a long view on the characters. It is not possible to assess, for example, who is "good" or "bad," whom we are meant to like or dislike, which is as true of historical figures as it is of any people past or present. Don, Betty, and Peggy have admirable characteristics alongside their flaws. By means of the long-form drama, we see their strengths and weaknesses, their mistakes and accomplishments, and how they change over time, not always for the better. There is no single point of view or perspective from which the events are seen—at some moments Don's adultery seems glamorous, exciting, all in good fun, but at other moments when we are granted access to the sorrow of the women around him and even to his own regret, it seems tragic and pathetic. The series does not offer a linear trajectory from fallen to redeemed or ignorant to enlightened. In fact, it is not teleological even in the way that written history is, all minor events leading toward some culminating event or situation. The characters are neither monolithic nor internally coherent. At times, we are disgusted by them. At others, we see them living with the mistakes they have made, and through empathy we can come to understand the structural constraints placed upon them.

If we are to consider in a more concrete sense the particular knowledge about this historical milieu produced by the show, perhaps the most obvious

and complex has to do with gender and gender roles. Weiner has said that his depictions of women and "women's condition" were inspired by the groundbreaking work of Betty Friedan and Helen Gurley Brown.[52] Perhaps as a result, *Mad Men* shows not only women's limited possibilities but also the conflicted positions in which they find themselves. The mise-en-scène is effective in highlighting the different sides of a character; this is quite clear in the case of Betty, who at times is represented as a naive little girl, in shorts or baby-doll pajamas, and at other times as a desexualized, depressed housewife in her housecoat. It makes visible the different roles she is forced to inhabit by the social world in which she lives. At times, she seems pathetic and vapid, but at others we feel empathy for her as her circumstances reveal the kinds of constraints and limitations placed on wives and mothers in the early 1960s, their disempowered positions within the family economy. It is in grappling with these contradictory, conflicting images—images that confront us through the use of costume, makeup, and so forth—that we are forced to come to a more complex understanding of not only how gender ideologies were played out differently in different contexts but also how women were subject to conflicting demands.

The show's depiction of women is also inevitably informed by the exploits of the handsome protagonist Don Draper, who, we learn in the very first episode of the series, is a philanderer. In much the same way that this long-form drama forces us to see Betty Draper occupying a range of roles, Don's treatment of women elicits a range of responses in us. He exudes charm and sexiness, and it is with a kind of voyeurism and perhaps even antifeminism that we watch him seduce and be seduced by myriad women over the course of the shows seven seasons. But that pleasure is undercut by the show's feminist consciousness, its ability to bring into focus the plight of the women injured by such actions. In one scene, Betty's friend Francine comes over, extremely distressed: "I'm so stupid, so damn stupid," she tells Betty. She inadvertently got her hands on the phone bill and, because it was so high, took a closer look. She found dozens of long-distance calls to Manhattan and surmised that her husband was having an affair: "I'm so stupid, two nights a week at the Waldorf. . . . Damn it, Betty, I know everything." Betty is unsure what to say, prompting Francine to explain why she came over: "I thought you'd know what to do." When Betty says, "Me? Why?" the audience cannot help but feel sorry for her because we know that she is in exactly the same situation as Francine, who ends the con-

versation by saying quite honestly, "I'm so embarrassed." Indeed, this exchange becomes the foundation for Betty's doubts and insecurity about her own marriage, compelling her to pick up and pocket the Draper phone bill. When Don returns that evening, he finds Betty seated at the kitchen table in a puffy white bathrobe in semidarkness. She's smoking and drinking wine, and her back is to the camera. "I had a terrible day, sit with me," she says, and he does, tentatively. She describes the conversation with Francine and says, "She's in pieces, Don. I didn't know what to say to her." Don says, "I'm surprised she told you." She looks directly into his eyes and says, "How could someone do that to the person they love? That they have children with? Doesn't this all mean anything?" In this moment, seated in their dark kitchen, Betty makes visible and palpable the cost of Don's infidelity and even more the charade of domestic bliss. She gives voice to the discontent many women would have felt. All Don can think to say is, "Who knows why people do what they do?" In other words, it is in conversation with her female friends that a kind of consciousness is born, a shared discontent, the likes of which Betty Friedan described in *The Feminine Mystique*. Furthermore, as the show forces us to move back and forth from enjoying Don's sexual escapades to being critical of them and then to enjoying them again, it forces us to think critically about the attitudes toward women; it gives us access to a moment when conflicting ideologies about gender roles existed uncomfortably side by side.

Part of what the show makes visible is how infantilized many of these married women are. And as I suggested earlier, much of this is achieved on the level of mise-en-scène. For the most part, Betty literally has nothing to do. She is trapped in the house. She is denied access to the true state of affairs, pun intended. She neither keeps house nor works. His locked desk epitomizes her alienation from her husband and from knowledge of who he really is. In one scene, a desperate Betty tries to break into the desk with a screwdriver. Shortly after her suspicions about Don's affairs have been raised, she is in a complete funk. When her friend drops by to borrow a dress for a party, the woman holds several up to herself as she looks in the mirror: "It doesn't matter, I'm invisible," she says. Like Betty, she is seeing a psychiatrist, and she tells Betty, "I got my diagnosis the other day—I'm bored." The show is able to give texture and voice to this discontent, to the deep sadness, emptiness, and purposelessness that many women in their socioeconomic milieu felt at that time. Betty confides in

one of the other mothers that "sometimes I feel like I'll float away if Don isn't holding me down." These women's lives are defined and circumscribed by their husbands, and yet their husbands are both literally and figuratively elsewhere. In popular culture and official discourse, the suburban home was touted as the site of familial bliss: as Elaine Tyler May describes, "The sexually charged, child-centered family took its place at the center of the postwar American dream. The most tangible symbol of that dream was the suburban home—the locale of the good life, the evidence of democratic abundance."[53] *Mad Men*, however, reveals the fundamental flaws in that picture. And unlike in short-form drama, the discontent here does not get wrapped up and resolved.

The show is also interested in re-creating the parameters within which women would have operated at work and in showing what was and was not possible for them given those constraints. Aside from the rampant sexism, cat-calling, lewd comments, and inappropriate touching that the show suggests were endemic to office life, *Mad Men* wants to make visible both the possibilities open to ambitious women and the price they had to pay. Peggy Olson, for example, who at the start of the series is brought in as Don Draper's secretary, must distinguish herself from the other women similarly employed. Instead of wearing form-fitting, leg- and cleavage-revealing clothing, she opts for more serious and conservative attire. In fact, when Pete Campbell (Vincent Kartheiser), one of the junior executives, first meets her, he asks if she is Amish in a way meant to register his critique. In other words, the mise-en-scène—costuming and hairstyle in particular—desexualizes Peggy. Although she does have some relationships with men, they are largely unsuccessful, suggesting that work and love/marriage are mutually exclusive for women. Because of a one-night stand with Pete Campbell, Peggy becomes pregnant but does not know it until she goes into labor. She does not even consider keeping the baby, which would have been an obstacle to her career. This either–or scenario appears later in the series, when Don's second wife, Megan, who was once his secretary, aspires to an acting career. Their marriage becomes complicated when she has her own separate world while working on a soap opera. Historians such as Elaine Tyler May and Stephanie Coontz have written about the bind in which many women in the 1950s and 1960s found themselves, but to see it dramatized this way calls attention to the costs for women of having ambition and makes it visible to a different and significantly larger audience.

FIGURE 2.5 Peggy Olson and Ken Cosgrove auditioning
voice girls. From *Mad Men*.

In a particularly poignant scene, Peggy and Ken Cosgrove (Aaron Staton),
another of the junior executives, are testing "voice girls" for a radio advertising
spot. Peggy and Ken watch the "girls" through a one-way mirror—they can see
and hear the girls, but the girls cannot see or hear them unless spoken to by
electronic means. The fact that Peggy and Ken are on one side of the glass and
the "girls" are on the other seems to suggest that Peggy and Ken share rank.
Of the voice girls being considered, Peggy has a favorite, and Ken concedes to
her choice, but when they ask the girl to run the lines, neither is pleased with
the results. Peggy tells the girl that she needs more confidence. First, Peggy of-
fers, "Try to imagine you're you, Annie, and you have everything. You're beauti-
ful, you're slim, you're the beloved prize of a handsome man," which does not
achieve the desired result. She turns to Ken for help: "Make her feel beautiful.
You know, the confidence that comes with beauty." But Ken turns to her and
says, "Peg, a woman who looks like that will never sound confident because she
never *is* confident." As Peggy looks at the girl, her own reflection on the glass is
superimposed beside the girl, pairing them (see figure 2.5). Whereas the scene
opened with Peggy as quite literally separated from the voice girls, in a position
of social power above them, they are now depicted side by side, mirror images
of one another. The girl tries a few more times and then says, "I don't know

that I understand." With each attempt, her voice sounds less and less confident. Peggy says coldly, "This isn't working out—we have to let you go," and the girl leaves in tears. This brief episode highlights the precarious nature of a woman's position in the workplace: she has to be able to feign confidence that she neither possesses nor is accorded. This is as true for Peggy as it is for Annie. Peggy occupies an uncomfortable position: neither one of the boys nor one of the girls.

Although the depictions of women in the show only some of the time provoke visceral, affective responses—either discomfort at their naïveté or anger at the way they are treated by men—the depictions of racism and racial prejudice almost always occur as jarring and disorienting affective encounters. What these encounters ultimately make visible, though, as Allison Perlman has pointed out, is a corrective to the dominant understanding of the civil rights movement in the North. She argues, "Set in the early 1960s, *Mad Men* certainly is not the first popular text to address racism during the Civil Rights era and to position shifting race relations as an integral part of how we remember the 1960s. Yet unlike other narratives, *Mad Men* finds racial discrimination in the modern offices of a New York advertising agency and the posh suburban homes of its executives rather than in the brutal climate of the Jim Crow south." The show, in other words, works against the "triumphalist narrative of racial progress in which racism, embodied by redneck southerners, is tamped out and American ideals of equality and justice are affirmed and strengthened."[54] Furthermore, the presence of African American characters on the periphery—as maids, bellhops, and busboys—indicates the prevalence of subtle and yet clearly structural racism and racial hierarchies within supposedly sophisticated northern urban culture. Perlman also points out the way that the civil rights movement plotline in season 3 gives the lie to well-worn depictions of the white, northern, civil rights freedom rider as principled, acting on the basis of deep-seated moral integrity. Paul Kinsey (Michael Gladis), one of the junior executives, has an African American girlfriend, Sheila White (Donielle Artese), whose presence it seems is meant to enhance his "bohemian credentials."[55] He introduces her around and uses the occasion to tell Hollis (La Monde Byrd), the African American elevator man who in most of the series is largely ignored, to call him "Paul" instead of "Mr. Kinsey": "Hello, Mr. Kinsey," Hollis says. "Paul," he cor-

rects him, making a show of this informality to impress both the girlfriend and the others. It is also in this scene that Paul tells Sheila that a business trip to California has come up, and he will not be able to accompany her to the South to register voters for the fall election. As Perlman describes, Paul "lacks the moral sensibility, [the] personal integrity of commitment to civic equality. . . . [His] investment in African Americans has more to do with his own search for meaning and style than [with] a commitment to the rights and lives of actual black people."[56] He ultimately does accompany her, but only after Don removes him from the team going to California. In other words, Paul's relationship to civil rights activism is purely opportunistic.

Moments of racism—both subtle and blatant—have a powerful affective charge. They cause the audience to cringe because they are embarrassing and awkward. In a different episode, Carla, the Draper's black housekeeper, is listening to Martin Luther King Jr.'s speech on the radio following the murder of four black girls in Alabama. Betty walks in, and Carla changes the station:

BETTY: You can leave it on your station. I don't mind.

CARLA: It's all right.

BETTY: What was that?

CARLA: The funeral for the little girls in Birmingham.

BETTY: Hmm. It's so horrifying. [The two women are standing on opposite sides of the table, putting things on it] Are you okay? Do you need a day off?

CARLA: No, I'm fine. Thank you.

BETTY: I hate to say this, but it's really made me wonder about civil rights. Maybe it's not supposed to happen right now.

CARLA: [Says nothing.]

For Betty, the issue of civil rights is not a matter of life or death or even of equality, and it certainly is not pressing. To reconcile our empathy for her as a disempowered woman at this moment with our critique of her racism requires intellectual work, which ultimately produces historical insights about the relationships between differently marginalized groups. In another scene, Betty is seated at the table with her children while Carla serves them dinner.

As Carla carries over plates, Bobby complains about the salad. Betty jumps in and says, "Watch your tone, young man." We assume his offense was being rude to Carla, but instead Betty explains, "Carla works for me, not you." In other words, Bobby's infraction here is not a lack of respect for Carla but failure to understand the power hierarchy or chain of command in the household. These moments of encounter with racial prejudice snap the viewer out of the narrative and compel cognitive processing. Betty's lack of concern about or investment in civil rights resonates with the majority of the characters' responses in the series. As Perlman has noted, instead of offering viewers access to the iconic images of the civil rights movement, the series "trouble[s] the way we have imagined radio and television broadcasts of [civil rights] to have mobilized northern white support, igniting the moral outrage of their audiences."[57] The primary characters seem unaffected by the civil rights movement and treat it as something that is largely relevant elsewhere.

For the most part, any contact and engagement that the white characters do have with African Americans are meant to enhance their own personal agenda; this self-interested attitude toward racial equality is particularly clear in the opening scene of the series. The very first face on screen in the pilot episode belongs to an African American man. The camera does not rest on this face or follow it but remains impassive as the man moves across the screen. Next we see Don Draper from behind, writing on a cocktail napkin in a bar. A busboy, also African American, carries over Don's drink. Don asks him for a light, and the busboy lights his cigarette. Don says, "Old Gold man, huh?" The busboy looks him in the eye. Don says, "Lucky Strike here. Can I ask you a question? Why do you smoke Old Gold?" Before the man can respond, his white boss comes over and says, "I'm sorry, sir, is Sam here bothering you? He can be a little chatty." Within moments of the series' commencement, we encounter racial prejudice in a visceral way as the boss lays bare the assumption that a white businessman might be made uncomfortable by the lingering presence of an African American waiter. Don, however, challenges that assumption, telling the boss, "No, we're actually just having a conversation—is that okay?" And then, once the boss leaves, to the busboy, "So you obviously need to relax after working here all night." The busboy agrees. While this scene sets us up to see Don's humanity, his lack of racism, it shows us something else as well. His interest in the busboy and his cigarette preferences are not simply unmotivated chat, but market re-

search. He is *using* this exchange to come up with an ad campaign for Lucky Strike:

DON:	But what is it? Low tar? Those new filters? I mean why Old Gold?
BUSBOY:	They gave 'em to us in the service. A carton a week for free.
DON:	So you're used to them. Is that it?
BUSBOY:	Yeah, they're a habit.
DON:	I could never get you to smoke another kind? Say, my Luckies?
BUSBOY:	I love my Old Gold.
DON:	Let's just say tomorrow a tobacco weevil comes and eats every last Old Gold on the planet.
BUSBOY:	That's a sad story.
DON:	Yes, it's a tragedy. Would you just stop smoking?
BUSBOY:	I'm pretty sure I'd find something. I love smoking.
DON:	"I love smoking." That's very good.

Like Paul, Don, in the guise of being above racial prejudice, exploits his interaction with an African American for his own gain. These scenes reveal a particular self-interested investment in African Americans, which was also visible on a larger scale in Cold War racial attitudes. Indeed, as historian Mary Dudziak has argued, "At a time when the United States hoped to reshape the postwar world in its own image, the international attention given to racial segregation was troublesome and embarrassing. . . . The need to address international criticism gave the federal government an incentive to promote social change at home." The U.S. government realized that in order to combat the Soviets and communism, social change at home was going to be necessary. Dudziak describes this change as no less than an attempt to "fight[] the cold war with Civil Rights reform."[58]

But *Mad Men* also offers a microhistory of the role of advertising as a crucial and yet underrepresented front of the Cold War. Historians have established the fact that the 1950s marked a new kind of consumerism in America.[59] As May has argued, "Consumerism in the postwar years went far beyond the mere purchases of goods and services. It included important cultural values, demonstrated success and social mobility, and defined lifestyles. It also provided

the most vivid symbol of the American way of life: the affluent suburban home. . . . It is also evident, however, that along with the ideology of sexual containment, postwar domestic consumerism required conformity to strict gender assumptions that were fraught with potential tensions and frustrations."[60] As the famous Nixon–Kruschev "Kitchen Debate" made visible, consumption as a capitalist practice was hailed as a foil to communism. Americans could take solace in the fact that their individual acts of consumption were part of the larger ideological battle with the Soviet Union.

This idea of advertising as part of the Cold War struggle is borne out in several of the advertising campaigns Sterling Cooper Draper undertakes, but most notably in its work for Hilton. The company's CEO, Conrad Hilton, routinely phones Don in the middle of the night to discuss ideas. In one such call, Hilton says, "It sounds like pride, but I want Hiltons all over the world, like missions. I want a Hilton on the moon, that's where we're headed. . . . America is wherever we look, wherever we're going to be." The rhetoric taken up by ad men, in other words, is of a piece with the Cold War rhetoric about the importance of consumption and the superiority of the United States to the Soviet Union. Hilton's emphasis on the moon speaks directly to this Cold War struggle and the role of capitalism when the United States and the Soviet Union were engaged in a "moon race," each side intent on getting there first. On another evening, Hilton summons Don to his room:

HILTON: It's my purpose in life to bring America to the world, whether they like it or not. You know, we are a force of good, Don, because we have God. Communists don't. It's their most important belief. Did you know that?

DON: I'm not an expert.

HILTON: Generosity, the Marshall Plan, you remember that? Everyone who saw our ways wanted to be us.

DON: I'm glad you're telling me this.

HILTON: After all those things we threw at Khrushchev, you know what made him fall apart? He couldn't get into Disneyland.

In other words, Hilton's capitalist mission is inseparable from America's political-imperial mission to defeat the Communists and the Soviet Union.

Advertising becomes the language in which these imperial ambitions—and their attendant ethnocentrism—are voiced, uniting the assertions of the power of capitalism and an imperial sense of American superiority. Don's advertising pitch to Hilton betrays these intertwined sentiments:

> How to lure the American traveler abroad? Now there's one word that raises the thrill of international travel with the comfort of home . . . Hilton.
>
> How do you say "ice water" in Italian? . . . Hilton.
>
> How do you say "fresh towels" in Farsi? . . . Hilton.
>
> How do you say "hamburger" in Japanese? . . . Hilton.
>
> Hilton, it's the same in every language.

Hilton is displeased, however, for although the campaign advances U.S. cultural imperialism, it does not engage directly enough with the Cold War. He asks Don, "But what about the moon? There's nothing about the moon. I said I wanted Hilton on the moon. I couldn't have been more clear about it."

What *Mad Men* offers is a kind of decentered history, an interpretation of what life might have looked and felt like for a particular group of people who were not directly involved in the major events of the day but who nevertheless lived in the shadows cast by those events. The show, I think, reveals the messiness of history and offers a critique of the narrative of progress. The road does not run from failure to success or from an unethical America to a suddenly moral America. The depiction of the 1960s is not teleological. The serial format offers the possibility of representing the complexity of the journey. Being put in a position to feel compassion for a character who is racist or sexist can be uncomfortable in a way that compels one to look at the past in a more complicated way—not in terms of how far we have come, how much better we are now, but rather with how easy it was for them to feel the way they did, which we otherwise might not understand. We are made to feel uncomfortable as we are put in a position to have insight into how people could have believed things that we see as morally reprehensible. Again, the experience here cannot be reduced to identification. We are not simply positioned to identify with the characters here—instead, our proximity to them offers us insight into their motivations and forces us to confront difficult questions of

racial and gender inequality. That we can be put in a position to understand and have compassion for those characters whose beliefs on the surface seem so different from our own compels us to interrogate and think critically about our own beliefs.

ROME

Like *Mad Men* and *Deadwood*, HBO's series *Rome* (2005–2007) attempts to exploit the distinctive attributes of the serial format to depict social history. Its strength is its representation of everyday life in ancient Rome, which reflects an awareness of historical scholarship. Like a social history experiment, political, economic, and social conditions or parameters are set by both the narrative and the mise-en-scène, and characters are then placed within those constraints—their actions revealing both the possibilities and limitations, what is thinkable and not thinkable given the constraints of the historical moment. The series opens with Julius Caesar and his army defeating the Gauls in 52 B.C. and then traces the political machinations that ensue, in particular the struggle between Caesar and Pompey for Rome; season 1 ends with the infamous death of Caesar. Although few academic historians have seriously engaged the HBO series, those who have assessed the show's historical accuracy have suggested that as far as this particular plot line goes, the depiction is by and large borne out by the sources. Paul Harvey Jr., for example, writes:

> These opening episodes of the series get the politics just about right: a faction of senators prod an overly optimistic Pompey into a confrontation with Caesar. That same faction of senators severely over-estimates Pompey's military abilities and disastrously undervalues Caesar's political shrewdness, ruthlessness, and speed. The result (as we all know) was that Pompey and a group of senators evacuated Rome while Caesar crossed the Rubicon—not invading Italy, mind you, as Caesar reminded his readers in the opening sections of his *Civil War*, but coming to the aid of the Roman people, whose tribunes that same faction had foolishly put to flight. The portrayal of several significant debates in the Senate (presented here, manifestly, on the model of the House of Commons) and of conversations among political potentates are plausible:

issues of Caesar's prestige and military record are set out well against vague expectations of what Pompey thought he could accomplish.[61]

However, the series is equally, if not more invested in some of the lesser-known figures portrayed, both among the elite and the plebeians. The strategy of the series is to tack back and forth between scenes featuring these well-known and often-depicted historical figures such as Julius Caesar and Mark Antony, on the one hand, and the lives and experiences of two little-known senior centurions from the Thirteenth Legion of Caesar's army, on the other: Lucius Vorenus and Titus Pullo. Though Vorenus and Pullo are actual historical figures who appear in the fifth book of Julius Caesar's *Gallic War*, very little is known about them. And yet their friendship and the way in which historical events shape their daily lives becomes, in the words of *New York Times* TV reviewer Alessandra Stanley, "the bright spot of 'Rome.' "[62]

Although the depiction of well-documented historical events lends credibility to the subplots, the real work of the show and the site of its historical innovation have to do with the subplots themselves. Because of the nature of the historical records that survive from antiquity—written primarily by elites and focusing on great men—the contours of daily life for plebeians and ordinary Romans is less well known. Academic historians and archaeologists have learned a great deal about daily life, but that knowledge has not for the most part entered the public archive of representation. Part of this series' historical work, then, is to construct a *plausible* account of what life *might* have been like. This is not so much an "alternate history" as a social history experiment enabled by the long-form, serial format, which affords the time necessary to construct the parallel though intersecting story lines in all of their complexity.[63] Jonathan Stamp, historical consultant for the show, is eager to challenge the popular myths that persist about ancient Rome and to paint a vivid—and visceral—picture of daily life, depicting in an unflinching way a crucifixion, brain surgery, death during childbirth, and other gruesome scenarios. Indeed, as a bonus included in the season 1 DVD box set, one can opt to turn on "All Roads Lead to Rome," in which captions appear on the screen as the episodes play, detailing historical facts about daily life in Rome that pertain to the depicted scene, such as "Lucius Vorenus was a centurion in charge of roughly 80 infantrymen called Legionaires" or "The *insulae*, in which the majority of Rome's

population lived, were rented apartment buildings. In the poorest buildings, rent was payable by the day. Press enter to learn more about the *insulae*."[64] Although this commentary is available only on the DVD and must be turned on by the viewer, its existence suggests that the show takes historical interpretation seriously and that the details of daily life depicted are supported by the existing sources; these captions are meant to function as footnotes of sorts.

The series seeks in part to depict how everyday Romans lived and, in particular, how gender and racial ideologies were manifested in domestic and interpersonal relationships. In popular consciousness, ancient Rome exists as a white city, both racially and architecturally. The series, however, paints Rome in bright colors. Whereas other popular depictions have emphasized democracy on the one hand and gladiator violence on the other, this one focuses on evoking the period. It also depicts the urban grime and filth; it was, after all, as Stamp's commentary suggests, a city with a "population . . . close to a million at this time." The streets are crowded with people selling wares, carrying goods for trade, and so on. The soundtrack emphasizes urban noisiness, leading one character to complain to another, "What a dreadful noise plebs make when they're happy."[65] Rather than depict Romans as "white," though most of the main characters are, street scenes and side plots are replete with foreigners who are active traders in Rome and foreign slaves of varied races, attesting to the multicultural character of Rome. In one scene, Vorenus encounters some spice traders from India; Africans, too, are conspicuously present in the street scenes and in the Vorenus and Pullo subplots, which reflects the fact that Carthage in North Africa was one of Rome's provinces.

The arguments that I have made about *Deadwood* and *Mad Men* hinge on what I describe as these shows' complex mode of address, forcing viewers to oscillate between a visceral engagement with the story and an experience, also often visceral, of being alienated or held out by it. This dynamic exists in *Rome* only in a limited way, and yet the subplot about Vorenus and Pullo and their personal and professional lives—precisely because it is unfamiliar—has the potential to foster historical consciousness. If one of the dangers of history on film or television is that it flattens out the differences between past and present, part of what this engagement with social history attempts is a defamiliarization. The relationship that develops between Vorenus and Pullo draws us in, in part, because it is recognizable in Deleuze's sense and therefore does not force us to think.

Yet other aspects of daily life, in particular the Romans' polytheism, which the show highlights, call attention to the vast differences between the characters' beliefs and those of most contemporary viewers. Blood rituals—either with blood from an animal or with one's own blood—are common occurrences and are offered in preparation for an upcoming event or to ward off negative outcomes. In one scene, Servilia, Caesar's spurned lover, curses him. We see her carving a figure into lead with a stylus, the pressure of her hand registering her anger. She intones, "Gods of the inferno, I offer to you his limbs, his head, his mouth, his breath, his speech, his hands, his liver, his heart, his stomach. Gods of the inferno, let me see him suffer deeply, and I will rejoice and sacrifice to you."

In an essay entitled "Accidental History," Christopher Lockett emphasizes the way *Rome* serves as a countervailing force to great-man history, depicting a world in which ordinary people's lives bump up against the lives of leaders and heroes. The show reminds us that history occurs by accident and happenstance, directed as much by everyday people's small actions as by leaders' conscious decisions.[66] Yet I want to make a different claim about the historical knowledge produced by *Rome*. By suggesting that the show functions like a social history experiment, I am suggesting that its careful reconstruction of the socioeconomic, cultural, and political conditions of ancient Roman life serves as a sort of laboratory into which the show's creators place largely invented characters such as Pullo and Vorenus. By subjecting these characters to the conditions and value systems under which Roman soldiers lived, the show offers up a plausible account of how people experienced their world and related to one another at the time. Lockett jokes that Pullo and Vorenus are reminiscent of Forrest Gump, popping up all over the place at important historic events. But, unlike Gump, who *was not* really at those events, Pullo and Vorenus, as documented members of Caesar's army, could plausibly have been at the events depicted. And this is where the show's innovation lies: in its use of the *conditional* to explore the contours of a historically specific moment.

In part, the Vorenus and Pullo subplot functions as a way to explore the effects of war on social and familial relations, on the relations between husbands and wives and parents and children. These relations as they are played out in the show are shaped by what is known about Roman laws pertaining to adultery and patriarchal authority. We learn early on that, unlike the unmarried Pullo, Vorenus has remained faithful to his wife, Niobe, over the course of the

seven years and 140 days that he has been away fighting. She, however, assuming he was dead, engaged in a sexual liaison with her sister's husband and is cradling the child born of that union when Vorenus returns home. He sees her first inside their upper-level apartment home, its simple, dark, and noisy interior quite unlike the lavish patrician houses. Shocked, she says, "You're alive." Unsettled by the baby, he asks accusatorily, "What child is that?" "He's your grandson," she replies, thinking on her feet. "Speak sense, whore," he barks. "Son of your daughter . . . his name is Lucius," she explains. This rocky reunion concludes with her allowing that she's a "bit surprised to be called a whore." The daughters, horrified by what they have seen, are afraid of him. This scene is followed by one of a slave market. Juxtaposing the scenes of slaves with the scenes of Vorenus and his daughters asks viewers to make a connection between women and slaves in this patriarchal society.

Laws, including those forbidding adultery, had palpable effects on the social world, and the series attempts to make visible the ways they structure modes of feeling and engagement. We see Niobe sending her lover away, telling him that she made a vow. Later Pullo overhears Niobe telling her brother-in-law that she loves her husband, and yet he suspects that there was something between them. After seeing Niobe's sister and brother-in-law fighting, his suspicions deepen, and he confides in Octavian, Caesar's nephew, whom he is training. To protect Vorenus, Pullo and Octavian track down the brother-in-law and begin an interrogation: "Tell us what's between you and Niobe." Octavian and Pullo begin to torture him. In obvious ways, these plot lines are in the tradition of the soap opera, yet what is different is that the actions that occur are structured by the "rules" governing the social world, and those rules in this case are historically specific. As the drama unfolds, the viewer is forced to confront, often viscerally on the level of affect, the legitimate, legal violence that was part of everyday life in Rome. This experience complicates commonly held views about the lofty Roman republic.

Long-form serialized drama, in the form of historically conscious drama on the cable networks, opens up some potentially productive avenues for the production of historical knowledge. Their format enables them to represent change over time. They are inherently less focused on closure and thus

more able to explore the complexity and contradictions within a given situation; they are less teleological than academic history. That they do not have to adhere to network television's guidelines regarding profanity, violence, or sexuality affords them greater license to shock or provoke viewers in a visceral, affective way that ultimately compels analytical processing and meaning making. Because for the most part they are more interested in how people lived at a specific, clearly drawn historical moment than in re-creating the important historical events of the period, it makes sense to treat them as social history experiments that render visible the contours of life for everyday people as they were shaped or circumscribed by historical parameters and conditions. I have tried to elucidate these shows' complex mode of address (visual, aural, even tactile)—which is more clearly the case in *Deadwood* and *Mad Men* than in *Rome*—and how, as with the films I discussed in the previous chapter, their formal structures and conventions move the viewer through affective engagement from a position of proximity to the story and its characters to one of alienation from them, the effect of which is to motivate historical thinking. By alternating over the course of an episode or several episodes from the experience of proximity to characters and their needs, problems, and desires to a position of distance from them, provoked by jarring moments of difference from the present or by feelings of disgust, the viewer is compelled to come to terms with those differences. It is in this oscillation—especially in those moments of being brought into intimate contact with racism or being alienated by the language in *Deadwood*, for example—that one is snapped out of the narrative and made to think critically about how those ideas about race were conditioned by the historical, social, and economic parameters under which those characters lived or even about how inaccessible the past is in some fundamental way. We are left to process intellectually the visceral reactions that wake us up, that make us uncomfortable. And it is in precisely these moments of being forced out of the narrative that something like Collingwood's historical thinking can take place. I use these shows not because they are the only or the best examples of the historically conscious drama, but rather because they make visible a particular audiovisual methodology for the production of historical knowledge and illustrate how such a methodology can provoke something like historical consciousness in the viewer.

3

ENCOUNTERING CONTRADICTION

REALITY HISTORY TV

It suddenly sunk in in a way that it hadn't until then that I was going along and being an imperialist. . . . I am reenacting a whole system that I don't believe in and that I disapprove of, and yet it's the roots of our own nation.

CAROLYN HEINZ, PARTICIPANT IN *COLONIAL HOUSE*

AT THE END of his introduction to a special issue of the journal *History and Theory* titled "Unconventional History," Brian Fay asks, "Don't unconventional practices of historical representation, analysis and assessment—unconventional relative to those present in academe—provide an opportunity to see the weaknesses (as well as the strengths!) of conventional historiography?"[1] Many of the weaknesses that unconventional forms make visible result from conventional history's privileging of a cold, clinical, detached gaze on the past, its categorical refusal to breathe life into the situations, events, and individuals depicted, its rejection of any modes of engagement that lie outside the cerebral, and its inability to make the past seem relevant, important, or useful to people in the present.

One would be hard-pressed to imagine a form of historical representation *more* unconventional than the genre "reality history TV." In the shows I consider in this chapter—*Frontier House* (PBS, 2002), *Colonial House* (PBS, 2004), and *Texas Ranch House* (PBS, 2006)—individuals from the present are

cast into the past: they are made to abandon all aspects of their contemporary lives, from clothing and personal effects to values and dispositions, and are then placed in a setting that is meant to simulate life in a particular historical place at a specific historical moment. Participants are made to confront the material, ideological, political, and economic conditions that would have shaped existence at a given historical moment. Because this "unconventional historical practice" breaks virtually every rule of academic history, it is easy to dismiss the genre as mere entertainment, as many historians have done. Indeed, one would be remiss *not* to take account of the way in which the generic conventions of reality TV have shaped these products, making their entertainment value part of the equation. Nevertheless, these shows' unconventional form raises some significant epistemological questions about how historical knowledge is both produced and acquired. In other words, following Brian Fay's lead, I ask what a profoundly unconventional practice of historical representation—perhaps more accurately called a historical experiment—can make visible both in terms of a specific historical understanding of the period depicted and in terms of the larger project of history itself. What are the differences between the kinds of knowledge produced by traditional written academic history and the kinds produced by the more experiential history experiments of reality history TV that rely on an embodied form of reenactment? In her insightful and important book on historical reenactments, Rebecca Schneider has sought to articulate the complex temporality of reenactment; furthermore, her research reveals that at least some reenactors, contrary to their "common depiction," are well aware of the "problems of ambivalence, simultaneous temporal registers, anachronism, and the everywhere of error" and that "many of them find reenactment to be if not the thing itself (the past), [then] somehow also *not not* the thing (the past), as it passes across their bodies in again-time."[2]

It is important at the outset to distinguish these reality history TV shows from more common forms of historical reenactment. Although the participants on these shows want the immersive, living-in-the-past experience that all reenactors strive for, the parameters of the show prevent or at the very least complicate such immersion. The continual presence of video cameras and cameramen as well as the requirement that participants reflect on their experience by making video diaries and be interviewed in the course of their experience have the effect of breaking the illusion or frame. And as I later describe in de-

tail, the ways in which participants are made to confront race and homophobia also work to alienate them from the past, to confront the differences between past and present, thereby creating the possibility that they will gain some kind of historical consciousness. Furthermore, although some historical reenactments do attract audiences, the experience is primarily for the reenactors. That is not the case for reality history TV, which as its name suggests, is intended for a large television audience.

On these shows, there is a qualitative difference between the participants' experience and the viewers' experience. Just as Schneider points out that some reenactors are able to acquire a critical self-awareness, my analysis of reality history TV suggests that some of the participants on these programs do acquire substantive historical knowledge. Nevertheless, for many the experience is so seductive that a critical distance is difficult for them to maintain. By contrast, the viewers stand to learn the most. Viewers of reality history TV are structurally positioned to remain continually aware of the mediation and cognizant of the reenactment as reenactment rather than actual experience of the past. The viewers' distance, literal and critical, from the experience makes them more likely to maintain the kind of awareness or self-consciousness that, as Collingwood points out, is essential to historical thinking. Viewers gain an intimate look at the participants' deprivations, their intellectual and physical crises, and their often unsuccessful attempts to grapple with them, but they also see the participants' unwillingness to fully abandon the mindset of the present. As I have described in the previous chapters, the viewers' affective engagement is not reducible to identification. In fact, some of the historical insights come from the viewers' critique of or alienation from the participants' experience. Because these shows represent, among other things, *formal* innovations—by which I mean experiments with the form that historical representation can take—I begin the chapter by considering briefly the role that form plays in structuring knowledge and the potential value of formal innovations in producing new ideas or enabling otherwise unthinkable thoughts. I then consider the reality format and the specificities of this genre by considering its formal logics, which I investigate more thoroughly in an analysis of the three shows themselves.

As I described in the introduction, formal innovations—which can refer both to unconventional genres for representing the past as well as to

unexpected stylistic decisions and modes of addressing the viewer—have the potential to reframe the past and in the process produce new insights about it. Artistic practices, which of course would include work in the filmic, televisual, and digital realms, are important to Jacques Rancière in that they represent "ways of doing and making" that have the potential to intervene in and challenge or reconfigure the prevailing "distribution of the sensible." In the case of such a disruption, or "heterology," "the meaningful fabric of the sensible is disturbed: a spectacle does not fit within the sensible framework defined by a network of meanings, an expression does not find its place in the system of the visible coordinates where it appears."[3] Rancière calls attention to the profound relationship between form and meaning as well as to the ways in which formal changes and innovations make seeable, sayable, and thinkable—not to mention *experienceable*—ideas and formulations that otherwise remain inconceivable, literally outside the grasp of thought. Such innovations address the viewer sensuously and in so doing change the way the world looks and can be perceived. Jill Bennett makes precisely this point when describing specific instances of art about trauma; the art pieces she describes are "not representations of the body in pain, which serve to induce shock or secondary trauma, but a sense of what it is to see from a series of compromised positions: from the body of a mourner, from the body of one who shares a space with the mourner, from the gap between these two. And it is perhaps, above all, the refusal to reconcile these differential placements that moves us away from a sympathetic identification or mimicry toward a critical thinking of loss in this context; toward a way of seeing that changes the terms of our engagement."[4] The point here is that formal innovations have implications for knowledge production more broadly as new forms make possible new vantage points and insights.

Walter Benjamin's writing on photography serves as another instance of aesthetic innovation's capacity to intervene in the "distribution of the sensible"—to define, in Rancière's words, "what is visible or not in a common space, endowed with a common language."[5] Benjamin believed that new visual technologies—as well as their attendant practices and conventions—produced new kinds of perception, new ways of seeing. Human perception, he suggests, is not static or natural but rather conditioned by history and thus changeable over time: "Just as the entire mode of existence of human collectives changes over long historical periods, so too does their mode of perception. The way in

which human perception is organized—the medium in which it is occurs—is conditioned not only by nature, but by history."[6] Perception is quite literally altered by new technologies for looking, which produce new kinds of looking; things heretofore invisible come into view. In this chapter, I explore the particular generic conventions of reality history TV in ways that are inflected by Walter Benjamin's claims about the relationship between form and perception.

Iain McCalman and Paul Pickering point out in their introduction to the volume *Historical Reenactment: From Realism to the Affective Turn* that throughout history each new realist technology has been instrumentalized in the service of historical reenactment: each is imagined to enable greater verisimilitude. Now with computer-generated imagery, McCalman and Pickering suggest, it has become increasingly "possible to depict people and events of the past with seemingly literal and living detail . . . an illusion so real as to be indistinguishable from archival footage." Although McCalman and Pickering worry about the potential for the simulation to be more real than the past itself, they insist on the need to take seriously individuals' desire in the present "to experience history somatically and emotionally—to know what it felt like." They articulate the notion of "reflexive reenactment," which acknowledges the unpredictability inherent in reenactment, thus underscoring that it is never simply a simulacrum of the past. This notion instead emphasizes a "creative exchange with the past."[7] Theirs is another way of articulating or theorizing the self-conscious component that Collingwood takes to be essential in historical thinking. For Collingwood, historical thinking is predicated on one's consciousness of one's engagement with history; one must be aware that one is thinking about the past.

Coming at reenactment from another angle, Graeme Turner has coined the expression "demotic turn" to refer to the increasing visibility of "ordinary" people in the media; his work explores how ordinary people "turn[] themselves into media content through celebrity culture, reality TV, DIY websites, etc." Although he is in some ways critical of the politics of participation, his bigger project is to "examine closely what is going on in these new media developments, and what kinds of potentials they actually offer to the ordinary people involved." Reality TV, he suggests, reflects a "major shift in how television content has been produced, traded, and consumed over the last decade or so." Yet opinion on its cultural function is divided between those who see it as a

tasteless, cynical exploitation of people's interest in becoming famous as well as their fascination with other people's humiliation and those who see it as an empowering development that has opened up the media to new participants in ways that mirror the democratization so often attributed to the digital revolution and Web 2.0. Turner is skeptical of the claims for democratization, but he does believe that there is a potentially important pedagogical dimension to the format in that the shows function like an extension of everyday life and thus invite the audience to participate in an ethical critique. The viewer is compelled to assess the choices made by the participants. Furthermore, according to Turner, the way that the experiences embed themselves in everyday life for both viewer and participant makes them very different from genres such as drama that are framed as outside of one's everyday life.[8]

The runaway popularity of "reality television" in the 1990s, on the one hand, and the continued popular interest in the historical past, on the other, spawned the creation of this most unexpected genre: reality history TV. The format was largely the brain child of Alex Graham, founder of Wall to Wall Video, a UK company that has been at the forefront of unconventional historical programming (including not only the *House* series that I discuss here, but also the wildly successful *Who Do You Think You Are?*). Wall to Wall's first "living historical experiment" was *The 1940s House* (1999), which enjoyed critical acclaim and a wide viewership. It was followed by *The 1900 House* (1999–2000), *Edwardian Country House* (2002), *Frontier House* (2002), *Colonial House* (2004), and *Texas Ranch House* (2006)—the last three of which I consider in detail in this chapter. These miniseries aim to illuminate a particular historical era or epoch in a specific historical setting by borrowing the conventions and devices associated with reality TV in the tradition of MTV's *The Real World* (1992–), such as thrusting participants into a shared living experience and filming in what we might describe as a warts-and-all documentary format. But unlike the standard reality TV fare, the reality history TV series insists on the importance of a rigorously researched historical frame—a setting and overall material environment—created by academic and public historians. In these shows, individuals are meant to travel back in time. The idea is that they will live, albeit briefly, under conditions (material, ideological, political) identical to those of their historical predecessors. The promotional material for these shows likens the experience to a time machine; at the beginning of each episode of *Texas Ranch*

House, for example, we are told: "This is the true story of fifteen brave men and women who travel back in time, daring to live as the early cowboys and ranchers did over 130 years ago."[9]

As the product of strange bedfellows, these shows really do embrace contradictory impulses. The programs borrow some conventions from the contemporary documentary, including unscripted speech, authoritative voice-over, and intimate and at times embarrassing footage. Yet these reality history TV shows have a predictable narrative arc: several families and a handful of unmarried people are taught about the historical period they will enter and are trained by historians and practitioners in the skills they will need to survive; they are given a mission (for example, store enough food to last through a Montana winter, round up cattle for the cattle drive to make enough money to pay your debts, and so on); they attempt to carry out the mission and are ultimately assessed by a panel of experts on the extent to which they were successful in their endeavors. This kind of narrative is of course different from the fully scripted narrative of a film or a historically conscious drama series. The documentary film style asserts that what we see is in some way "real life," actual experience—as opposed to acting. The format combines authoritative voice-overs, which supply historical details and context, with both direct camera address by participants and a cinéma vérité–like observation of their experiences. There are no scripts, and much of the filming occurs in real time. Although there is inherent drama in inserting individuals from the present into physically and emotionally demanding historical circumstances, the drama is amplified by the editing process, in which thousands of hours of footage are winnowed down to highlight particular events, traumas, fights, obstacles, and pleasures. Because these shows are clearly meant to entertain, even if their primary mission is to educate, many of the events that occur are played up for their dramatic (even melodramatic) effects in ways that threaten to undercut any productive work they do. Nevertheless, there is a commitment to the idea that the participants learn by doing, and the audience learns both by watching their contemporaries struggle and by analyzing the nature of those struggles.

It is hardly surprising that these shows' very premise has been criticized: it is of course impossible to fully abandon one's contemporary mindset. Some critics focus on the epistemological problems of collapsing time, of losing the sense of distance between past and present or the sense of the past as a "foreign

country," which is crucial to the historian's conception of historical inquiry. Vanessa Agnew, for example, worries about the presentism such experiences invite, the fact that "testimony about daily life and social interaction in the present is often equated with, and becomes evidentiary for, a generalized notion of historical experience."[10] Her concern that participants will misread the past by projecting their own contemporary responses backward is not unfounded. This concern is connected to the one I mentioned earlier: that experiential sites and events—such as historical reenactments—foster an easy identification with the past, creating the illusion that one can know in some concrete way what it was like back then. And yet as the popularity of these reenactment-based reality history TV shows suggest, people are drawn to the prospect of being brought close to or *engaging* the past somatically. As I have suggested in the previous chapters, the real potential for the production of knowledge about the past in these nontraditional formats occurs in those instances when a delicate balance is maintained between drawing individuals into specific scenarios/crises/issues of the past in an affective, palpable way and yet also relentlessly reminding them of their distance and difference from the past—which is also often achieved affectively.[11] I articulated the importance of this balance in my work on prosthetic memory. There, I use as an example the experience of visiting the United States Holocaust Memorial Museum in Washington, D.C. Visitors to the museum take on Holocaust-*related* memories, which makes them feel more connected to the events yet does not lead them to think even for a moment that they themselves had the experience of living through the Holocaust.[12] In the case of reality history TV, what is captured on film and offered to viewers is the participants' experiences living in an artificially constructed version of the past. Although the participants may at moments feel that they are actually living the past, viewers never do. Viewers are offered intimate access to the struggles the participants face, but for them the artificiality of the experience is always front and center. The artificiality prevents them from being immersed in the reconstruction and thus predisposes them to the kind of reflexivity necessary to historical thinking.

What needs to be explored, then, is the particular ways in which this engaged, affective experiential relationship with certain aspects of the past, as contextualized and framed by the parameters set by archaeologists and public historians, produces knowledge that is largely inaccessible through traditional

history monographs. Can the shows produce a deeper understanding of the *complexity* of the past, or do they simply turn the past into a charade? Does these shows' medium—their generic form in particular—create the conditions whereby one is forced to engage critically with the past in all its complexity and contradiction? Does the fact that the participants, try as they might, can never fully lose their perspective from the present force them to grapple with the contradictions (such as being dependent for one's survival on other frontiers-people or being prejudiced against some of them on racial grounds) that they must live daily in practical and material ways—contradictions that might be easily reconciled intellectually? In other words, rather than assuming naively that participants can actually lose themselves in the mindset of someone from the remote past, we must consider what those ideological confrontations look like on the ground. These shows are not without their flaws, but I hope to show that there is more to them than meets the eye. As I suggested in the introduction, Gilles Deleuze argues that the familiar, that which is immediately recognizable, impedes critical thinking by producing complacency. Changing the forms through which we engage the past might thus be a crucial step toward thinking critically about and thus gaining new understandings of the past. To make this case requires us to abandon the idea that these shows "dumb down" history or, equally condescendingly, "meet people where they are."

Despite the shortcomings of reality history TV, the experience structured by this kind of reenactment does produce some otherwise difficult to obtain insights about a very different world. Historian Alexander Cook, who participated in the 2001 BBC series *The Ship*, in which a "crew of fifty 'experts' and volunteers [including historians Vanessa Agnew and Ian McCalman] sailed a replica of Captain James Cook's ship *Endeavour* from Australia to Indonesia along the path it sailed in 1770," has reflected at length on this experience. As a reality history TV participant himself, he argues that, "despite their obvious inauthenticity as a replication of historical experience, these reenactments at least invite participants and audiences to take seriously the challenge of considering historical actors as human beings rather than as incidental by-products of material conditions, the bearers of some abstract historical spirit, or as passive vehicles for the self-articulation of discourse. At the same time, and to some extent conversely, they also force participants and audiences to consider the material, environmental, and cultural constraints under which all lives are lived."[13]

In other words, without being strictly deterministic, it is legitimate to suggest that material and physical constraints affect the contours of life—what is seeable, thinkable, sayable at a given historical moment; being placed in a position to confront those conditions or to watch one's contemporaries confront them reveals a radically different distribution of the sensible, an experience that opens up the possibility that new historical insights will emerge. Importantly for Cook, these historical experiments are valuable only if they produce new historical insights (instead of simply revealing what historians already know); in this conception, participants are more like researchers than pawns. For Cook, the biggest potential pitfall is the problem of analogy: our experiences are not and can never be identical to the experiences of those who lived in the past. He writes, "The key to using these experiences constructively is to remember that no proper conclusions about history can ever be drawn from unsupported analogy. If the visceral nature of personal experience can be a powerful stimulus to reflection, it can only work effectively by sending us back to conventional sources of historical evidence armed with a new set of questions and a renewed sensibility."[14] There must be, in other words, an active relay between affective experience and cognitive processing that is structured or supported by a historical frame. Rather than posit history as fixed and unchanging, this genre inevitably makes visible history's unfinished nature, its contingency, and its connection to the needs of the present.

In subsequent sections, I explore what the formal parameters of this genre—everything from physical deprivation and unexpected obstacles such as bad weather to the cinematographic choices such as cinema vérité camera footage coupled with authoritative voice-overs and direct address by participants—have for the kinds of historical meanings and understandings that might emerge. If the parameters of academic writing—the use of footnotes as a kind of intellectual scaffolding, the distancing effect of the cold detached tone, the third-person narrative voice—affect one's sense of one's relationship to the past, so too do the constraints of this television genre.[15] The specific formal elements of the reality history TV genre help to condition the kinds of meanings and perceptions that emerge. I argue that the genre produces new types of historical knowledge in three ways: through the principle of encounter in the Deleuzian sense; through the emphasis on the embodied nature of the endeavor (which has implications for one's relationship to the period and events encoun-

tered); and through the trying out of historical paths not taken in a manner not dissimilar to what is known as "alternate history."

In Deleuze's articulation, for new thoughts to come into existence there needs to be a provocation: "Something in the world forces us to think. This something is an object not of recognition but of a fundamental encounter." In the essay "Image of Thought," he suggests that recognition promotes complacency and thus forecloses thought or inquiry. The provocations he describes often occur on the level of the sensible in the aesthetic realm. A sensuous encounter "may be grasped in a range of affective tones. . . . In whichever tone, its primary characteristic is that it can only be sensed. In this sense it is opposed to recognition."[16] Such sensuous provocations, though, compel interpretation, meaning making. In the *House* series, individuals from the present are forced into sensuous encounters and made to confront—in sometimes jarring, visceral ways—aspects of the past less legible in written history. These shows are actually structured around the principle of encounter—both physically (in terms of the confrontations with vastly different living conditions) and intellectually (in terms of ideologies about race, religion, and sexuality). When participants encounter the unexpected and the unfamiliar, cognitive work has to be done to process and make sense of it.

Many of these confrontations—and this is the second point about affect and the body—come as a result of physical, tactile, embodied confrontations. The problems these encounters pose are not first and foremost intellectual, though they do compel intellectual work, but are instead physical in that they have the potential to lead to insights about the past—not just for participants but for viewers, too. Bodily discomfort and deprivations are central to all *House* participants' experience. Finally, in many instances, the participants from the present make choices that are not "historically accurate" but rather a product of their contemporary mindset in the twenty-first century. In so doing, they are in effect producing an "alternate history." In this genre, Catherine Gallagher writes, "a slight change in circumstances sets off a chain reaction that takes the course of history in a direction dramatically different from that of actual events."[17] But alternate history is, as Gavriel Rosenfeld points out, "inherently presentist" in that "it explores the past less for its own sake than to utilize it instrumentally to comment upon the present."[18] This logic undergirds reality history TV in several ways. First of all, the genre exposes the extent to which

individuals look to the past to fulfill their own personal and even idiosyncratic needs in the present. Second, it brings to light the material, economic, and political conditions taken for granted in the present. And finally, by inserting people into the past, the shows produce alternative outcomes on some issues. It is clear how these alternative outcomes, which function like correctives to the past, have political ramifications for the present and future. As Rosenfeld suggests, the primary function of alternate history is "to express our changing views about the present."[19] What is less clear is how these reality history TV shows advance historical knowledge of the past. What I argue in my discussion of them is that by perhaps counterintuitively highlighting the point of departure, the moment at which the past is so intolerable that people from the present refuse to reenact it, they bring that intolerable moment into dramatic relief.

To think more concretely about both the potential of this form and its pitfalls, I turn to the shows themselves. Although they follow a clearly defined, formulaic structure—first, training in the skills necessary, then journey to the site, followed by a close-up look at challenges and tribulations, and finally the culminating assessment—they all do not work in exactly the same way. *Frontier House* (2002) was the first of the *House* shows set in the United States, and its goal was to offer a window onto the difficult lives the frontierspeople led in the effort to "prove up" the land. As an authoritative voice-over describes at the beginning of the first episode, "Land in the American West was once advertised as free for the taking. Under the Homestead Act, nearly two million families came to settle virgin territory. The frontier. Their struggle to survive still haunts the landscape."[20] Authoritative voice-overs such as this one are central to all of these shows, and they serve an important pedagogical function. First and foremost, they work to construct the historical frame within which the historical experiment takes place. They create the parameters for what I have elsewhere described as a "transferential space,"[21] an artificially constructed frame inside of which actual experience occurs. They explain the political, economic, and social conditions that shaped life in this historical period. In this way, they anchor the participants' *experience* to very specific social, political, and economic conditions and constraints. As several commentators have also noted, these voice-overs often work to debunk commonly held myths about the period or event at hand. Malgorzata Rymsza-Pawlowska, for instance, suggests that "a main misconception that is prevalent in romanticized accounts of

the Old West is that of ethnic homogeneity," due, in part, to the influence of shows such as *Little House on the Prairie* (NBC, 1974–1983).[22] The voice-overs, in other words, serve as a pedagogical corrective, replacing the more common Hollywood and popular-culture depictions of the period with one that better matches the current scholarly consensus.

These shows are not exploring just *any* historical periods: they focus on iconic historical eras central to American national myths—starting a New England colony, moving out West as a pioneer, or being a cowboy or rancher—and as such their project is inherently demythologizing. For these myths to have persisted, more violent and less palatable histories have been submerged—in particular, the dispossession of native inhabitants and the mistreatment and enslavement of Africans. These shows thus force participants and viewers alike to confront and reckon with the incompatibility of the national myths and the history that lies buried beneath them.

FRONTIER HOUSE

The format of the reality history TV show, as I have suggested, is unconventional in that it combines a historical frame that has been worked out by teams of historians, many of whom work in the area of applied history, with a reality, entertainment-driven format. Of the five thousand applicants to participate in *Frontier House*, three families were chosen, and they had to submit themselves to a period of training with historians and other specialists (i.e., livestock handlers) and to a lesson in the historical conditions in Montana in 1883. This training was necessary both so that participants could begin to imagine the structure of daily life at the time but also more practically so that they would have the skills needed to survive—milking cows, chopping down trees, building log cabins, lighting fires, cooking without electricity or modern ingredients, and so forth. In a fairly conventional documentary style, the program reveals the participants engaging in these daily activities. But in keeping with the reality TV format, the participants also address the camera directly, often in a confessional tone, telling viewers what they think about their experience, how they feel physically and emotionally, the extent to which their expectations are being met or thwarted, and, most insidiously, what they think about

the other families. In addition, each family has been given their own video camera to record in video diary format their most private thoughts in private moments, away from the camera crew and often late at night. The technology they use for these video diaries is of course anachronistic. And yet recording these diary entries has the effect of forcing the participants to reflect in a self-conscious way on what they are encountering. In other words, it creates a critical, self-conscious engagement with the reenactment itself. In this way, the technology actually forces a kind of perception, a kind of self-reflexivity crucial to historical thinking. Furthermore, we as viewers are offered the opportunity to reflect on what the participants are doing or not doing both at these self-conscious moments and, perhaps more importantly, at the moments when they are most fully engaging in the experiences that make them feel they have traveled back in time.

The three families selected for *Frontier House* represent geographic, racial, and class diversity. The Clunes are a wealthy, white family from Malibu, California; Gordon has his own business, and Adrienne stays home with the children (Aine, fifteen; Justin, eleven; and Conor, nine). They are accompanied by a niece, Tracy, also fifteen years old. The Glenn family, also white, from Robertson County, Tennessee, would be considered middle class. Karen, a school nurse, has two children, Erinn, twelve, and Logan, eight, from a first marriage and is now married to Mark, a community-college professor. The Brooks family is represented by Nate, a young African American man from Boston who works in education, and his father, Rudy, a retired correctional officer. Rudy accompanies Nate until Nate's fiancé, Kristen McLeod, a white woman also living in Boston, joins them for a "frontier wedding." Including African Americans among the settlers was a deliberate strategy to debunk myths about the frontier as racially homogenous and to serve as a visual corrective to commonly held ideas about frontier life. As a voice-over in the first episode points out, "Many history books ignore the presence of African American pioneers. In fact, by 1880 almost half a million black Americans were living in the West." Part of the show's pedagogical force comes from confrontations like this— deliberate challenges to mainstream ideas about the place and time. These voice-over confrontations are largely cognitive, but they are nevertheless of apiece with what I am describing as moments of encounter that take place af-

fectively in the participants' day-to-day lives—with the important exception that they are exclusively for us, the viewers.

The dominant impulse that drives virtually all of the knowledge production in the series is not narrative or narrative arc, but rather "encounter." These encounters are both large and small, but virtually all of them are characterized by a kind of bodily confrontation with a set of circumstances that are unfamiliar or unexpected. As many commentators have noted, physical deprivations are among the first experiences voiced by the participants.[23] At those moments, the participants are encountering something outside of what their contemporary lived experiences have given them access to. Importantly, though, the deprivations and discomforts are circumscribed by the historical frame—so they do not experience just hunger qua hunger but hunger in the context of the uncertainty of life on the frontier, of not knowing how long the supplies will last or whether the harvest will be sufficient. Indeed, the show describes the challenge facing the participants primarily as a struggle for survival: an early voice-over asserts that "60 percent of the homesteaders did not survive the five years required to prove up their land and secure ownership. Our challenge: Can modern-day families live five months and prepare for a Montana winter under the same conditions?" In the first episode, for example, before even reaching "Frontier Valley," Nate Brooks notes the changes in his body, the soreness, and Adrienne Clune concedes that she is so tired she wants "to cry." Upon setting out for Frontier Valley, a horse gets spooked, and young Conor Clune falls out of the wagon. Upon reaching the site where they will camp for the night, Adrienne declares, "Quite a day . . . quite an introduction to the hazards of the frontier. It was, like, incredible. A little more than I had anticipated. A little more real than I wanted to get." Conor adds, "I fell out a wagon, I lost my worm without even getting a bite, I was attacked by a vicious dog." These physical encounters make the experiences feel real for the participants in a way that they do not for viewers. However, for both groups, viewers and participants, the show has already begun to debunk the myth of the frontier as romantic and exciting. Of course, the deprivations and physical challenges grow more intense over the course of the participants' time in Frontier Valley. Adrienne Clune laments that she does not have enough food to feed her growing children, that they have to learn to use alternatives to toilet paper, that they have to grapple

with the bone-chilling cold. One snowy morning, the Clune girls must walk to the Glenns' house, where they expect to find their milk cow, who wandered off in the night, but without any dry clothing to wear the girls set out wrapped in blankets: "We had to walk like almost a mile in the snow, which was maybe ten inches deep, and I didn't have any clothes, so I had to go outside with a blanket and two gloves for my socks. . . . Aw, my leg is numb, I don't feel it. It's burning." They do indeed find the cow there and proceed to milk her, despite the elements. Mark Glenn, who has fully embraced the role of homesteader and who lacks any self-consciousness about the reenactment, comes out and reprimands the girls for milking on his property, which reduces them to tears. Nate, on his way to visit the Glenns, comes upon the girls and expresses genuine concern over their uncovered, raw skin (see figure 3.1). He offers to take a turn with the milking, saying, "You should get up and walk around. You don't want to get too cold." He tells them to go home before frostbite sets in and offers to take the cow. "Forget about the camera, forget about everything else, just concentrate on getting your feet warmed up and getting back to your place," Nate says. His concern exceeds the parameters of the show, in effect breaking the frame, reminding viewers both that the situation is artificial (it is being filmed) and at the same time that it is real (the girls are actually in physical danger). This experience, though of a different order of magnitude from the real danger people of the time faced, nevertheless dramatizes the unpredictability of life on the frontier.[24] In addition to these physical confrontations with the elements, the participants face the unexpected: the road is out, and so they must walk because they have no other choice. Unlike unpredictability in the modern world, which can be easier to manage, on the frontier the stakes were much higher. Says Nate, "I think back to the folks back in 1883 that came out this way. You can have the best intentions of coming out and starting a life here, and it only takes one broken leg or a weather storm that came or animals eating your crops, and before you know it, you're bust."

To highlight the way this experience affects the body and to show in a dramatic fashion how the participants' bodies have literally changed over the course of their time in Frontier Valley, the opening titles for the show use morphing technology. These physical experiences work different ways for the participants, at times proving to them that they have really gone back, are really living the lives of their historical predecessors, and at others catalyzing

FIGURE 3.1 Nate Brooks tells the Clune girls to go home
to avoid frostbite. From *Frontier House*.

reflection on the experience and casting that knowledge backward. The seductiveness of the physical changes, the way they serve as evidence for having gone back, however, in general works against their ability to think critically about the reenactment. However, their romantic notions of meeting the wilderness and starting anew are challenged by the difficulty and the physical strain. The point is not that they ultimately know exactly what the settlers felt (in actuality they are just as far from the past as viewers watching at home are), but rather that at certain moments their own embodied experience leads them to view the frontier experience through a different lens. The experience is not an identification with the past so much as the gaining of a new vantage point on it, one that is inaccessible through other means.

Some of the encounters produce cognitive dissonance—forcing an individual to inhabit simultaneously two mutually contradictory narratives. Such an experience compels interpretation and meaning making. Acquiring historical knowledge conventionally, either by reading books or by sitting in a class, is largely a mental exercise. What is being transmitted are ideas: about what people believed, how they lived, what conditions governed their lives. Because these ideas about the past are fundamentally abstract, lacking the shape and

texture of the kind of knowledge we have about things we have experienced, it is possible to compartmentalize them so that even contradictory ideas can be maintained side by side. Indeed, the ability to hold contradictory ideas is often considered a sign of intelligence and higher-level thinking. But that ability also has the potential to block deeper thought or interrogation. In other words, being forced to confront or even experience the discomfort of those contradictions has the potential to catalyze deeper, more complex thought. It becomes much less possible to manage the contradiction. In some cases, the contradiction is experienced as cognitive dissonance, where one's beliefs do not align with reality, as is the case in the next example.

Because the children of Frontier Valley will be missing more than two months of school, the families take steps to establish one there. The families are told, however, that existing laws would prohibit any children that Nate, an African American man, and Kristen, his white wife, would have from attending the same public school as their white children. Kristen knows intellectually that her future children will be considered black, and obviously she knows that racial difference continues to have social significance even in 2001. And yet when she learns about this law, she is forced to confront racism in a literal and visceral way. She says, "It just shocked me because I haven't experienced racism firsthand yet. And I've experienced it through Nate's stories. But I didn't even, it didn't even dawn on me, and to have someone say we're not going to let your kid in, I realized, my kid, oh *my* kid, my gosh, this is going to affect me and my family. I'm naive, and I haven't made that connection really yet." This situation, in other words, forces her to *experience* that connection, which affords her a visceral understanding of the form racism took *then*, but which will also affect how she will live in both the present and the future.

This situation with the school also highlights the way in which these experiments create the occasion for alternate history. Although the families are willing to adopt certain dispositions of the past and to adhere to their logics (in terms of diet, creature comforts, daily schedule, and so on), none of them is willing to live or express the racism that certainly would have existed at the time. Furthermore, they make a collective decision to hire a private teacher so that the school will be open to Nate and Kristen's future children, a decision they acknowledge would have been historically unlikely. In fact, although these families have been divided over virtually every other issue, they are united

in their response to this situation. As Karen Glenn says to Judy Harding, the teacher, after learning about the law prohibiting the attendance of children of African descent: "We have an African American family here in our community already. And we adore them. And I don't think anyone at this table would ever not want them not to have the same rights and education and opportunities that our children have." Gordon Clune, with whom Karen has been continually locking horns, agrees, saying, "We'd want them to be educated along with our children. We'd want that." They decide to establish a private school and pay for it themselves. The families then tell Nate about the racist laws. Their inability to reenact this part of the past is particularly enlightening for viewers. The white families seem untroubled by the fact that their collective decision here works against the "accuracy" of the reenactment. However, the viewer has the opportunity to reflect on the significance of the participants' inability to reenact racism. By writing the history differently, with an outcome that does not match the historical record, the participants are inadvertently calling attention to both the new trajectory and the old. As Nate explains, "When racial discrimination existed in 1883, I'm sure it was very prevalent here in the Montana territories, but that doesn't change the fact that the people who we are today in the modern world were not 1883 couples. We're living an experiment." In other words, being forced to live this experience of racism makes the couples choose an alternate route, but one that in the process makes palpable and even more visible the racism of 1883, putting a face on it that even those living in 2001 cannot willfully ignore. As Nate describes, "It's scary when we look back at an 1883 history book, and we get to laugh at it and say, 'Oh God we've come so far. We certainly don't do this anymore.' When the racism or the prejudice or stereotypes are still there, they're just subtle." Kristen, too, gains a tangible, material awareness through this experience of what it would really have been like for an interracial couple on the frontier as the circumstances force her to encounter those prevalent beliefs. She muses, "I wonder what it would really be like for us. I think it would have been a much huger issue. Nate would have been *black* black then." In some ways, this encounter calls attention to the different form racism takes in the present moment, a point upon which both Kristen and Nate reflect. Racism is alive and well in the present, but it is more subtle and indirect, and it tends to be structural and systemic as opposed to interpersonal. To be "*black* black" in Kristen's words, might be to experience racism directly,

as an a priori condition of existence, a racism that is socially acceptable. Even though the families opt not to treat Nate or his and Kristen's future progeny as "*black* black," their confrontation with the racist laws highlight in an intimate way their implications for frontier society.

COLONIAL HOUSE

Focusing on another iconic historical moment, *Colonial House*, like *Frontier House*, produces historical knowledge in ways similar to those I illustrated earlier: through the logic of encounter and its subsequent production of cognitive dissonance and more complex understanding as well as through the playing out of alternate histories. In *Colonial House*, seventeen applicants were chosen from the United States and Europe to shed their contemporary lives and set out for seventeenth-century New England with the goal of establishing a successful and sustainable colony. They would be assigned roles and have to live on a plot of land on the coast of Maine away from civilization for four months. As the narrative voice-over at the start of the series announces, "Four hundred years ago the east coast of America was a promised land. This remote site is home to a new colony. Everyone here is learning what life was really like. They travelled back to 1628 to the roots of a nation. Can this group of strangers live by seventeenth-century laws and build a prosperous community? What will become of them in this new world?"[25] The principal participants were Jeff Wyers, a Baptist minister from Waco, Texas, in his 2004 life who is named governor of the colony, his wife, Tammy, and their three children, Bethany, Amy, and David; Don and Carolyn Heinz, both professors at Berkeley in the present; Paul Hunt, a present-day laborer from Manchester, England, living as an indentured servant in the colony; Jonathon Allen, a present-day graduate student from South Carolina, living with the Heinz family as an indentured servant; Danny Tisdale, an African American living in Harlem in the present; John Voorhees, a carpet salesman from Beverly, Massachusetts, his wife, Michelle, a seamstress with her own shop in the present, and their son, Giacomo; and Amy-Kristina Herbert, an African American actress and adjunct professor, assigned the colonial identity of a widow living with the Voorhees family.

As was the case with the participants on *Frontier House*, the first layer of experience and a pervasive theme, particularly early on, is bodily deprivation; we are told that as night falls, "the temperature plummets to near zero." Aboard a sailing ship heading for a plot of land in Maine, the participants confront the bone-chilling cold. The men set off on small boats to explore the shore, while the women and children remain aboard the sailing ship; we are told by voice-over that in 1621 the women and children lived aboard the Mayflower for two months while the men set up the colony. The experience of being away from her husband in unknown circumstances causes Michelle Voorhees to tear up. Dabbing at her eyes, she says, "I know that the men'll get back. But I can't imagine being those people not knowing. Can you imagine being those women and children just being stuck on the boat? You can't see anything. Just being alone, wondering if they'll ever come back. It must have been horrifying." Before the series began, she had known in an intellectual way that it must have been frightening, but the experience of being on the boat and apart from her husband literalizes it for her. And once at the colony, the situation stays very much the same: lots of tears and confessions about how little they understood about just how difficult it would be.

Very early on the show makes visible something not often considered in relation to the project of history, especially as it is understood by people outside of the profession: the radically different motives people have for engaging with and learning about the past. For Don and Carolyn Heinz, the experiment would shed light on the ideals upon which the country was founded. Michelle and John Voorhees, by contrast, declare that "we are here to see how we can live close to the land without modern conveniences." And Jeff Wyers is motivated by religious faith. In response to his son's pleas to take them all home, he says: "What it brought home to me was all the people watching their loved ones die for a dream, a dream of having a place where you could worship God without the state telling you to do it, and many of them held their children as they died, and they were still glad they came." In tears himself, Jeff continues, "I told him that we were doing it in the hope their story could be told and people could see how deep their faith is and how real God was for them. I'm not here for the camping trip . . . I'm here to tell those people's stories." Furthermore, because the participants have different motivations, they are in different relationships

to the project of reenactment and are thus not all equally capable of engaging in the kind of historical thinking the reenactment makes possible. Viewers, by contrast, are more straightforwardly positioned to encounter the participants' experiences, both the successes and failures, as provocations to historical thinking.

The participants' encounters with the indigenous peoples provide the first opportunity for the production of an alternate history. Within the first moments of the opening episode, we are told in authoritative voice-over that it is wrong to think the colonists found nothing but wilderness; in reality, they settled on land where native communities already lived. And, indeed, the participants have several meetings with current members of the local Passamaquoddy tribe, which in the present day owns the land they are meant to settle. The meetings with the Passamaquoddy, who are "real Indians," are epistemologically unstable. Although the tribal members on the series do not live as their ancestors did, they nevertheless have a different relationship to the role they play than do the colonists, who have no direct connection to either the land or to the English colonists of the seventeenth century. Importantly, the presence of these "Indians" makes visible and material the issue of dispossession; for both the participants and the viewers of the show, seeing these actual Passamaquoddy as *people* fosters a sense of discomfort, making it harder to maintain their idealized vision of the colonies as a society built on lofty principles of freedom. To drive home this point, the Passamaquoddy refer to the treatment of the indigenous peoples as "a holocaust" on our soil. The use of this anachronism (the Holocaust would not occur for more than three hundred years) calls attention to the difference between the original experience and the reenactment, creating the conditions for historical thinking and reflection.

This encounter with the native peoples as well as the ones that occur later in the series take the form of alternate history. The colonists know that they will need to depend on the natives for trade; first and foremost, they need seed corn to establish a crop. In the very first episode there is an awkward moment when they are unsure if they should go in search of the natives or wait for them to come. When they do see the natives in the distance, the governor's daughter, Bethany Wyers, waves, and the colonists yell, "Hello." Although there is some nervousness—John Bear Mitchell, a member of the Passamaquoddy tribe, describes a bit of "fear on both sides"—this encounter is significantly less worri-

some than the encounters of 1628. As a member of the colonists' group points out, their predecessors would have "put on armor and readied muskets." This encounter, in its awkwardness, offers an alternate history to the accepted version: there is no violence, implied or carried out. But we are offered in a very straightforward manner the point of view of the contemporary indigenous population, which serves to challenge some of the enduring myths about the colonial settlements.

As was the case in *Frontier House*, the most provocative and provoking moments in the series occur when characters are forced to experience in an embodied way a kind of cognitive dissonance. The epigraph for this chapter gives a comment from participant Carolyn Heinz, an anthropology professor in the present day. She is articulating a conundrum posed by her encounter with members of the Wampanoag tribe: "It suddenly sunk in in a way that it hadn't until then that I was going along and being an imperialist. . . . I am reenacting a whole system that I don't believe in and that I disapprove of, and yet it's the roots of our own nation." She has been placed in a scenario where she is forced to live two contradictory, perhaps even mutually exclusive narratives simultaneously: that the U.S. nation was founded on the ideal of freedom and that the U.S. nation was always, from its earliest colonial days, an imperial presence, dispossessing others of their freedoms. Neither of these narratives or ideas is on its own surprising, and she has clearly thought about each one on its own terms. And yet this historical experiment has brought her to an intellectual crisis wherein she is forced to inhabit two positions that cannot be reconciled. In her life in 1628, she is simultaneously living both of these ideas, and that experience is perplexing, a catalyst to thinking about the colonial enterprise in a more complex way. Engaging in this reenactment forces her to experience these two well-established historical truths as a *contradiction*—and that, I think, reflects some of the potentially important and useful work done by this kind of reenactment for the more self-aware participants. There is something about the structure of embodied encounter here that makes these insights visible, makes it seem problematic to separate the high-minded notion that the United States was founded on an idea of freedom from the more negative notion that it was from its inception an imperial venture. Importantly, in the moment of reenactment Carolyn is not having the experience of the colonist; she is having the experience of a twenty-first-century self engaging in the practices of the colonist,

an experience that compels her to self-awareness about her own historical thinking.

Other problems arise around some of the colonists' unwillingness to conform to the deep religiosity that would have characterized colonial life in New England. In the second episode, the colony's preacher, Don Heinz, prepares for the first Sunday Sabbath service. Religion was a fundamental part of life for the majority of the colonists in 1628, but it is not for the diverse group to whom Heinz must now preach. Michelle Voorhees, for instance, worries about saying prayers she does not believe in and asks the camera, "If in the future I feel I really have a problem with it, will I be excused?" The religiosity of the Wyers family (the father is a Baptist preacher in his contemporary life) was enhanced by a tragedy that occurred to his family in Texas during this historical reenactment: his daughter Bethany's fiancé and his older son were seriously injured in a car accident. The Wyers departed the colony for a short period but returned with renewed vigor for the project: Jeff declares, "My perspective has deepened—they would have lost people here—it's very real." Interested in those who came for religious reasons, Jeff wants the colony to be a "City of God." But according to the other colonists, Jeff is "tightening the screws"; in keeping with seventeenth-century common law, Jeff says that the colony will no longer tolerate profanity, that modesty shall be observed (shirts and trousers for men, head coverings for the women), and that violation of these laws will lead to punishment: offenders will be tied to a post or tree or placed in the stocks. Jeff further declares, "It is the law that everyone observe the Sabbath." Michelle Voorhees experiences this law as a loss of freedom and refuses to attend service, opting instead for a picnic with her family. And they are not alone in their resistance to the rules. Many have violated the laws against profanity. On Judgment Day, all law breakers must be punished: Paul Hunt is shamed and given a scarlet letter in the shape of a P for *profanity*. The punishment for Sabbath dissenters is different—John Voorhees must punish his own wife by tying up her leg. Jeff ultimately makes a decision that again creates something of an alternate history: he concedes that the Sabbath punishment is unenforceable at this point. He will suspend the enforcement of laws concerning attendance at the Sabbath service while continuing to encourage everyone to come. Again, as was the case in *Frontier House*, the participants do not self-consciously reflect on their unwillingness to play by certain rules, to adhere fully to the social norms

of the times, but it is extremely obvious to viewers. This departure from historical accuracy again calls attention to the nature of the difference. It brings into dramatic relief for the viewers a world in which people's everyday lives were fully shaped and confined by religious beliefs and their attendant ideologies about profanity, modesty, and women's place—"silence is the best ornament on a woman"—and blasphemy.

The issue of race is raised quite pointedly, not in relationship to the native peoples, but rather in the decision to cast two African Americans and an Asian American as colonists even though blacks and Asians would not have been part of the racial makeup of the New England colonies as understood by historians. In much the same way that Kristen, white wife to Nate in *Frontier House*, is forced to embody the contradiction between her ideas about race and the reality that her kids would be black and thus unable to attend school with white kids, Danny Tisdale, an African American who plays a freeman in the colony, must inhabit a role that puts him in a position of bad faith toward his contemporary self and ancestors. Within the show's narrative, his character is desperately in need of corn crop, a crop that will require extensive human labor. The need for labor makes real for Danny the conditions that led to chattel slavery. He is thus inhabiting the role of a freeman who has a vested interest in crop production and so feels himself complicit in the development of slavery: "It's 1628; fifty years later we have slavery. . . . In a very strange way I'm part of it." Danny thus departs without saying good-bye to the rest of the colony, leaving the governor short on manpower. In the role of a freeman, he is forced to confront the fact that he is *participating* in a system that would soon slide into slavery. Like Carolyn Heinz, he is forced to embody two contradictory positions that might be maintainable side by side intellectually, in the abstract, but are literalized and made irreconcilable through this experiential form of engagement. He asks, "Am I reliving a slide that led to disastrous results?"

Amy-Kristina Herbert, the other African American in *Colonial House*, also leaves early, though she says she had planned to do so all along. She does not explain it in these terms, but her reason for participating in the show is precisely to create an alternate history. "Part of the reason why I wanted to do this project as a black woman, black American rather, is that this is the beginning of the country I live in, you know; my roots do not come from Puritanism, but this is the beginning of America, and I am American. People need to stop thinking of

FIGURE 3.2 Black pilgrim Amy-Kristina Herbert leaves
the colony. From *Colonial House*.

'here's my people' when they think of America. They need to see American and
think of America and see faces that aren't white, see faces that aren't stereotypi-
cal, and this is the best place to do that. You know, me a black girl with braids
in my hair in a pilgrim outfit—as ridiculous as the image is, it's no more, it's no
more ridiculous than trying to classify who's more American than who" (see
figure 3.2). Does peopling the New England colonies with Africans who would
not have been there rewrite the past for the present? Or is it jarring, calling
attention to how out of place an African American woman looks in the New
England colonies, reminding us of the homogeneity within the colony?

Another alternate history is constructed on the issue of sexuality. Halfway
through the series, Jonathon confesses that he holds the biggest secret in the
colony: that in his twenty-first-century life he is gay. We watch him suffering
until he can no longer stand it. As was the case with race, this is another instance
in which the colonists are unwilling to abandon their twenty-first-century dis-
positions. Not only would a 1628 governor have punished with death a person
for homosexual acts, but the very idea of a homosexual as an identity category
did not yet exist. And yet when Jonathon asks for a private conversation with
Carolyn and Don Heinz and then "comes out," Carolyn immediately says,
"Jonathon, this is not an issue for us. . . . Don's daughter is gay"—her use of the

term *gay* obviously an anachronism in the colonial context. When Jonathon eventually decides to come out to the whole community, at church no less, he is once again supported by the congregation. He says, "I am gay, and for the past two months I have really struggled being here because in 1628 I wouldn't even be having this conversation. I wouldn't be speaking to you because the governor would probably stop it and take me out there and kill me because homosexuality was punishable by death. For the past two months I've been struggling because I haven't been able to be myself, and I just hope that history will not repeat itself and, when I reveal this, that people will not look at me and say, 'Well, hate the sin but love the sinner.' That doesn't work for me. I have to say it's liberating actually. I feel a lot better now." For the viewers, seeing how he suffers with the secret and acknowledging what would have happened to him had he lived in the seventeenth century make palpable the discomfort and fear one would have experienced as a nonconformist. Again, there is a difference between knowing intellectually that homosexual practice was not tolerated in the colonies and watching a gay person confront that realization. But, importantly, Jonathan does not have to pay the price. Like the decision to hire a private teacher so that Nate and Kristen's kids can go to school with the other families' kids in *Frontier House*, the community here cannot shake their contemporary attitudes toward sexuality. By choosing to accept Jonathon, they are enacting an alternate history. As in the previous examples, they do not interrogate their actions; the desire to accept Jonathon seems self-evident because they cannot fully shed their present-era mindset. For the viewers, however, the colonists' refusal to follow the social norms of the times has the effect of casting a light on the alterity of the past.

TEXAS RANCH HOUSE

Although twenty-first-century participants in these historical reenactments are unwilling to embrace the racial prejudice that they would surely have felt in the seventeenth and nineteenth centuries or the prejudice that New England colonists would have felt against individuals who engaged in homosexual acts, in neither instance do the male participants have trouble adapting to a strongly patriarchal society, a critique that Maura Finkelstien, a twenty-five-

year-old graduate student assigned the role of house girl, voices in *Texas Ranch House*. In 1867, two years after the end of the Civil War, Texas and the South were in economic ruin. As a voice-over explains, homesteads were bought up by entrepreneurs and turned into ranches. The project for *Texas Ranch House* participants is to turn the ranch into a profitable cattle business. As owners of the ranch, the Cooke family from suburban California are supported by Maura, the "girl of all work," along with six cowboys and a cook. Although *Texas Ranch House* is clearly the most soap opera–like of the three series I am considering, it has a few moments that function in the potentially constructive ways I have identified in the other shows. It is worth considering, for example, Maura's observation that the men have no trouble slipping into a traditional patriarchal mindset, raising the question of why the male participants find that so easy when other prejudices are too uncomfortable for them to reenact. She says, "I thought you could come out here and make a happy life as a woman . . . but you can't; all the guys are so diverse—from different places—and yet they all are sexist, and . . . they all love it and embrace it, and it took them five minutes to put on that jacket." This is another instance where we as viewers, thanks to the distance created by our mediated relationship to the reenactment, are led to insights about gender that many of the participants themselves do not attain. Viewers are encouraged to analyze why it is that whereas racism is less acceptable but has taken on more subtle and covert forms in the present, sexism both evident and not so evident is still to a certain extent acceptable.

Even more provocative is the encounter between the ranchers and the Comanche. As in *Colonial House*, part of the historical impetus of *Texas Ranch House* is to challenge the idea of westward expansion and ranching as a benign, wholesome family adventure. And also as in *Colonial House*, the indigenous peoples figured in *Texas Ranch House* are not just assuming a role: though living in the modern world, the Comanche on the show understand themselves to be Comanche in the contemporary present, destabilizing the clear lines between reenactment and reality. We are to understand the limited scope of the Cooke family's vision both literally in that they are completely oblivious to the natives' camp nearby and figuratively in that they are ignorant about the history of the land as land already occupied by an indigenous tribe. Viewers are told in voice-over, "Just seven miles from the jubilant cowboys a Comanche scouting party has returned to the land of their ancestors. The Comanche peo-

ple were feared for their ferocity and aggressive horsemanship." We hear voices speaking in what we assume to be Comanche and see a teepee being erected. Documenting the land as Comanche land, the voice-over continues, "They numbered in the tens of thousands and controlled 240,000 square miles of territory that extended into what is now Colorado, Kansas, Oklahoma, Texas, and New Mexico. Descendants of Comanche chiefs, the visitors [the present-day Comanche] have come to experience their ancestral history." Among them is Michael Burgess, chief tribal administrator for the Comanche nation in the present; he explains: "It might have been one hundred years since the last time a teepee was anywhere within fifty miles of here." He explains that they have been "struggling with the onslaught of the modern world." Although Burgess is himself a Comanche in his "real" life, this form of experiential re-creation is as much of an historical experiment for him as it is for the "white" participants. Of the traditional clothing he has donned for this experience, he says, "It's different to walk around with these leggings, these buckskins, and I'm thinking this is something our Comanche people need to do." Although we are to understand that these Comanche participants have a more authentic connection to their historical predecessors of 1867, there is something to be gained for them too by wearing the clothing and inhabiting the space that their ancestors inhabited. Comanche artist and musician Calvert Nevaquaya describes a palpable sense of belonging on the land, that they "can feel our people there, can feel their presence." The Indians are the provocateurs here (in an earlier episode, two of the Cookes' horses went missing, and we learn here that they were rustled by Comanche), but a historical voice-over contextualizes this kind of theft within the larger context of western expansion, explaining that during the nineteenth century, as the Texas frontier expanded, the Comanche defended their territory by raiding horses and cattle to trade.

Two of the Cookes' ranch hands, foreman Robby and cowboy Jared, come upon the Comanche while "riding the line." Michael Burgess invites them into his camp and then into the tepee. Part of the work of the encounter is to reframe the whole project or conceit of *Texas Ranch House* or to call attention to the fundamental problem of its very premise: the premise, as Cooke later describes it to Burgess, is that "we're here peacefully; we're just looking at making a life, taking care of the family." Herein lies the contradiction: they *cannot* be there peacefully. This, too, is a case where the participants are forced to inhabit

two contradictory positions simultaneously, which produces cognitive dissonance and catalyzes historical thinking. As a voice-over attests, "In 1867, the great Comanche trail actually passed though the location of the Cooke ranch." Burgess himself makes this point to the ranch hands and the viewers: "It's not that we don't own this land; it's that this land is still ours even though there's a government and other people who live here. We never gave this up easily, we were duped out of a lot of it, and we were murdered out of a lot of it. That's part of the history." Nevaquaya, speaking to the camera, explains what he sees as this encounter's purpose: "I wanted them to know how bad it damaged our people. . . . When I was sitting there talking about it, I felt myself getting angry. They were looking at me as a Comanche, a wild Comanche, and it was just kind of that rivalry there, that villain. Of course, I hear a lot, too, from people, 'That was a long time ago—why you still talk about it today?' . . . Well you know it still, it affects our people today. . . . Why let it go? . . . This is our country." As he says this, he is quite literally speaking *to* the viewer. In so doing, he points a finger at the viewer, too, who is also complicit in the violence against his people.

The unstable situation caused by the presence of "real Indians" within the sphere of reenactment/experiment and the effects of their ontologically uncertain status affect the other participants in a range of ways. In discussions with the ranch hands in the tepee, Burgess makes clear that he wants to trade horses (including the ones they stole from the Cookes) for some of Cookes' cattle. They discuss some terms and set up a meeting for the following day at the Cookes' ranch, but before the men leave, Burgess very calmly states that Jared will stay with them. To Jared, he says, "You'll be safe—promise." Although we do not see Jared's face, we see him look over at Robby. Clearly they are surprised. Robby smiles at him, and Jared shifts his position. He smiles awkwardly and blushes. "There were a thousand thoughts racing through my mind all at once," he says. "As friendly as the invitation was, I had just become a captive." Jared is clearly not scared for his life, but he understands that he has no real choice but to comply. Like the danger in *Frontier House*, the danger here is of an entirely different magnitude from what it would have been had Jared actually become a prisoner of the nineteenth-century Comanche. A voice-over tells us that "Jared's detainment is symbolic. In the nineteenth century, both cowboys would almost certainly have been viciously tortured and killed." And yet

the experience of uncertainty within the context of hostile relations between ranchers and Comanche engenders a sense of insecurity that he wears and manifests on his body. Jared knows he is merely a participant on a TV show, but the shock of the experience is clearly destabilizing nonetheless.

The situation with the Comanche more broadly and with Jared specifically makes the Cooke family anxious. Although no one thinks Jared will actually be harmed, his captivity was unexpected and shocking. Mrs. Cooke, speaking to her girls and Maura, says, "Hopefully they'll be peaceful." A voice-over alerts us to the fact that her great-great-grandmother Debbie Anne Wise was killed by a southern Plains tribe. Maura, responding to Mrs. Cooke, echoes what was said earlier in the day at the tepee: "We did actually, you know, invade their land and kill most of them off." One of the daughters retorts, "They did their fair share of killing, too." That night Mr. Cooke calls a special meeting to discuss the situation, asking Robby to confirm: "You didn't get a sense that they were hostile?" There is no mention of Jared, but we see him in the early morning darkness participating in the Comanche's sunrise ceremony: we hear the music and see them in the dark playing instruments and chanting. They leave Jared behind when they go off to negotiate with Cooke.

In some ways, the planned meeting between the Comanche and the Cookes is like the alternate histories we have seen in *Frontier House* and *Colonial House* in that no racial prejudice is expressed. In fact, while nervously awaiting the arrival of the Comanche, the Cooke ranch prepares a luncheon for them. A voice-over attests: "Laying out the best china and entertaining Comanche would have been unthinkable for early ranchers"—they would have loaded guns and hunkered down. When the Comanche arrive, greetings are given and introductions made in English. The camera reveals two Comanche warriors on the hill. Those at the ranch take a seat; Mr. Cooke speaks first: "We're here peacefully. We're just looking at making a life, taking care of the family." Although at the start of the series that claim might have resonated with viewers, it no longer seems tenable after hearing the Comanche point of view. The rancher narrative of "just making a living" on open land is fundamentally incompatible with the violent dispossession of Comanche lands that was part of westward expansion. The viewer is forced to see the contradiction: although the two narratives can be maintained intellectually, they cannot exist side by side in

practice. Burgess and Cooke begin discussing trade terms, going back and forth with little progress. As was the case with Jared's captivity, Burgess here asserts a kind of quiet power, which poses a conundrum for participants and viewers. He says to Cooke, "You'd be bargaining from the weakest position ever. We were trading, and I told you ten cows per horse, and you didn't meet my price, there'd probably be ten warriors over here, ten more over here." Mr. Cooke, upset that he has no leverage in this negotiation, says: "In 1867, we would have had guns and ammunition." Trying to get Cooke to see the contradiction, the cognitive dissonance between his sense of "trying to live peacefully" and the fact that he is doing this on stolen land, Burgess says, "You want to live peacefully. And you want to stay here, and you're in our land, so what you're going to end up doing is trading with us so you can live here." Finally understanding, Cooke says, "So the price would be higher because it is your land."

In some ways, this episode seems like another instance of alternate history in that the family prepares lunch for the Comanche instead of grabbing their guns. But this scene functions differently because the Comanche here are supposed to be threatening; the show tries to create an undercurrent of fear. In part, this is a result of the fact that for the Comanche participating in the show, as for the indigenous peoples participating in *Colonial House*, this dispossession happened to their actual ancestors, not to some abstract historical predecessors. When the two sides appear to be at loggerheads, a very uncomfortable moment arises. In a quiet voice, Burgess says, "If we don't get thirty cattle, we might have five women," and counts the five women at the ranch with his fingers over his shoulder (see figure 3.3). We know all the while that his threat is not real, that the contemporary Comanche would never harm the Cooke women, and yet *voicing* the threat in the context of the negotiations creates a powerful confrontation or encounter that produces an embodied sense of discomfort and one that ultimately provokes a deeper understanding of the stakes for the ranchers. Of this moment, Mrs. Cooke's describes, "My skin was crawling. Technically our whole well-being were in the hands of just those few men, so it was a very unempowered feeling. And very scary. I started to feel defensive for my children." Again, the epistemological insecurity of the "realness" of the Indians, despite the contrived nature of the scenario, produces a kind of friction that functions as a productive catalyst to new thoughts, a greater

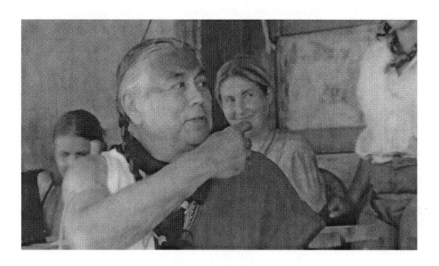

FIGURE 3.3 Comanche chief Michael Burgess with
Cooke women. From *Texas Ranch House*.

understanding of the complexity of the situation. She understands in a visceral
way her complicity in the violence, that despite her well-meaning, twenty-first-
century intentions (like those of the colonists in *Colonial House*) the ranchers
are inhabiting the subject position of land thieves. She reflects, "It was a very
humbling experience to have the Comanche say, 'Well, this is ours; we're just
letting you stay here.' Coming up from California, we didn't know this land
belonged to someone else. And then there was the question, Should I really be
here? I almost felt like I was being sold a stolen car. And now we're face to face
with the original owner, and I can't say I disagree with them."

Michael Burgess also strongly makes the point that the experiential is a cru-
cial mode for certain kinds of knowledge acquisition, not only for his own peo-
ple but for the white participants as well. Although Jared, the cowhand held
captive, is eager to return to the ranch, we are to understand that he has had a
fulfilling experience among the Comanche. Of his experiences as their "cap-
tive," spending the night with them, he says, "They've been very willing to teach
me. . . . I will carry it with me up here [taps his head]. I will speak to others
about the history—I will teach them what I've learned." Burgess underscores
the importance of this experiential engagement, of going through the motions

in an embodied way. Of Jared he reflects, "I really think that Jared was the person this was for. Jared, the inquisitive mind. . . . You can read a lot, but until you get involved in it, you don't learn a lot."

But at issue is not *only* going through the motions: it is being forced to encounter, as an embodied person, the contradiction between two intellectual positions that can be held side by side only in the abstract. Of being forced to inhabit two mutually incompatible positions, Jared asserts, "When you tell history from one side, then you tell history from the other side, sometimes it doesn't even seem like the same story." Trying to think through those contradictions has the capacity to produce more complex understandings of the past. Instead of the pluralist model where each group's story sits side by side with every other group's story, the experience of the show forces viewers and participants alike to reckon with the fact that not all stories can sit easily beside all others, that they are mutually incompatible, even contradictory. That experience has the capacity to force viewers to rethink even the progressive-seeming multicultural narratives.

Texas Ranch House tries to position the viewers, along with the participants, so that they experience these encounters almost like a punch: we are told in voice-over that by the 1870s the U.S. Army was involved in a full-scale campaign to rid the West of Indians and kill their buffalo. The voice-over quotes Colonel Richard Irving Dodge: "Kill every buffalo you can. Every buffalo dead is an Indian gone." Of the 30,000 Comanche once populating this region, only 1,597 were left when in 1875 they were forced onto the Oklahoma reservation. This comment is meant as a visceral hit to viewers, and now that they have seen how the dispossession takes place, it is all the more affecting.

I have tried to show the ways in which these reality history TV shows in certain instances and around certain kinds of issues can and do provoke historical thinking in the vein Collingwood describes and thereby produce historical knowledge. And yet, of course, the programs are also quite flawed. In many ways, they feel like soap operas, playing up interpersonal tensions for heightened dramatic impact. And although the participants do face a low level of danger, the very fact that there are camera crews present, the contemporary

world sits just around the corner, and they can exit the situation whenever they want means that the stakes can never come close to replicating the life-and-death struggles of the past. In some ways, the dynamics of these shows are quite different from those of the fictional television series discussed in chapter 2. *Deadwood* and *Mad Men*, precisely because they are scripted dramas performed by actors, are able to take an unflinching look at racism and racial prejudice. By contrast, the participants in the reality history shows could not bring themselves to embrace those ideologies. At first, this seems like a real limitation of the form because racial prejudice would have been fundamental to the way individuals of the past experienced their world in all three historical moments depicted. However, the participants' obvious failure to embody and perpetuate racial prejudice calls attention to itself; this departure from the historical record functions like alternate history, the new version inadvertently bringing into relief the old. Furthermore, the inclusion of contemporary Native Americans in *Colonial House* and *Texas Ranch House* works to destabilize and upset the artificiality of the frame, producing real discomfort for the participants. In both cases, this discomfort serves as a productive catalyst to thought. These shows aim to entertain, but they also reflect an attempt to reckon with the past—to take it on, take it seriously, and force both participants and viewers to contemplate the fact that the contradictory ideas we hold about these episodes in the American past cannot be reconciled as easily as we tend to think they can. Even a long-form drama such as *Mad Men* that oscillates between seducing viewers into its pleasures and excesses at one moment and forcing them into a position of critique at others cannot make competing or contradictory narratives seem mutually exclusive to the extent that the *House* programs do.

4
DIGITAL TRANSLATIONS
OF THE PAST
VIRTUAL HISTORY EXHIBITS

Curiosity brought me here. I entered skeptical, thinking this exhibit couldn't add much to what I had already learned about these horrible times. But after my visit, I had to log off and sit quietly. I came back to leave this message.

COMMENT FROM VISITOR TO THE *WITNESSING HISTORY: KRISTALLNACHT THE NOVEMBER 1938 POGROMS* EXHIBIT ON *SECOND LIFE*

Reproducibility—distraction—politicization.

WALTER BENJAMIN, "THEORY OF DISTRACTION"

AS I HAVE been suggesting in each chapter of this book, even within capitalist mass culture it is possible to locate instances of complicated and potentially progressive engagements with the past. I have attempted to justify treating film and television as experiential media in the sense that they engage their viewers both cognitively and affectively. In this final chapter, I consider a very specific form of engagement with the past on the Internet, which represents a qualitatively different dimension of the experiential: the virtual. Specifically, I examine a very small subset of history websites: those that offer up a three-dimensional virtual space through which the visitor moves and in which the visitor encounters artifacts, photographs, and testimonies from the past. There are countless history-oriented websites (academic, commercial,

amateur), some independent and others affiliated with universities or brick-and-mortar museums and sites, and the vast majority comprise text and image. Most commonly, embedded hyperlinks allow users to move to other pages or sites for further information. By contrast, the sites I consider here not only allow but compel the viewer to enter a three-dimensional space within which he or she will encounter objects, photographs, and voices that are meant to testify to past events. Indeed, there is a strong affective, embodied, experiential component to navigating such a site. And yet, as I show, these sites refuse their visitors a kind of seamless point of identification with individual historical figures or specific perspectives. Instead of fostering the illusion that the user is "actually there," these sites' artificiality and stylization call attention to their constructedness and thus have the effect of visually reminding users that the experience is virtual and not an actual experience of the past. This tension between *actually experiencing* the virtual space and understanding it as a mediation, as opposed to the real thing, instantiates a complicated mode of engagement.

The particular sites I consider are dedicated to past atrocity. For myriad reasons—from prurient interest to a legitimate desire to bear witness—atrocity compels attention. The representation of atrocity can similarly have both productive effects (ethically and politically) and negative effects (gratuitous displays of violence, identification with the victim, and so on). Atrocity has the potential to politicize, to make the past seem urgent and important, and perhaps to produce empathy, as Dominick LaCapra and E. Ann Kaplan have suggested, but historical knowledge cannot be produced, nor can any long-term politicization occur if the representation of atrocity only works to encourage a sympathetic identification with the victim or, even worse, a kind of voyeuristic pleasure in another's suffering. Nevertheless, there is both an intellectual imperative and a political imperative to *try* to understand the nature and effects of such events and situations in the past; knowledge of past atrocities is understood to have the potential to shape or inform present and future political action in part by fostering empathy: a connection with another that is predicated on distance and difference, not on sameness.[1]

In part, this chapter advances my earlier suggestion that there can be a political dimension to an affective engagement with the past. Some theorists of affect have begun to explore why politics rely on the body, suggesting that for people to take a political stand they need first to feel personally affected or moved.

Such theorists have pointed to the importance of affect as a motivator or catalyst to political action. Deborah Gould, for instance, has convincingly argued that a particular form of affect was crucial in mobilizing the gay community to organize and politicize itself: "I begin with the premise that feeling and emotion are fundamental to political life . . . in the sense that there is an affective dimension to the processes and practices that make up the political, broadly defined."[2] In *Prosthetic Memory*, I argue that even memories of events that one did not live through can be affectively charged and therefore have the potential to produce empathy and to alter an individual's political commitments.[3] These arguments hearken back to Walter Benjamin's claims about the historically conditioned nature of both perception and attention. He was interested in the ramifications of new technologies of reproduction for ways of seeing, which in turn opened up the possibility of politicizing the masses. Although Benjamin could never have anticipated the Internet, his account of the experience of urban modernity resonates in some unexpected ways with the experience of cyberspace. In his essay "On Some Motifs in Baudelaire," he describes the kind of haptic and optic experiences of shock that were endemic to the city: "Moving through this traffic involves the individual in a series of shocks and collisions. At dangerous intersections, nervous impulses flow through him in rapid succession, like the energy from a battery. Baudelaire speaks of a man who plunges into the crowd as into a reservoir of electric energy. . . . [T]echnology has subjected the human sensorium to a complex kind of training."[4] The mode of engagement solicited by the Internet, particularly in the era of Web 2.0, is a distracted mode, exemplified by multitasking as opposed to deep concentration or absorption. This chapter considers in detail some embodied encounters with history on the Internet and suggests that these encounters can provoke historical thinking and the production of historical knowledge that can foster political consciousness.

I look primarily at two exhibits: *The Secret Annex Online*, accessed on the Anne Frank House website, and *Witnessing History: Kristallnacht—the November 1938 Pogroms*, hosted on the virtual world *Second Life* and accessed at the United States Holocaust Memorial Museum website. In the case of *The Secret Annex Online*, the visitor's virtual experience is both material and immaterial—material in that the online exhibit bears an iconic relation to the real Anne Frank House in Amsterdam and its constructed space is experienced

by an embodied viewer, yet immaterial in its profound artificiality as a two-dimensional, graphic rendering of a three-dimensional space that one experiences in one's own home. The Kristallnacht exhibit on *Second Life* immerses visitors in the aftermath of the destruction of Jewish communities throughout Germany on November 9–10, 1938, but the visitor, rather than inhabiting the subject position of a victim, moves through the exhibit's virtual world as a reporter trying to understand what happened. Like *The Secret Annex Online*, the Kristallnacht installation calls attention to its mediated status and its artificiality, even as the visitor is invited to move through the ransacked buildings following the pogrom.

Most academic historians would agree that we can never *really* know what happened in the past. Some past events have left ample documentary trails, both official in the form of governmental and census records, published proceedings, and so forth as well as unofficial in the form of diaries, interviews, domestic records, and material artifacts. Other events, though, have left only residues, traces. Even when there are ample sources, however, what is left is nevertheless still partial, fragmentary.[5] In some fundamental way, no matter how many records or sources we have, the past as it "actually was" or, more specifically, as it was *lived* by people of the time is not really knowable. Furthermore, because history, as Alun Munslow has described, is "a storied form of knowledge,"[6] imaginative work is required to make the past meaningful, to turn it into history.

A way to theorize this imaginative work of history is as a process of translation. Inherent in the notion of translation is the notion of incommensurability, approximating rather than achieving verisimilitude. Theorizing the production of historical knowledge through encounters with these virtual sites as a process of translation is to foreground the inevitable partiality, incompleteness, imperfection of the transmission. The process of translation in the cases I here consider is not just a linguistic practice but also a material one with an important experiential dimension. Such a translation would convey the specific, material details of historical experience but also the sensory, affective aspects. In a fundamental sense, translation serves the purpose of making something available or accessible to many more people; it is about increasing access. Furthermore, translation is deemed important or necessary when one believes a particular text—or in this case event—has value beyond its immediate context, a point

Walter Benjamin makes in his essay "The Task of the Translator": "Translatability is an essential quality of certain works, which is not to say that it is essential that they be translated; it means rather that a specific significance inherent in the original manifest [*sic*] itself in its translatability." Benjamin makes several other observations about literary translation that are germane here: he suggests that "the original is closely connected with the translation" and that the connection is, in his words, a "natural" one, a "vital connection," something like an "echo."[7] This seems important because it suggests that something vital *can* move from the original to the translation—like a spark or a charge. And yet Benjamin is careful to qualify that translation is not and could never be a replica of the original: "in its afterlife—which could not be called that if it were not a transformation and a renewal of something living—the original undergoes a change." A great translation does not merely copy; literalness is not the goal. In fact, says Benjamin, "it is self-evident how greatly fidelity in reproducing the form impedes the rendering of the sense." Finally, he writes, the goal is to produce the meaning and intention of the original without necessarily being tied to the same language structures: "the language of a translation can—in fact, must—let itself go" not as a mere "reproduction but as harmony."[8]

I am in part asking what comes of considering the project of history as a translation of the past into the present.[9] However, if what is in part at issue is the transmission of something of how the past was lived—a spark—then it becomes essential to consider the embodied or experiential dimension of such a translation. Benjamin's words are revealing, for he suggests that in a good translation something vital is conveyed. In the ever-growing realm of popular history in experiential formats—from experiential museums and living-history sites such as Jamestown, Williamsburg, Plymouth Plantation, and Sturbridge Village to reenactments and reality history television shows—the transmission of some vital connection to the past is the goal. There is an implicit supposition here that with experiential, bodily engagement, another dimension is added to one's understanding of the past or even that the affective dimension does something that a textual account cannot, producing a distinct form of knowledge. Moreover, the past *was* at one time lived. So with respect to representations of the past or of past atrocity in popular formats, there is a rationale for attempting to convey or translate that dynamic sense of life. The past was lived in all its complexity by people, who moved through the world as embodied

subjects. Part of the aim of experiential sites is to re-create the past as dynamic, lived. The kind of translation made possible at experientially oriented museums might thus be understood as a *bodily* translation that has both cognitive and affective dimensions.

As the surveys conducted by Roy Rosenzweig and David Thelen demonstrate (see the introduction), most Americans seek to "experience history" directly, and they feel they can actually do that at certain museums and historical sites. For many respondents, these "direct" experiences were understood to be free from the kind of manipulation they associated with those representations of the past (in book or film) that distort the past to serve particular ends. When faced with authentic objects from the past, individuals felt "transport[ed] . . . straight back to the times when history was being made."[10] In the burgeoning field of affect studies, some work has been devoted to exploring the role of affect and experiential engagement in the acquisition of historical knowledge. In an essay about the Churchill Museum in London, for example, Sheila Watson has argued that the museum's "intensely immersive experience" produces memory through "affect and emotion." The museum uses, in Watson's words, "objects, sound, light, photography, film and interactives," but she pays particular attention to the way voice and sound more generally are used and concludes that "this method of interpretation, using sound and images, provides the visitor with something akin to a sense of the experience of 1940 that has been forgotten in the myth-making." Again, as in the case of the reality history TV *House* series, affective engagement works to demythologize the past. At the Churchill Museum, says Watson, the "confusion, uncertainty, a rush of events without meaning at the time, and an emotional impression of the leadership of one man who provided a kind of certainty in the midst of chaos" were in some way fundamental to the experience of 1940 and thus "evoke[] historical understanding, encouraging the visitors to make historical sense from their emotional engagement with the subject."[11] But of course the strong affective dimension is enabled in part by the authenticity of the site, for the museum is housed in the original Cabinet War Rooms that served as the wartime bunker in which Churchill and his government experienced the Blitz. Moreover, that affective engagement is not entirely unproblematic, as Vanessa Agnew has thoughtfully articulated.[12] How can someone in the safety of the present experience "something akin" to the dangers of life in London in 1940?[13] Furthermore, the illu-

sion is also dangerous insofar as it is premised, first, on the idea that there exists some objective truth of the past that can be accessed directly and, second, on the notion that one can have an experience of proximity with a past long gone. The power of the place, the aura associated with the actual site, can be an intoxication, creating a kind of overpresence. Visitors are thus seduced into feeling that they can actually *live* the past through these immersive means and that they can know the full historical truth while avoiding the "bias" of an author with his or her own agenda.

Part of the value of theorizing this transmission of knowledge about the past as an act of translation is that it is premised on the impossibility of verisimilitude and yet is motivated by the *necessity* of meaningful transmission. In other words, a translation admits in its very premise that it is *not* the original, that even if vital meaning gets conveyed through it, it does not simply replicate the original but produces something new. There is and should be a fundamental tension between the original and the translation, the past and the present. This is similar to the oscillation between the experience of proximity and the sense of distance that together are conducive to historical thinking and the production of historical consciousness. The tension between the original and the translation is thus another potential site for the production of empathy— feeling for someone else while maintaining one's sense of difference from him or her. The sense of difference is important because it prevents one from thinking that one can ever fully understand or put oneself in the place of the other, a condition LaCapra has called "empathic unsettlement."[14] And yet the attempt to understand, to try to see through the other person's eyes, can be very productive and can both produce historical knowledge and, in the case of atrocity, politicize the viewer, encouraging him or her to prevent such events in the future. The best translations keep these dialectical tensions in play.

Virtual sites can be particularly adept at undercutting the illusion fostered by actual historical sites. Without "the aura" generated by an authentic location and the pervasive sense of the presence of the past that comes along with it, virtual sites do not foster the illusion of literally entering the past. Overcloseness to the past cannot be an issue because the original is not there in any literal sense. In a virtual site, the mediation between viewer and the past is unmistakable, due in part to the graphic and somewhat surreal renderings of space, so the illusion of an unmediated relationship is not really possible. And yet the

complex interface and mode of address create the conditions for an engaged and affective experience to take place, which is crucial for the acquisition of the kind of historical knowledge I am describing. As I hope to show, there can still be a strong affective and experiential encounter, a materiality to one's experience, even in a virtual environment. An early advocate for museums on the Internet, Lynne Teather has argued that "more than the object fetishism, more than information and data transfer, and certainly more than public relations and sales opportunities, the museum experience is about meaning and knowledge building that is based in the visitor, or in people's experience of the museum." Rather than be defined as a warehouse of objects, the museum in its contemporary form needs to be theorized as first and foremost an experience: "it is in the personal experience of museums that the essence of the museum lies," states Teather.[15] She quotes Douglas Worts and Kris Morrissey, who contend that virtual museums ought to be understood to "facilitate[] experience—not deliver[] it."[16] Ross Parry and John Hopwood have described a shift in the nature of museum space from "hard" to "soft"—"from a museum space that is prescribed, authored, physical, closed, linear and sitant, to a space that instead tends to be something more dynamic, discursive, imagined, open radial and immersive." In their discussion of virtual reality technology in actual museum space and on a museum's website, they suggest that it quite literally "reconfigure[s] what and where museum space is."[17]

However, Hilde Hein cautions that "real" objects and their attendant authenticity are the one thing that museums have always had: "In relying on 'simulation and simulacra,' however moving, museums are displacing the very thing that previously distinguished them, namely their presentation of 'the real thing.'" She acknowledges that visitors and viewers have real experiences—in her words, "you really do touch[,] smell[,] blink at, or hear something that the museum has put in front of you. Maybe it makes you weep or feel dizzy. You have an experience, a real one." But she worries about how that experience gets connected to a meaning or, more precisely, an educational meaning, which is the purported objective of most museums and certainly of all history or atrocity-related museums. It is imperative, she believes, that what is presented is "genuine" and that "the stimulus must not be fraudulently contrived."[18] Although her concern is indeed warranted, I am not sure that having "real objects" necessarily prevents an exhibit from being contrived. As Spencer Crew

and James Sims have famously argued about museum objects, "The problem with things is that they are dumb."[19] Objects don't speak; curators speak. One need only consider the numerous controversies over museum exhibits on the mall in Washington, D.C. The *Enola Gay* is undoubtedly a "real" or authentic object, but that alone does nothing to guarantee how it is narrativized or brought into meaning by an exhibit. Moreover, the multilayered, multisensuous mode of address of a virtual space—the solicited tactile engagement (which I explain more fully later), the use of sound and voice-over, the appearance of photographic images—can be used to encourage the connection of the experience to specific historical meanings.

It is instructive to distinguish between the different kinds of history exhibits online. There are the bare-bone ones that I mentioned at the outset: sites devoted to some element of the past but composed primarily of text and image. Unlike a book, however, such sites often have embedded hyperlinks that allow the reader/viewer to pursue the specific aspect of the topic in which he or she is interested and thus to move in a less linear fashion through the material. More and more, however, one encounters sites that take the form of three-dimensional environments, both re-created museums or museum rooms and reconstructions of real-world sites.[20] Some websites allow the visitor a three-dimensional, 360-degree, panoramic view of a room. The website for Orchard House, the home of Louisa May Alcott, for example, provides links to several rooms in the house. By clicking on a link, the viewer enters the room and has the opportunity to explore the space. Although no additional information about objects in a room is provided, a sense of the space is evoked (see figure 4.1).[21] At this site, each room is accessed individually from the main page; one cannot move directly from room to room; the restrictions on one's mobility work against a sense that one is actually there.

Although a range of exhibits and museums might fall under the category of "virtual museum," there is no single accepted definition of such a museum. That said, some cite Geoffrey Lewis's 1996 article in *Britannica Online*, in which he defines the virtual museum as "a collection of digitally recorded images, sound files, text documents, and other data of historical, scientific, or cultural interest that are accessed through electronic media. A virtual museum does not house actual objects and therefore lacks the permanence and unique qualities of a museum in the institutional definition of the term."[22] Werner Schweibenz

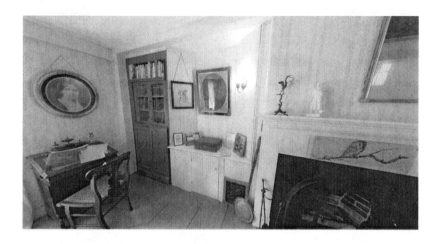

FIGURE 4.1 Orchard House virtual tour, Louisa May Alcott's room.

has defined the virtual museum as "a logically related collection of digital objects composed in a variety of media, and, because of its capacity to provide connectedness and various points of access, it lends itself to transcending traditional methods of communicating and interacting with the visitors[,] being flexible toward their needs and interests; it has no real place or space, its objects and the related information can be disseminated all over the world."[23]

Some brick-and-mortar museums have websites that offer what they call "virtual tours" that enable visitors to click through a series of static images or photographs of objects from their collection. Others enable visitors to wander through the virtual museum space at their own leisure, following their own interests. The "Panoramic Virtual Tour" at the Smithsonian Natural History Museum website works this way: one clicks on arrows on the floor to follow different paths through the museum.[24] Although a smaller space, the Vatican's virtual Sistine Chapel is also a three-dimensional environment.[25] When one clicks on the link to enter, one finds oneself standing in the back of the chapel, gazing at *The Last Judgment* on the far wall. Religious choral music begins to play. One can move freely about the chapel with the mouse or trackpad, zooming in on any area of interest. Unlike in an actual visit to the Sistine Chapel, one can zoom in on the ceiling frescoes for a closer look. Parts of other museums are available in this virtual format, although, as I have been suggesting, there is great deal of variation in what is designated as a "virtual tour."[26] In their re-

view essay on the state of the field, Sylaiou Styliani and colleagues conclude that "virtual museums cannot and do not intend to replace the walled museums. They can be characterised as 'digital reflections' of physical museums that do not exist *per se*, but act complementarily to become an extension of physical museums' exhibition halls and the ubiquitous vehicle of the ideas, concepts and 'messages' of the real museum."[27] And yet it seems to me that part of the power of the virtual is its ability to reconstruct spaces that literally do not exist anymore or do not exist as they once did and to translate those temporally lost experiences into the present.

THE SECRET ANNEX ONLINE

The Secret Annex Online exhibit enables a more concrete examination of all of these issues: the experiential aspect of virtual sites, the possibility of an embodied translation of the past, the oscillation between a sense of affective engagement with the past and alienation from it, and the problems of overpresence. A virtual exhibit housed on the Anne Frank House website offers individuals located anywhere in the world the ability to enter into a three-dimensional graphic re-creation of the building on the Prinsengracht canal in Amsterdam in which Anne's family, Fritz Pfeffer, dentist and friend, and the Van Pels family hid from 1942 to 1944.[28] I argue that this virtual site creates the occasion for the kind of bodily translation of the past that I have begun to theorize here. Furthermore, I try to convey how credibility and materiality are here created virtually. This site is, to use Hein's word, "contrived." And yet in part because it bears an iconic relationship to what we know to be the real building in Amsterdam and in part because the way we experience this site relies very heavily on Anne's own words taken from the diary she wrote while in hiding, it has a kind of authority. Our knowledge of the existence of the real Anne Frank house enables the virtual experience to have meaning and to feel real.

In addition to information about the museum, a visit to the Anne Frank House website also reveals several educational links designed to provide information about Anne and her experiences. One of these links, *The Secret Annex Online*,[29] takes you to the exhibit I focus on here. Clicking on *The Secret Annex Online* brings you to the home page, where a voice-over, a woman

speaking in British-accented English, explains why the Frank family had to go into hiding; this voice-over, accompanied by photographs, reconstructions of the rooms, photographic images of the family, and photos of Anne's hand-written diary provide a brief though thorough overview of the experience. You can either let this sequence play through or click on several other visible windows, one of which says, "Go straight inside," and takes you to the move-able bookcase behind which lies the secret annex. Other options include "The Outcome," "About the House," and "Who's Who." These last few windows, like the one that opens and immediately starts playing, are not interactive, but kinesthetic—especially "About the House," in which instead of selecting where you will go, you are moved from room to room. For those visitors interested in a more textual description, there are several links at the very bottom of the page that offer written narrative accounts of aspects of Anne Frank's history.

Our ability to engage with and experience the canal house is a powerful way of producing specific and embodied knowledge about the past because the ar-chitectural space itself dictated the contours of Anne's existence. In his essay "Networked Media: The Experience Is Closer Than You Think," Stephen Bory-sewicz calls attention to the importance of movement through architectural space as part of the museum experience; it is a "kinetic experience affecting most of our senses." He thus urges that the Web be "a resource that more closely resembles a museum *visit* than a museum *collection*,"[30] which is the case with the virtual Smithsonian Natural History Museum. Walter Benjamin uses the ex-ample of an individual's engagement with architecture to articulate his theory of distracted attention or engagement. He suggests that buildings and architec-ture conceived more broadly are received "tactilely and optically" as an embod-ied experience. In fact, this is the experience of urban modernity par excellence, as embodied by Baudelaire's *flaneur*, who moves through the city. Benjamin writes, "The tasks which face the human apparatus of perception at historical turning points cannot be performed solely by optical means—that is, by way of contemplation. They are mastered gradually—taking their cue from tactile reception—through habit."[31] What he describes is an active, tactile, embodied form of mastery, a form of engagement enabled by *The Secret Annex Online*, which re-creates the quirky architectural spaces of the canal house in which the Frank and van Pels families hid along with Fritz Pfeffer. For Anne and her family, the nature of the space and how it was lived—as well as the power of

that space to shape experience—was a crucial component of her story and thus crucial to understanding in a palpable way something of her historical experience of confinement. The visitor to the site is invited to interact with and move through the space in an active way that produces a kind of knowledge about the conditions of existence for Anne and her family.

But aspects of the design also have the effect of alienating the virtual visitor. First of all, there can be frustrations associated with the interface; using the computer trackpad or mouse to navigate the rooms is challenging at first, and you may often overshoot the object you are attempting to approach. Also, not all objects in the rooms are accessible; they all do not yield up information. These frustrations have the effect of reminding you, the virtual visitor, that you are not really there, that you are engaging with a representation.

The three-dimensional environment and use of graphics in *The Secret Annex Online* very effectively create the illusion of space and thus can enhance our sense of engagement with the place, but, importantly, not replicating Anne's experience of the place where she hid. Although I am most interested in this site's interactive parts, I want to call attention to the menu item "About the House," which is not interactive, because it mobilizes some of the pedagogical strategies that I would like to highlight. If you click on "About the House," a page opens with a photo of Anne. Clicking on her photo initiates a tour of the annex, which is introduced by a voice-over: the female narrator speaks in accented English. Then you hear a girl's voice, also in accented English, reading from Anne's diary a description of the rooms. With Anne speaking to you, you remain yourself. As you are moved through the rooms, you first see a graphic three-dimensional representation of the empty space, which is followed by a gradual fading in of furnishings, until the image appears as a photograph, though one that looks aged. There is an intentional blurring here of computer graphics and photographs. In fact, the "photographs" of the house that appear here are actually reconstructions created by museum curators. As the website itself explains, the Anne Frank Museum in Amsterdam displays the rooms of the annex empty, with no furnishings or objects; they had been removed after the inhabitants were arrested, and Otto Frank wished it to remain in that state. The furnishings and objects you see in the online version "were created based on photographs made in 1999, when the front part of the house and the secret annex were temporarily furnished as part of the creation of educational

materials showing how they were used."[32] The represented architectural space creates a sense of presence—a sense of movement and of being in space—but is also artificial and contrived, foregrounding its status as a reconstruction. The oscillation between empty rooms graphically drawn and photos of the furnished spaces reminds visitors both that they are not actually there and that the house no longer exists as it actually was.

When you end this tour given by Anne, you have the opportunity to explore the house on your own. The particular mode of engagement elicited here complicates the standard notion of interactivity that dominates the way we think about engagement on the Web and with websites. What I am claiming is that the experience of the Anne Frank website is more like an *encounter* than it is a simple matter of pointing and clicking on objects, though there is that, too. You do things intentionally, but things happen to you as well. You can click on a window that allows you to explore any room in the entire warehouse, but there is also a window that allows you to begin at the famous moveable bookcase, behind which lies the secret annex. Even this experience, though, is not one of complete choice and agency. Upon clicking on a door, you are swept right up to it, at which point it opens, and you are carried into the room (see figure 4.2). Your vision pans from one side to the other; the experience, in other words— and I mean this both literally and figuratively—is a combination of both moving and being moved. The site offers you a nuanced position between agency and submission. You may choose where you would like to go. You can pause on an item or architectural detail. You can click on certain designated objects to learn more about them and what they tell us about the contours of existence in the annex. But each time you click on a door or object, you are moved by it, forced to confront objects and encounter the space as your embodied self and then process intellectually what is there. In an eerie way, you are both there and not there. If you have the exhibit site open on your computer but are not actively engaging with it, muted sounds still emerge from the house.

Sandra Dudley has emphasized the way objects in a museum engage viewers sensuously in order to make the claim that "the material properties of the thing itself are essential to how our bodily senses detect it and thus to how we experience and formulate ideas about it."[33] I would of course agree that objects are provocative, in the sense of provoking, especially those objects that come out of the past, promising to bring with them some piece of that prior experience and

Hallway secret annex

▶ ◄» Hallway to secret annex 00:18
 Little hallway directly behind the door
 with the bookcase
 ⌄

FIGURE 4.2 Door to the Frank family's hiding place on *The Secret Annex Online*.

thereby facilitate our comprehension of the past. And yet in brick-and-mortar museums the tactility of displayed objects is registered not through the physical sensation of touch—we are not allowed to touch the objects—but through vision, by looking at them. In other words, the objects we encounter virtually on a website function much like the objects in a museum—they testify to a kind of materiality; they invite a kind of tactile engagement because they *might* be touched and have a physicality, although, as in a physical museum, they cannot literally be touched. I am calling attention not only to the fact that in a virtual environment clicking on the mouse is a way to touch objects by proxy, but also to the way in which aural and visual solicitations stimulate a sense of touch. Furthermore, "the cultural artifacts that are exhibited in the physical environment of a museum are usually shown in display cases, where only a limited amount of information about them is available. In virtual museum exhibitions, museum artifacts can be digitized and visualized in a virtual interactive environment. A virtual exhibit can contain information that a physical exhibit

in a museum showcase cannot."[34] As Dudley asserts, however, the objects also *authorize* the experience. Authentic objects are meant to serve as a guarantee of connection to the past, to history, anchoring or securing the narrative. Similarly, even though we are not face to face with three-dimensional objects while at *The Secret Annex* website, the authenticity of what we are seeing is conveyed through our knowledge of the real house and the objects that the Frank family lived with and among. The online exhibit is authorized by the museum. Just as in a literary translation, what matters most is a fidelity to the original meaning.

Indeed, I am suggesting that there is a materiality, a corporeality, to the experience of *The Secret Annex Online* despite its virtuality. Film theorists have recently argued for the materiality of the cinematic experience, as I described in detail in chapter 1; such claims pertain here as well because this virtual annex experience is strangely a physical visual experience: we are not literally there, but through our vision as well as through various aural cues we are coaxed into the space. We translate what we are seeing on the computer screen into an embodied experience. Vivian Sobchack has written extensively about the ontology of embodied vision, explaining that "we sit in a movie theater, before a television set, or in front of a computer terminal not only as *conscious* beings but also as *carnal* beings. Our vision is not abstracted from our bodies or from our other modes of perceptual access to the world. Nor does what we see merely touch the surface of our eyes."[35] However, she makes a distinction between the kind of "presence" offered by cinematic or photographic representations and those offered by digital ones, privileging the former. The digital, she assumes, is predicated on a system of simulation, copies that lack an original. And yet the case of the Anne Frank *Secret Annex Online* is quite the opposite because there *is* an original. What is lacking is an experience of the original in the past. The electronic representation is a way of experiencing a virtual proximity to an original. Sobchack disputes that electronic space can be inhabited, but that is precisely what happens at *The Secret Annex Online*. Some small bit of Anne's experience—which was very much an experience of a historically specific space, the confined space of their secret hiding place—is translated as we move through the virtual house, listening, approaching, and even touching (with a mouse) the virtual objects on display. We *interact* with the space. While our body is affectively engaged watching a movie, we have limited agency; here we are affectively engaged but also able to move and interact with the object on the

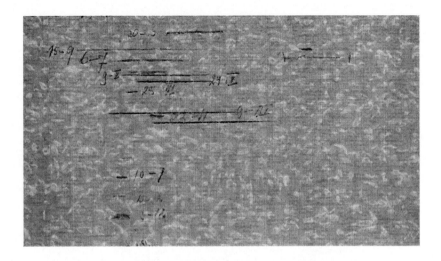

FIGURE 4.3 The Frank children's height chart shown on *The Secret Annex Online*.

screen before us. The experience is ontologically different from sitting before a movie or TV screen, no matter how engaged we are with the representation.

A particularly powerful "object" in *The Secret Annex* is Otto Frank's height chart on the wall of the "Room Frank Family" (see figure 4.3). Either by clicking on a link called "Anne and Margot grow fast" upon entering the room or by moving around the room and finding the handwriting on the wall and then clicking on it, you are pulled into the spot where their parents kept track of the children's heights. This "object" is powerful both because of its familiarity—many of us have marked our own growth this way or have marked the growth of our children—but also because their height chart is so different—the Frank girls *stopped* growing when their hiding place was invaded and they were taken away to Bergen-Belsen. We see the marks Otto's pen made and his handwriting on the wallpaper, and there is a physicality, a materiality, a singularity to it.

The poignancy of this encounter is disruptive in a constructive way. Saul Friedländer describes the way individual voices pierce through the complacency of written historical accounts, suggesting that "such a disruptive function . . . is essential to the historical representation of mass extermination and other sequences of mass suffering that 'business as usual historiography' necessarily domesticates and 'flattens.'"[36] In her book *The Skin of the Film*, Laura Marks underscores the materiality of film and, in particular, the way in which

the objects depicted in film can stimulate viewers' senses and thus produce embodied knowledges. Because of this stimulation, she suggests, intercultural cinema becomes a site at which a kind of "sensory translation of cultural knowledge" occurs.[37] Her model is potentially very useful in that it implies that a kind of embodied transmission can take place across geographic, temporal, and cultural divides, which is what I am proposing happens at *The Secret Annex Online*. However, her emphasis is on the transmission of cultural continuities rather than on gaps. Furthermore, she believes that the experience is primarily mimetic, "an experience of bodily similarity to the audiovisual images we take in."[38] I would suggest otherwise: that our experience is characterized by a fundamental alternation between mimesis, sameness, and connection, on the one hand, and difference, absence, and distance, on the other. What is being transferred here is a play of presence and absence—both Anne's and our own. In fact, it is the very absence—of Anne, of the real annex in Amsterdam when we are seated at our own computers, of the past as it was actually lived—that makes translation necessary.

This website relies very heavily on photographs, both those of Anne and the other occupants of the annex as well as those of the interior of the house and the families' possessions. Indeed, the photographs and their indexical link to the Franks, their lives, the rooms they made their home and the events that transpired there help both to authenticate and to mediate the virtual experience. The fact that the photos that appear on the website are often coupled with spoken voice-over enhances their affective quality; the voice-overs, all female in British-accented English work to transport the visitor across space and time. The voice that reads passages from Anne's diary is the voice of a young girl, powerfully breathing life into the photos on view, but also speaking directly to us, the listeners/visitors.[39] Of course, the voice is not actually Anne's voice, but the words are hers. And the experience of *hearing* them has a great emotional impact, particularly while we are looking at the photographs.[40] Elizabeth Edwards suggests in her essay "Photographs and History: Emotion and Materiality" that photographs do not suffer in the digital arena because they have always been reproducible. In fact, digital formats can often breathe new life into photos, and that is clearly the case at *The Secret Annex Online*. She writes, "While these new technologies may bring about changes to the immediate material reality through which photographs are experienced and deter-

mine forms of attention and precise modes of perception . . . , using such facilities involves the viewer's own sensory and embodied practices: . . . the finger on the keyboard, the sweeping movements of the mouse . . . almost stroking the photograph into life."[41] The visitor's body becomes the site of the translation.

On *The Secret Annex* site, photographs serve multiple functions, but it is important to reiterate that they seldom stand alone, unaccompanied by voice-over. They are stroked into intelligibility by the stories we hear in the form of voice-overs; they rekindle a life long gone. Hearing Anne's words spoken while virtually exploring that space connects us to it in powerful ways, but not in the form of simple identification. These images also serve an evidentiary function, calling attention to certain key elements of the annex—the window by which Anne and Peter van Pels stood during their heartfelt conversations, the height chart, the magazine cutouts on her wall. There is a materiality to these details. The virtual three-dimensional space is overlaid with these affective details, specifics that set her history apart, making it precise and not generic: they are very specifically her details. And the photographs in this digital arena help to do this work.

WITNESSING HISTORY: KRISTALLNACHT THE NOVEMBER 1938 POGROMS

Unlike *The Secret Annex Online*, which is a graphic representation of an actual and singular space, the *Witnessing History: Kristallnacht—the November 1938 Pogroms* online virtual exhibit is an imaginative reconstruction of a German town at a specific historical moment. I have to admit to trepidation in writing about an installation hosted on *Second Life*, a self-proclaimed "3D world where everyone you see is a real person and every place you visit is built by people just like you."[42] Although there is much to say about this "virtual world," I address only the aspects relevant to this project. *Second Life* is a for-profit, interactive platform where users produce content and then buy and sell commodities of all kinds. Because the content is user produced, there is no rhyme or reason, no underlying logic, behind the existence of particular places and the absence of others. Some sites are meant to be simulacra of real-world places and others pure fantasy. Most seem to be set in the present, but there

are some historical sites as well. Some seem heavily researched, and others not as much (or at all). I entered *Second Life* for the first time when following a link to the exhibit *Witnessing History: Kristallnacht—the November 1938 Pogroms* posted on the page "Online Exhibitions" at the United States Holocaust Memorial Museum (USHMM) website.[43]

Because *Second Life* is neither a coherent nor a comprehensive world, because its sites can vary dramatically from one another, and because they are produced for different purposes by different users, you do not need to visit numerous sites to be able to make claims about a specific location. That said, a few general points need to be made about the platform. First of all, though anyone can join *Second Life*—and there is no fee to join—you do have to register to enter this world. As part of joining, you must select an avatar that will move through the three-dimensional space as your proxy, the experience of which has epistemological ramifications that I take up later. Second, the sites are graphically rendered and composed with tools that all who create them must use, so there is some standardization to the look and feel of sites. The look of the animation, not dissimilar to that of a graphic novel, is stylized and somewhat surreal and artificial, quite unlike a photograph. And finally, you must use your avatar to move through the space, either by pointing a mouse to where you want the avatar to go or by clicking on a control pad with arrows indicating which way you want the avatar to move and whether to walk, run, or jump. Moving the avatar is somewhat clumsy and does not feel at all like natural movement.

The *Witnessing History: Kristallnacht—the November 1938 Pogroms* installation was created to commemorate the seventieth anniversary of Kristallancht.[44] The occasion presented an opportunity "to explore the applicability of this emerging technology for staging virtual exhibitions and finding new ways to incorporate visitor voices into the exhibition development process."[45] In the summer of 2008, USHMM partnered with Global Kids, a youth civic leadership nonprofit in New York City, "to help [it] train teenage interns at the museum to design a space on the *Second Life* teen grid that would allow their peers to learn about Kristallnacht."[46] Upon this project's completion, USHMM realized its potential and decided to move forward with it by contracting a design company to work with the museum in creating the online Kristallnacht exhibit: "As the ability of virtual worlds to enable kinetic experiences became more obvious as a result of this work, the Holocaust museum decided to build a more

elaborate and nuanced installation on the main *Second Life* grid based on the design document originally created by the teenage interns at the museum."[47] The images and objects depicted come from the museum or museum research, and the audio testimonies were solicited for this purpose. Project manager David Klevan conducted interviews with nine survivors and used five- to eight-minute segments of those interviews for the installation.[48] The installation is authorized and legitimized by its connection with USHMM.

USHMM's permanent physical exhibition was originally designed to be a visceral experience for the visitor, engaging him or her not just intellectually but emotionally as well.[49] Because this approach was considered a crucial strategy for learning about the Holocaust, it follows that the *Second Life* installation would also be committed to a similar mode of address. As Karl Kapp and Tony O'Driscoll explain in their case study on the exhibit, "People learn in museums by moving through an installation in a way that allows them to absorb the content in a kinetic and synthetic way." Accordingly, "the Holocaust Museum wanted to explore the possibility of building virtual installations to learn more about the ways in which visitor experiences mimicked or differed (both for better and for worse) from those in real-world exhibitions."[50] As Styliani and colleagues have argued, "In a virtual museum environment, the visitor is not an observer but s/he interacts with the learning objects and s/he constructs her/himself the knowledge."[51]

Linking to this particular location in *Second Life* first transports your avatar to a space outside of the USHMM; although the image of the outside of the building resembles or is evocative of the actual brick and mortar museum in Washington, D.C., it is not identical to it; unlike the actual museum, the virtual museum is surrounded by water. Likewise, the German town recreated in the exhibit is meant to be evocative of the historical moment but is very clearly an imaginative reconstruction; it does not correspond to an actual German town. As you maneuver your avatar toward the museum, a text box appears, proclaiming, "Welcome to Witnessing History. You are entering an environment focused on a single event—Kristallnacht (The Night of Broken Glass). Here, you will take the role of a journalist, recalling the testimony of eyewitnesses as you investigate what happened during the November 1938 pogroms." What is epistemologically important from that start is the conceit: you enter not as a Jew living through the event, but as a reporter. In fact, there are several

FIGURE 4.4 The newsroom entrance to the *Witnessing History:
Kristallnacht* virtual exhibit.

layers of mediation between you and the events of Kristallnacht: you are enter-
ing *Second Life* not exactly as yourself, but as your avatar, and with that avatar
you enter the museum in the role of reporter. As you enter the lobby of the
building—which, like the exterior, is reminiscent of the actual museum, a space
built in brick and stone, but not an exact replica of the museum—another text
box opens up with instructions: "Enter the newsroom in front of you to begin
the experience. Review the bulletin boards, and when you are ready to con-
tinue, click the yellow dossier folder." In the newsroom, one sees rows of tables
with books and lamps and a bulletin board with photos and memos, which are
meant to offer some background or context to the event. On a desk in the far
corner, a yellow folder glows (see figure 4.4). Moving in the room opens an-
other text box, which adds, "Welcome. Review the background information on
the boards. When you're ready to continue, touch the yellow dossier, and learn
more about Kristallnacht through the recollections of eyewitnesses." A layer of
mediation between visitor and event is erected by this frame. It is predicated on
a temporal distance from this past event. You are not invited to live through or
experience Kristallnacht, nor are you positioned to be a Jewish victim. Rather,
you are directed to move through the destroyed environment, listen to aural
testimony, and report on it after the fact.

Clicking on the yellow folder initiates the movement to 1938 Germany: the back wall of the newsroom disappears, and in its place appears an outdoor street scene. A text box explains, "As you leaf through the accounts of the eyewitnesses [contained in the folder], your mind takes you back to that night . . . And you begin to reconstruct the events of Kristallnacht through their stories." And yet even though you enter as a reporter, you do in fact *enter* the space. You literally step from the floor of the newsroom onto the cobblestone streets of an unnamed town, which functions as a composite of many towns in the German Reich in early November 1938. The evening light is haunting. A text box tells you that "this environment was inspired by the stories of Kristallnacht survivors" and invites you to "explore and touch everything." Once you are on the street, there is no longer easy access to the newsroom. It is dark, and there are no precise instructions for where to turn. You sense that the unexpected might happen at any moment. The street is littered with books and papers. Some walls have graffiti in German; clicking on the writing renders a translation. In one place, the words read, "Ist in Dachau." A box translates, "Is in Dachau," and explains, "In the aftermath of Kristallnacht, more than 10,000 Jewish men were interned in Dachau, the first concentration camp founded by the Nazi government."

As you move your avatar through the street, you are unsure of where to go or what you will see. Any open door may be entered, and lit signs and windows yield information. Entering the police station, prominently located near the center of this square, yields up moving real (rather than re-created) testimonies that are initiated by your avatar's presence in the room. You hear accented voices explaining what the speakers' experienced that night. One testimony bleeds into another. One woman recounts, "So my mother told me that my father was arrested and the circumstances under which he was arrested. He tried to hide in the attic, and the policeman came and said, 'Look, I have to bring in a body. If he doesn't come, I have to take you into custody.' So my father gave himself up, and he was sent to Buchenwald. He was in Buchenwald for four weeks and was dismissed because he was a World War I veteran fighting for the German army, the German army. And the dismissal was under the condition that he would leave the country right away."[52] Other testimonies recount the men being taken away from the synagogue to concentration camps. A different

voice describes two SS men holding the rabbi by either arm and a third cutting off his beard.[53] What I want to emphasize here is that you are having a real experience in the virtual arena, but it is not an experience of Kristallnacht. It is an experience of hearing survivors talk about *their* experiences. A textbox entitled "The SS and the German Police" explains,

> As the pogrom spread, units of the SS and Gestapo (Secret State Police), following [Reinhard] Heydrich's instructions, arrested up to 30,000 Jewish males, and transferred most of them from local prisons to Dachau, Buchenwald, Sachsenhausen, and other concentration camps. Significantly, Kristallnacht marks the first instance in which the Nazi regime incarcerated Jews on a massive scale simply on the basis of their ethnicity. Hundreds died in the camps as a result of the brutal treatment they endured; most obtained release over the next three months on the condition that they begin the process of emigration from Germany. Indeed, the effects of Kristallnacht would serve as a spur to the emigration of Jews from Germany in the months to come.

When you exit the room, the testimonies cease. The experience of the room is in some ways evocative of the experience of reading the graphic novel *Maus* by Art Spiegelman in that the voices sound authentic and real, and they conjure up a living, breathing person, but the visuals are rendered graphically, more surreal than real. In other words, there is friction between the stylized graphics and the realness and authenticity of the survivors' accented voices. Much of the affective charge comes from the haunting quality of the testimonies.

Moving your avatar around a certain street corner, you come upon an illuminated store window—Strauss Markt. As you approach the window, testimonies begin to play: "Display windows had been broken . . . ink had been poured—there was yelling and screaming on the streets." Suddenly the sound of glass breaking pierces the silence; the window shatters before your eyes. This is a shocking, jarring moment, a moment of the unexpected (see figure 4.5). You encounter, albeit in a mediated form, the shock and violence of the event, but, again, not exactly as a victim; you are still on the outside looking in. As with *The Secret Annex Online*, here you both do things and are compelled to process the things that happen to you. A text box explains, "During Kristallnacht,

FIGURE 4.5 Broken window in a Jewish neighborhood on Kristallnacht.
From the *Witnessing History: Kristallnacht* virtual exhibit.

Nazi storm troopers smashed Jewish store windows, destroyed goods and carried out massive looting. The Nazis forced Jews to pay the costs of the violence perpetrated against them and banned Jews from gainful economic activity." The combination of the actual voices and the artificial, highly stylized graphics creates a kind of dissonance—it suggests that the real experience is out of reach, but that a trace, perhaps even the spark that Benjamin described, remains.

Other sites you might visit are the embassy (where you learn of the experience of people trying to escape), a school that has been ransacked and from which Jewish children are later forbidden, a synagogue that is being burned, and a hiding place for Jews. To learn both about the hiding places and about the experience of Jews trying to hide, you enter the cramped lobby of a building with an old-fashioned elevator—touching the elevator initiates testimonies that describe the experience of hiding. You can enter the elevator and travel up to a hiding place itself. Inside the hiding place, you hear the testimony of a woman recalling how on that fateful evening her family went home and silently got into bed. In the middle of the night, the Nazis came pounding on the front door. She recalls the fear it instilled in her as a child, a fear, she says, "you can never forget." She remembers that a neighbor eventually opened the door and asked the men what they were doing. They said they were looking for Jews,

and she told them they were not home. They never knew if the neighbor did this to protect them or not.[54] A text box later explains,

> SA and Hitler Youth units throughout Germany and its annexed territories engaged in the destruction of Jewish-owned homes and businesses; members of many units wore civilian clothes to support the fiction that the disturbances were expressions of 'outraged public reaction.' The pogrom proved especially destructive in Berlin and Vienna, home to the two largest Jewish communities in the German Reich. Mobs of SA men roamed the streets, attacking Jews in their houses and forcing Jews they encountered to perform acts of public humiliation. Although murder did not figure in the central directives, Kristallnacht claimed the lives of at least 91 Jews between 9 and 10 November. Police records of the period document a high number of rapes and of suicides in the aftermath of the violence.

The conditions in the ransacked school explicitly testifies to what the experience was like for children. Voices explain that Jewish children were expelled from school, and the desks were heaped in the yard. The destruction happened on the night and early morning of November 8 and 9; one survivor recalls that Jewish children were told, "there's no school for you today, go home." Like all of these virtual sets, the school room is recognizable as a school room but is not literally modeled on an existing schoolroom; rather, it is an imaginative reconstruction. What happens when your avatar enters the room is that a translation occurs. There is an attempt at meaningful transmission, but it is not literal. You see rooms destroyed, but the rooms are graphically rendered, not photographic (see figure 4.6). There is an imaginative translation at work.

Like the USHMM visit itself, this online exhibit ends with a set of video testimonies from survivors; visitors are then prompted to record their responses on a public comment board. As Kapp and O'Driscoll suggest, "A cursory reading of the public comment board is more than sufficient to convince anyone that the Holocaust Museum succeeded in delivering a kinetic, intellectual, and visceral learning experience for participants." Importantly, the fact that these artifacts and testimonies are accessed *in* a virtual historical setting, as opposed to simply on a webpage, enabled them "to be woven into an immersive experience that allowed participants to viscerally feel the connection between history,

FIGURE 4.6 A ransacked room in the *Witnessing History: Kristallnacht* exhibit.

personal action, and place."[55] Clearly, visitors to the *Second Life* exhibit were moved; there is a strong affective dimension. One visitor wrote, "I was at the DC Holocaust Museum last year, and hate to say—the noise and crowds somewhat diminished the powerful effect of this for me. but this, at my own pace, in my own space—wow. perhaps the most emotionally powerful place I've seen on *Second Life*. THANK YOU for your awesome work."[56] By way of conclusion, Kapp and O'Driscoll state, "it is hoped that visitors gain a better understanding of what it was like for those who experienced the tragic events of Kristallnacht in reality."[57] But I think they overlook a key aspect of the exhibit's design: the experience of the exhibit is an experience of the past's *mediation*. We approach it as outsiders, which we always have to do when we approach the past. This is not to say that the experience is not affecting—it most certainly can be. But the exhibit does not try to re-create the experience of living through that dreadful night. This is important for ethical reasons—it does not allow visitors to wallow in the victims' pain—but also for the purpose of producing historical knowledge and fostering historical thinking: there is a re-creation of sorts here, but the visitor is made self-conscious of that project from beginning to end.

The experience of this website is multisensorial in the ways I have described as well as clearly visceral and affecting for visitors in the way the staff at the Holocaust Museum intended it to be. But it should not be considered immersive, at least in the straightforward sense. The strategies that work to make the

experience affecting, that attempt to create a sense of proximity to this episode in the past, can never quite overcome the profound distance between visitor and the actual event, and that, I think, is a good thing. The original is not present. What we experience is a translation. There is an important tension between our affective, experiential engagement with the site, which makes it feel real, and our awareness of it as a mediation, a representation. Considering it a translation foregrounds the distance between visitor and the history represented, but also the possibility that a spark, something vital, some meaningful transmission, has occurred.

So what kind of constructive and perhaps even politicohistorical work can be accomplished by a virtual museum or installation such as the ones I have described? I conclude by way of an ongoing research project at the University of Manitoba, Embodying Empathy,[58] which aims to assess "the ability of new digital technologies to represent experiences of suffering in contemporary museums."[59] The members of the research team—composed of scholars working in the fields of philosophy of history and representations of atrocity, English, psychology, sociology, and cognitive science—share an interest in the possibilities opened up by digital technologies "to assist in forging empathetic and ethically engaged communities from those who witness, interact, and attempt to come to terms with representations of suffering in museum contexts." In other words, they are interested in exploring quite specifically the political dimensions of the particular kinds of affective engagements made possible by the construction of online spaces where visitors interact with and engage complicated aspects of the past. As in the Kristallnacht installation on *Second Life* and *The Secret Annex Online*, here too the researchers are building a web platform comprising "several virtual spaces based on real buildings and peopled with characters and narratives which blend 'found' archival testimony and fiction." Although their particular interest is the history of Canada's Aboriginal Residential Schools, dormitories run by the church and aimed at separating Aboriginal children from their families and traditions, their methodology would be applicable to other sites of atrocity. As their prototype depicts, a visitor enters a dormitory, which yields up objects most associated with the residential schools: "a school

FIGURE 4.7 Reel-to-reel player in a virtual Aboriginal Residential School created for the Embodying Empathy project website. (Courtesy of Struan Sinclair and Dylan Fries)

desk, a chair, a writing slate and a reel-to-reel tape recorder, as well as two of the spaces most often associated with the IRS [Indian Residential Schools]: the schoolroom and the dormitory." Like the other sites, this one, too, relies on the logic of encounter. For instance, when you pass a reel-to-reel tape recorder, an oral history begins to play (see figure 4.7).

Importantly, as in the Kristallnacht exhibit, in the Residential Schools exhibit you are visiting a school after the fact. What is left are traces; the voices are mediated by the tape recorder. You hear a girl's voice describing, "On my first day in boarding school, my dad delivered my brother, older sister, and me to this huge, cold, cucumber-smelling place that chilly, September day in 1949 or 1950. I remember the priest and a couple of nuns pulling us apart as we desperately tried to cling on to one another. I swear those nuns look like identical twins. Little did I know that I would not see my brother again for another ten months, not up close anyway. Once in a while I would manage to get a glimpse of him from a distance, but we were never allowed to interact." As she speaks, you hear children's voices in the background and muffled sounds that evoke a cafeteria. As in the Kristallnacht exhibit, some of the objects in the room function as portals into other connected story rooms. Instead of taking on an avatar to enter the world, you enter as yourself. But once there, as the video prototype

attests, you encounter "fully animated interactive characters drawn from our archive of oral histories." In many ways, this research project aims to harness the power of these digital technologies to produce both historical knowledge and empathy. It suggests, as I have, that affective engagement can be a powerful tool in the production of certain kinds of historical knowledges and that the online experience can function ontologically as experience even as it looks and feels artificial. Indeed, its obvious constructedness is part of what makes the knowledge production and empathy possible—you have a real experience of engagement with some aspect of the past, but it is clearly a mediated experience, not the event itself.

What I hope to have shown in this chapter is that virtual sites can make possible a real experience that you, the visitor, nevertheless understand to be qualitatively different from the experiences of the people from the past whose histories you are learning. You do not move through the annex in some simplistic or straightforward way *as* Anne. Rather, she speaks *to* you. The virtualness of this experience and the stylized graphic depictions of the space preclude the possibility of thinking you are living the past, that you could ever occupy Anne's place or fully understand her experience. You are a visitor to that space, made to see it, to be moved by and in it, and, most importantly, to think about it—but not *as* Anne. Similarly, in the Kristallnacht installation, the presence of an avatar and the use of a narrative frame—you enter as a reporter—insist on the fundamentally different nature of your experience vis-à-vis the atrocity from that of a person who lived through Kristallnacht. Furthermore, there is the assertion of a temporal break: you are in the present looking back. And yet these sites' powerful affective qualities and the sense of inhabiting and engaging in a multisensuous way with the space of the digital environment are crucially important for the embodied translation and the kind of meaningful transmission of that spark that I have described. The story of Anne Frank is a story about a very specific place at a very specific time. It is a story about a series of rooms and what one girl did and thought there—which sheds a glimmer of light on a particular episode of Jewish life in Europe in the 1930s and 1940s. Curators and museum designers cannot control the meanings that visitors will make from their exhibits, but, like the researchers working on the Embodying Empathy project, they can create the conditions in which past atrocities can become part of a usable past.

CONCLUSION

THIS BOOK REPRESENTS an attempt to think through the ways that historical knowledge is being produced in the contemporary, mass-mediated, public sphere. The project of history in these formats inevitably looks and feels different from conventional history on the printed page. And yet, as I hope I have shown, it is possible for even these mass-mediated and digital historical representations both to foster in viewers the kind of historical thinking that academic historians have prized and to evoke the complexity and messiness of the past with which historians themselves grapple. I have also attempted to theorize the experiential in an age of mass mediation. Experiences, whether they are mediated or not, are felt and interpreted by the body, and they feel real. But just because these experiences of engagement with the past are meaningful does not mean that they are understood to be identical to the experiences of those who lived through them. In fact, what I have tried to make visible are the range of ways in which the mediated nature of those experiences are made visible for the viewer by the frame narrative, by the modes of address of different television genres, and so on. Understanding this mode of engagement is crucial to understanding how history works in the contemporary mediated public sphere.

It should also be clear by now that this book is far from a blanket endorsement of the mass media's engagement with the past. Much of what is produced

in the name of history tends to oversimplify the past, to render it too accessible, and to create the illusion that one can actually move seamlessly into it. But there are countervailing trends, too, and they are the ones that I have taken up here. By no means am I suggesting that academic history is on the decline or somehow irrelevant in the face of the proliferation of history in the mass-mediated public sphere; the mass-cultural texts and sites I have taken up do not replace academic history. But they have a broader reach. And yet I do hope to have called attention to the way in which the best cases share some of the convictions of academic history despite their radically different mode of address. In fact, many of the criteria I have used to articulate the concept of historical knowledge grow out of academic historians' theorizations.

As I have argued, the main way in which contemporary, mass-mediated historical production differs from academic history is in its emphasis on the mobilization of affect. Many of the conventions of academic history have worked deliberately against the elicitation of affect, opting instead for a detached, clinical gaze at the past. This stance is meant in part to suggest that the history produced is objective rather than subjective, reasoned rather than emotional or biased. Although it is certainly the case that academic historians intend their work to be evenhanded and understand themselves to be producing sound historical knowledge, they also understand that their work is not in any strict sense "objective"; they advance specific interpretations based on their own analysis of data. But what I hope to have at least gestured toward in this book is the complicated way that affect works in the historical representations here considered. Although affect can be deployed to foster simplistic, facile identification with a character onscreen, that model of engagement is actually an impediment to historical thinking. But affect does not have to work that way, as the texts I have analyzed have shown. In fact, affect can be used quite effectively in negative ways—for instance, to force the viewer out of the text or to make him or her feel uncomfortable rather than complacent. Affect does not necessarily work to draw the viewer *in*; it has the potential instead to leave a scar, to make the event or situation of the past meaningful, to touch the viewer in a lasting way.

In such cases, affect functions in a confrontational manner; by fostering moments of critical encounter, the texts I have considered highlight the relays between affect and meaning-making, processing, and analysis. When viewers

engage in this processing, they do so as themselves, not as the characters on screen. In the model of affective engagement that I have elaborated, the viewer maintains a sense of his or her self while being brought into proximity with something foreign; this awareness of mediation is fostered by the formal properties of the representation—both stylistic and narrative. In this way, the sense of mediation is foregrounded, as it is in Collingwood's account of historical thinking. The viewer is aware that he or she is engaging with the past.

Another important difference between these mass-cultural representations of the past and more academic versions of history has to do with goals. Although viewers approach history-conscious television or history films or history websites expecting some degree of fidelity to what is known about the past, they also know that such texts have license to be imaginative. They understand that certain characters are created, but created in a way that is faithful to what is known about the period or socioeconomic milieu. I have described this play of the imagination within clearly defined historical constraints as akin to a social history experiment, where what is really made visible and palpable are the conditions of existence for a particular group of people at a particular historical moment in a particular place—not the historical narrative of a specific important historical event. Unlike academic history, popular representations of the past are not concerned primarily with the discovery of new archives, nor are they intended to speak to the body of scholarship already existing on the subject. Rather, they are specific cases or episodes from the past that have ramifications for or applications in the present. This approach often takes the form of demythologizing the past, of challenging those enduring national myths that undergird or justify hierarchies and oppressions in the present. These representations thus have the potential to politicize their audiences or at least to awaken political consciousness. And this takes us back to Walter Benjamin, who understood history to offer a glimmer of hope for redemption in a barbarous world. The representations that I have here described, then, might be understood in Benjamin's words as an attempt "to seize hold of a memory as it flashes up at a moment of danger," rendering the history figured in these unconventional formats as vital and important as ever.

NOTES

INTRODUCTION

1. D. W. Griffith, "Five Dollar 'Movies' Prophesied," *The Editor*, April 24, 1915, quoted in Robert Lang, "History, Ideology, Narrative Form," in *The Birth of Nation*, ed. Robert Lang (New Brunswick, N.J.: Rutgers University Press, 1994), 4.
2. Ibid.
3. This is the premise of Robert Lang's essay "History, Ideology, Narrative Form." Frederic Jameson, looking at literature, has argued that all narratives are "political" and ideologically informed. See *The Political Unconscious: Narrative as a Socially Symbolic Act* (Ithaca: Cornell University Press, 1982).
4. Alison Landsberg, *Prosthetic Memory: The Transformation of American Remembrance in the Age of Mass Culture* (New York: Columbia University Press, 2004).
5. R. G. Collingwood, *The Idea of History* (Oxford: Oxford University Press, 1956), 7–10, 242–48.
6. Ibid., 282.
7. Ibid., 283.
8. Ibid., 300.
9. Ibid., 284.
10. Ibid., 287, 289.
11. Raphael Samuel, *Theatres of Memory* (London: Verso, 1996), 175–76.
12. Roy Rosenzweig and David Thelen, *The Presence of the Past: Popular Uses of History in American Life* (New York: Columbia University Press, 1998), 3, 12, 179. Using standard survey practice and random-digit dialing, Rosenzweig and Thelen completed 808 national interviews; as a pool, the interviewees reflected the varied demographics of America. Because the researchers were also interested in the way minority groups articulate their relationship

to the past and to American history, they also developed three minority samples: African American, Mexican American, and American Indian. For a detailed discussion of how the survey was conducted, see appendix 1 in their book.

13. Rebecca Schneider uses the phrase "affective engagement" to explain the way historical reenactment feels for participants (*Performing Remains: Art and War in the Times of Theatrical Reenactment* [London: Routledge, 2011], 8).

14. Griffith, "Five Dollar 'Movies' Prophesied," quoted in Lang, "History, Ideology, Narrative Form," 4.

15. Vanessa Agnew, "History's Affective Turn: Historical Reenactment and Its Work in the Present," *Rethinking History* 11, no. 3 (2007): 300.

16. Joan Scott, "Experience," in *Feminists Theorize the Political*, ed. Judith Butler and Joan Scott (New York: Routledge, 1992), 25.

17. Saul Friedländer, *The Years of Extermination*, vol. 2 of *Nazi Germany and the Jews, 1939–1945* (2007; reprint, New York: Harper Perennial; 2008), xxv–xxvi.

18. Dominick LaCapra, *Writing History, Writing Trauma* (Baltimore: Johns Hopkins University Press, 2000), 40.

19. Frank R. Ankersmit, *Sublime Historical Experience* (Stanford: Stanford University Press, 2005), 7, 121, 265.

20. Hans Ulrich Gumbrecht, *The Production of Presence: What Meaning Cannot Convey* (Stanford: Stanford University Press, 2003), 94, 124, emphasis in original.

21. Alun Munslow, editorial, *Rethinking History* 1, no. 1 (1997): 9, 15–16.

22. Alun Munslow, *Narrative and History* (London: Palgrave Macmillan, 2007), 44, 47.

23. See Raymond Williams, *Marxism and Literature* (New York: Oxford University Press, 1978), 128–35, and Berthold Brecht, *Brecht on Theatre: The Development of an Aesthetic* (New York: Hill and Wang, 1964).

24. Jacques Rancière, *The Politics of Aesthetics*, trans. by Gabriel Rockhill (New York: Continuum, 2004), 82, 13.

25. Ibid., 20–24.

26. Ibid., 12–13.

27. Walter Benjamin, "The Work of Art: Second Version," trans. Edmund Jephcott and Harry Zohn, in *The Work of Art in the Age of Its Technological Reproducibility and Other Writings on Media*, ed. Michael W. Jennings, Brigid Doherty, and Thomas Y. Levin (Cambridge, Mass.: Harvard University Press, 2008), 23.

28. Ibid., 37.

29. Frank Ankersmit emphasizes Benjamin's point that "the real" survives in photographs: "The photograph effects in us a conviction of being momentarily contemporaneous with the scene depicted in the photograph" (*Sublime Historical Experience*, 182).

30. Benjamin, "The Work of Art," 39, 40–41.

31. Ibid., 41.

32. Walter Benjamin, "Theory of Distraction," trans. Howard Eiland, in *The Work of Art in the Age of Its Technological Reproducibility and Other Writings on Media*, 56.

33. Gilles Deleuze, "Image of Thought," in *Difference and Repetition*, translated by Paul Patton (New York: Columbia University Press, 1995), 138.

34. Diana Coole and Samantha Frost, introduction to *New Materialisms: Ontology, Agency, and Politics*, ed. Diana Coole and Samantha Frost (Durham: Duke University Press, 2010), 5, 6.

35. Baruch Spinoza, *Ethics: On the Correction of Understanding*, trans. Andrew Boyle (London: Everyman's Library, 1959), 87.

36. Melissa Gregg and Gregory Seigworth, "An Inventory of Shimmers," in *The Affect Theory Reader*, ed. Melissa Gregg and Gregory J. Seigworth (Durham: Duke University Press, 2010) 1, emphasis in original. See also Teresa Brennan, *The Transmission of Affect* (Ithaca: Cornell University Press, 2004).

37. For instance, Brian Massumi, author of *Parables of the Virtual: Movement, Affect, Sensation* (Durham: Duke University Press, 2002) and *Semblance and Event: Activist Philosophy and the Occurrent Arts* (Cambridge, Mass.: MIT Press, 2011), describes affect in terms of intensities, finding them to be "asocial but not presocial—it includes social elements, but mixes them with elements belonging to other levels of functioning, and combines them according to different logic" ("The Autonomy of Affect," *Cultural Critique*, no. 31 [Autumn 1995]: 91).

38. Sara Ahmed, "Happy Objects," in *The Affect Theory Reader*, ed. Gregg and Seigworth, 33. See also Sara Ahmed, *The Cultural Politics of Emotion* (New York: Routledge, 2013) and *The Promise of Happiness* (Durham: Duke University Press, 2010).

39. See Lawrence Grossberg, *We Gotta Get Out of this Place* (New York: Routledge, 1992), and Deborah Gould, *Moving Politics: Emotion and ACT UP's Fight Against AIDS* (Chicago: University of Chicago Press, 2009).

40. See Jerome de Groot, *Consuming History: Historians and Heritage in Contemporary Popular Culture* (London: Routledge, 2009), and "Empathy and Enfranchisement: Popular Histories," *Rethinking History* 10, no. 3 (2006): 391–413.

41. On historic sites, see, for instance, Richard Handler and Eric Gable's analysis of colonial Williamsburg in *The New History in an Old Museum: Creating the Past at Colonial Williamsburg* (Durham: Duke University Press, 1997).

42. Walter Benjamin, "Theses on the Philosophy of History" in *Illuminations*, trans. Harry Zohn, ed. Hannah Arendt (New York: Schocken Books, 1968), 256–57, 263, 255.

1. THEORIZING AFFECTIVE ENGAGEMENT IN THE HISTORICAL FILM

1. Robert Burgoyne, *The Hollywood Historical Film* (Malden, Mass.: Wiley-Blackwell, 2008).

2. There is no historical consensus on whether this claim is apocryphal or not. Either way, though, it speaks to a sense of the overwhelming power of this new medium to write history in a vivid and new way.

3. Cecil B. DeMille, *The Autobiography of Cecil B. DeMille*, ed. Donald Hayne (Englewood Cliffs, N.J.: Prentice-Hall, 1959), 169, 170.

4. Ibid., 171.

5. Robert Rosenstone, "History in Images/History in Words: Reflections on the Possibility of Really Putting History Onto Film," *American Historical Review* 93, no. 5 (1988): 1178–79.

6. See, for example, Robert Rosenstone and Constantin Parvalescu, introduction to *A Companion to the Historical Film*, ed. Robert Rosenstone and Constantin Parvalescu (Malden, Mass.: Wiley-Blackwell, 2013), 1–8; Robert Burgoyne, *Film Nation* (Minneapolis: University of Minnesota Press, 2010) and *The Hollywood Historical Film*; Natalie Zemon Davis, *Slaves on Screen: Film and Historical Vision* (Cambridge, Mass.: Harvard University Press, 2000); Brent Toplin, *Reel History* (Lawrence: University Press of Kansas, 2002).

7. Rosenstone, "History in Images/History in Words," 1184–85.

8. Ludmilla Jordanova, *History in Practice* (London: Arnold, 2000), 94.

9. Robert Rosenstone prefers the term *history film* to the term *historical film*. By *history film*, he means the representing of the past in cinematic form. He uses the term *historical film* to designate those films that are historical in that they are "important to the development of either the medium or some particular genre" ("The History Film as a Mode of Historical Thought," in *A Companion to the Historical Film*, ed. Rosenstone and Parvalescu, 72).

10. Alun Munslow, *The Future of History* (New York: Routledge, 2010), 8–9.

11. Rosenstone, "The History Film as a Mode of Historical Thought," 84.

12. Joan Scott, "Experience," in *Feminists Theorize the Political*, ed. Judith Butler and Joan Scott (New York: Routledge, 1992), 35.

13. Hugo Münsterberg, *The Film: A Psychological Study* (1916; reprint, New York: Dover, 1970), 95.

14. Quoted in Miriam Hansen, "'With Skin and Hair': Kracauer's Theory of Film, Marseilles 1940," *Critical Inquiry* 19, no. 3 (1993): 458, emphasis in original.

15. Michael Taussig, *Mimesis and Alterity* (New York: Routledge, 1993), 21.

16. "Apparatus theory" refers to a body of work produced in the 1970s by French film theorists such as Christian Metz and Jean-Louis Baudry, who claimed that ideology was present not only in the filmic representations but also in the cinematic apparatus itself. Although the particulars of their arguments differ, they shared a belief that the cinema was first an apparatus for the positioning of the spectator as subject. See Christian Metz, *The Imaginary Signifier: Psychoanalysis and the Camera*, trans. Celia Britton, Annwyl Williams, Ben Brewster, and Alfred Guzzetti (Bloomington: Indiana University Press, 1982); Jean-Louis Baudry, "Ideological Effects of the Basic Cinematographic Apparatus," *Film Quarterly* 28, no. 2 (1974–1975): 39–47; Jean-Luc Comolli and Jean Narboni, "Cinema/Ideology/Criticism," in *Film, Theory, and Criticism*, 7th ed., ed. Leo Braudy and Marshall Cohen (Oxford: Oxford University Press, 2008), 686–93.

17. Contemporary film theory has contested the notion that the spectator is locked into a single and largely passive viewing position, arguing instead for a model of spectatorship where viewers move in and out of identifications with different characters in part as a result of cinematic devices and in part as a result of their own pre-existing subject positions. See, for example, Miriam Hansen, "Pleasure, Ambivalence, Identification: Valentino and Female Spectatorship," *Cinema Journal* 25, no. 4 (1986): 6–32; Linda Williams, introduction to *Viewing Positions: Ways of Seeing Film*, ed. Linda Williams (New Brunswick, N.J.: Rutgers University Press, 1995), 1–20; Rhoda Berenstein, "Spectatorship as Drag: The Act of Viewing and Classic Horror Cinema," in *Viewing Positions*, ed. Williams, 231–70; and Carol J.

Clover, *Men, Women, and Chain Saws: Gender in the Modern Horror Film* (Princeton: Princeton University Press, 1992).

18. Lisa Cartwright also challenges the standard notion of cinematic identification, making claims that I take up later. See Lisa Cartwright, *Moral Spectatorship: Technologies of Voice and Affect in Postwar Representations of the Child* (Durham: Duke University Press, 2008).

19. Walter Benjamin, "Theory of Distraction," trans. Howard Eiland, in *The Work of Art in the Age of Its Technological Reproducibility and Other Writings on Media*, ed. Michael W. Jennings, Brigid Doherty, and Thomas Y. Levin (Cambridge, Mass.: Harvard University Press, 2008), 56.

20. Jill Bennett makes a similar point in her analysis of spectatorship in contemporary art. She writes, "We as spectators inhabit this space, not through an identification with primary witnesses (for their identity is never made clear, in any case), but as our bodies enable us to respond to being-in-place, a place where our conditions or perceptions are themselves challenged" (*Empathic Vision: Affect, Trauma, and Contemporary Art* [Stanford: Stanford University Press, 2005], 68).

21. Vivian Sobchack, "What My Fingers Knew: The Cinesthetic Subject, or Vision in the Flesh," in *Carnal Thoughts: Embodiment and Moving Image Culture* (Berkeley: University of California Press, 1994), 60, emphasis in original.

22. In her groundbreaking book on the phenomenology of film, Sobchack suggests that the film text has a body apart from what is actually being depicted and that we as viewers engage with that materiality (*The Address of the Eye: A Phenomenology of Film Experience* [Princeton: Princeton University Press, 1991]).

23. Laura Marks, *The Skin of the Film: Intercultural Cinema, Embodiment, and the Senses* (Durham: Duke University Press, 2000), 145.

24. Jennifer Barker, *The Tactile Eye: Touch and the Cinematic Experience* (Berkeley: University of California Press, 2009), 4, 2.

25. Ibid., 19.

26. Cartwright, *Moral Spectatorship*, 24.

27. E. Ann Kaplan, *Trauma Culture: The Politics of Terror and Loss in Media and Literature* (New Brunswick, N.J.: Rutgers University Press, 2005), 124–25, first quote from Laub.

28. Film scholars have long debated the relationship between narrative and spectacle in film. See, for example, Donald Crafton, "Pie and Chase: Gag, Spectacle, and Narrative in Slapstick Comedy," in *The Cinema of Attractions Reloaded*, ed. Wanda Strauven (Amsterdam: Amsterdam University Press, 2007), 355–64.

29. Sobchack, "What My Fingers Knew," 64–65.

30. Dziga Vertov, *Kino-Eye: The Writings of Dziga Vertov*, trans. Kevin O'Brien, ed. Annette Michelson (Berkeley: University of California Press, 1984), 14.

31. Michael Bronski, "*Milk*," *Cineaste* 34, no. 2 (2009): 71.

32. Ibid., 73.

33. James Burns, "*Milk*," *Journal of American History* 96, no. 1 (2009): 319.

34. Ibid.

35. Dennis Bingham, "The Life and Times of the Biopic," in *A Companion to the Historical Film*, ed. Rosenstone and Parvalescu, 237.

36. John Geluradi, for example, writing for the *SFWeekly*, wrote a piece on January 30, 2008, based on an interview with Dan White's political adviser, Ray Sloan, who is gay and has a very different take on Dan White ("Dan White's Motive More About Betrayal Than Homophobia," *SFWeekly*, January 30, 2008, http://www.sfweekly.com/2008-01-30/news/white-in-milk/).

37. Oliver Stone's film *JFK* (1991) was radical and controversial in its use of archival footage within the history film. It was argued that the film was playing fast and loose with the truth and as such was manipulative, making some footage look archival when it was really a re-creation.

38. Gus Van Sant, dir., *Milk* (New York: Axon Films, 2008); all quotations are my transcriptions unless otherwise noted.

39. Bingham, "The Life and Times of the Biopic," 240.

40. Jean-Louis Comolli, "Historical Fiction: A Body Too Much," *Screen* 19, no. 2 (1978): 44, 46, 48.

41. Dustin Lance Black, *Milk*, script, IMSDb, n.d., http://www.imsdb.com/scripts/Milk.html.

42. Some critics have pointed out that *Hotel Rwanda* downplays the role the Belgians played in creating the tensions between Hutu and Tutsi to strengthen colonial rule. See Fatimah Shittu, "Imperialism: What You Won't See in *Hotel Rwanda*," Uhurunews.com, March–April 2005, http://uhurunews.com/story?resource_name=imperialism-what-you-wont-see-in-hotel-rwanda. Others have complained that there is an oversimplification of a complex historical situation, which is a critique lodged at many attempts at history on film.

43. Terry George, dir., *Hotel Rwanda* (Hollywood: United Artists, 1994); all quotations are my transcriptions.

44. See Siegfried Kracauer, *From Caligari to Hitler* (Princeton: Princeton University Press, 2004).

45. A. O. Scott, for instance, ends his very favorable review of *Good Night and Good Luck* with the proclamation that "most of the discussion of this movie will turn on its content—on the history it investigates and on its present-day resonance. . . . [Mr. Clooney] has found a cogent subject, an urgent set of ideas and a formally inventive, absolutely convincing way to make them live on screen" ("News in Black, White, and Shades of Gray," *New York Times*, September 23, 2005, http://www.nytimes.com/2005/09/23/movies/23luck.html?_r=0).

46. George Clooney, dir., *Good Night and Good Luck* (Dallas: 2929 Entertainment, 2005); all quotations are my transcriptions.

2. WAKING THE PAST: THE HISTORICALLY CONSCIOUS TELEVISION DRAMA

1. Pierre Sorlin, "Television and Our Understanding of History: A Distant Conversation," in *Screening the Past: Film and the Representation of History*, ed. Tony Barta (New York: Praeger, 1998), 207.

2. Ann Gray and Erin Bell, *History on Television* (London: Routledge, 2013), 2.

3. Ann Gray and Erin Bell, eds., *Televising History: Mediating the Past in Postwar Europe* (Houndmills, U.K.: Palgrave Macmillan, 2010).

4. Gray and Bell have classified factual history shows into five categories: heartland (straight narrative history built around an event or person or era), investigative (challenging and requiring engagement from the viewer, presenter led), immersive adventure (offering excitement to viewers through devices such as reconstruction and drama), contemporary journey (contemporary experience as a way into historical journeys, encompassing reality history and reenactment), and drama (scripted drama, distinct from dramatic reconstruction) (*History on Television*, 44–46).

5. Jerome de Groot, *Consuming History: Historians and Heritage in Contemporary Popular Culture* (London: Routledge, 2009), 247.

6. Gray and Bell, *History on Television*, 6.

7. Quoted in ibid., 22.

8. Robert Rosenstone, *Visions of the Past* (Cambridge, Mass.: Harvard University Press, 1995), 69, 70, 71.

9. Gary R. Edgerton, "Introduction: Television as Historian: A Different Kind of History Altogether," in *Television Histories: Shaping Collective Memories in the Media Age*, ed. Gary R. Edgerton and Peter C. Rollins (Lexington: University Press of Kentucky, 2001), 10, 4.

10. F. R. Ankersmit, *Sublime Historical Experience* (Stanford: Stanford University Press, 2005), 239.

11. Robert Rosenstone makes the point that many Hollywood images are both invented *and* true (*Visions of the Past*, 128). Natalie Zemon Davis suggests that imagined events that make a point are fine as long as the construction is visible and explained (*Slaves on Screen: Film and Historical Vision* [Cambridge, Mass.: Harvard University Press, 2000], 11).

12. Sorlin, "Television and Our Understanding of History," 211.

13. For more on empathy, see Alison Landsberg, *Prosthetic Memory: The Transformation of American Remembrance in the Age of Mass Culture* (New York: Columbia University Press, 2004), and the sources cited in notes 14–16.

14. Jill Bennett, *Empathic Vision: Affect, Trauma, and Contemporary Art* (Stanford: Stanford University Press, 2005), 10, 21.

15. E. Ann Kaplan, *Trauma Culture: The Politics of Terror and Loss in Media and Literature* (New Brunswick, N.J.: Rutgers University Press, 2005), 37.

16. Dominick LaCapra, *Writing History, Writing Trauma* (Baltimore: Johns Hopkins University Press, 2000), 41, 78, 41.

17. Glen Creeber, *Serial Television: Big Drama on the Small Screen* (London: BFI, 2004), 2, 12.

18. Alexander Dhoest, "History in Popular Television Drama: The Flemish Past in *Wij, Heren van Zichem*," in *Televising History*, ed. Bell and Gray, 185.

19. Gary R. Edgerton, "Introduction: A Brief History of HBO," in *The Essential HBO Reader*, ed. Gary R. Edgerton and Jeffrey P. Jones (Lexington: University Press of Kentucky, 2008), 1.

20. For the guidelines, see the Federal Communications Commission, *The Public and Broadcasting*, revised July 2008, http://www.fcc.gov/guides/public-and-broadcasting-july-2008 #OBJECTIONABLE.

21. Edgerton, "Introduction: A Brief History of HBO," 9.

22. In his well-known critique of reality history TV, Tristram Hunt allows that the earliest incarnations of that genre might be considered an "interesting social history experiment" ("The Time Bandits: Television History Is Now More About a Self-Indulgent Search for Our Identity Than an Attempt to Explain the Past and Its Modern Meaning," *Guardian*, September 9, 2007, http://www.theguardian.com/media/2007/sep/10/mondaymediasection.television1).

23. Costume dramas generally refer to those texts that try to capture the ambience of a period through lavish sets and costumes. *Wikipedia* regards both *Mad Men* and *Deadwood* as costume dramas ("Costume Drama," *Wikipedia*, n.d., http://en.wikipedia.org/wiki/Costume_drama), but, as my analysis suggests, they have greater historical ambition.

24. David Milch, "The Real Deadwood," n.d., http://www.hbo.com/deadwood/behind/the realdeadwood.shtml, accessed June 24, 2009, but no longer accessible.

25. Nancy Franklin, "Dead On: David Milch Explores the Dakota Territory," *The New Yorker*, June 12, 2006, http://www.newyorker.com/archive/2006/06/12/060612crte_television, including the quotation from Milch.

26. David Milch, creator, *Deadwood*, HBO, March 21, 2004–August 27, 2006 (Roscoe Productions); quotes from the series are my transcriptions.

27. Alessandra Stanley, "The Code of the West as Hard as a Gunfighter's Eye," *New York Times*, March 19, 2004, http://www.nytimes.com/2004/03/19/movies/tv-weekend-the-code-of -the-west-as-hard-as-a-gunfighter-s-eye.html.

28. Franklin, "Dead On."

29. Richard Cullen Rath, *How Early America Sounded* (Ithaca: Cornell University Press, 2003), x–xi.

30. Michelle Hilmes, "Is There a Field Called Sound Culture Studies? And Does It Matter?" *American Quarterly* 57 (2005): 249.

31. See Rick Altman, *Sound Theory, Sound Practice* (New York: Routledge, 1992).

32. Michael Chion, *Audio-Vision: Sound on Screen*, trans. Claudia Gorbman (New York: Columbia University Press, 1990), 33.

33. Ibid., 68. As Frank Ankersmit has written, "The world of sounds may sometimes give us an understanding of the *condition humaine* that we can never expect from the world of visual forms" (*Sublime Historical Experience*, 123).

34. Michael Taussig, *Mimesis and Alterity* (New York: Routledge, 1993), 21.

35. Carl Plantinga, *Moving Viewers: American Film and the Spectator's Experience* (Berkeley: University of California Press, 2009), 3, 120.

36. Chion, *Audio-Vision*, 90.

37. Jesse McKinley, "'Deadwood' Gets a New Lease on Life," *New York Times*, June 11, 2006, http://www.nytimes.com/2006/06/11/arts/television/11mcki.html?_r=1&scp=1&sq= deadwood&st=cse.

38. Allen Barra, "The Man Who Made *Deadwood*: The Creator of the Immensely Popular New Western Discusses What Makes It Truly New—an Interview with David Milch," *American Heritage Magazine* 57 (June–July 2006), http://www.americanheritage.com/content/ man-who-made-%C2%91deadwood%C2%92.

39. Ibid. Janet MacCabe has argued that Calamity Jane's use of profanity is a form of rule breaking: "the violence of her language betrays generic trauma, making visible the impact revisionist histories have had upon the legendary versions of the Western past Americans have most often favored as well as the value particular (male) bodies have to those (generic) memories" ("Myth Maketh the Woman," in *Reading Deadwood: A Western to Swear By*, ed. David Lavery [London: I. B. Taurus, 2006], 71). The way Calamity Jane's body functions within the show, MacCabe is arguing, and the kinds of things she says challenge preconceived ideas about the West and about the role of women. She also emphasizes how off-putting it is to hear familiar stories told unfamiliarly. By breaking the rules in this way, the show makes visible a new vision of the frontier.

40. Chion, *Audio-Vision*, 171, 177.

41. See, for instance, Gary R. Edgerton, "Introduction: When Our Parents Became Us," in *Mad Men*, ed. Gary R. Edgerton (London: I. B. Taurus, 2011), xxvii. As Jerome de Groot has described, "The show itself plays fast and loose with nostalgia, quite deliberately invoking it to explode it" ("'Perpetually Dividing and Suturing the Past and Present': *Mad Men* and the Illusions of History," *Rethinking History* 15, no. 2 (2011): 279).

42. "About *Mad Men*," AMC website, n.d., http://www.amctv.com/shows/mad-men/about, accessed DATE.

43. Elaine Tyler May, *Homeward Bound* (New York: Basic Books, 1998).

44. Part of the potential of the show's early seasons has to do with the fact that although the late 1960s have been well represented in popular culture, the early 1960s have not. As Edgerton has observed, "One of the most distinguishing and innovative aspects of *Mad Men* so far is that the series spent 37 of the 39 episodes of its first three seasons on the front of the decade, before the Kennedy assassination—a time that has been largely suppressed and long forgotten in popular culture—and with good reason. *Mad Men* exposes much of the over-the-top and out-in-the-open sexism, racism, adultery, homophobia and anti-Semitism, not to mention all the excessive smoking and drinking" ("Introduction: When Our Parents Became Us," xxviii).

45. Matthew Weiner, creator, *Mad Men*, AMC, July 19, 2007–unknown date 2015 (Weiner Bros.); all quotes are my transcriptions.

46. Ankersmit writes, "The past can properly be said to be present in the artifacts it has left us. They are protuberances, so to say, of the past in the present" (*Sublime Historical Experience*, 115).

47. Horace Newcomb has written about the role of television in the series. Of this episode, he writes: "For some viewers of *Mad Men* the images, the quotes, are perhaps new and informative, are 'history.' For some they are references, somewhat familiar, seen previously in documentaries or textbooks. For some however they are experiential. They are accounts of the experience of learning about the event, or watching for long stretches of time, of moments lived with television" ("Learning to Live with Television in *Mad Men*," in *Mad Men*, ed. Edgerton, 112).

48. Matthew Weiner, "Part 2: The Making of Mad Men," season 1, episode 3, AMC website, n.d., http://www.amctv.com/mad-men/videos/the-making-of-mad-men-part-2.

49. Jeremy G. Butler, " 'Smoke Gets in Your Eyes': Historicizing Visual Style in *Mad Men*," in *Mad Men*, ed. Edgerton, 56.

50. Amy Wells, "It Is as It Was: Inside *Mad Men*," season 1, episode 11, AMC website, n.d., http://www.amctv.com/mad-men/videos/it-is-as-it-was.

51. Butler, " 'Smoke Gets in Your Eyes,' " 59, 69, 59, quoting C. S. Tashiro, *Pretty Pictures: Production Design and the History Film* (Austin: University of Texas Press, 1998), 68.

52. Mary Beth Haralovich quotes a comment Weiner made to Charlie Rose: "I had this incredible experience of reading *The Feminine Mystique* and *Sex and the Single Girl* in the same week, and I said, 'oh, this is my show.' . . . It is literally the choice of what kind of woman to be at that time and today. . . . *The Feminine Mystique* spoke to so many people. . . . Helen Gurley Brown [was] giving you this advice on how to be a woman and how to use womanliness to get success" ("Women on the Verge of the Second Wave," in *Mad Men*, ed. Edgerton, 161–162, quoting Charlie Rose, "A Discussion of the Television Series *Mad Men* with Matthew Weiner, Jon Hamm, and John Slattery," *Charlie Rose*, July 28, 2008, http://www.charlierose.com/guest/view/6417).

53. May, *Homeward Bound*, 143.

54. Allison Perlman, "The Strange Career of *Mad Men*: Race, Paratexts, and Civil Rights Memory," in *Mad Men*, ed. Edgerton, 209, 211.

55. Ibid., 213.

56. Ibid., 212.

57. Ibid., 215.

58. Mary Dudziak, *Cold War Civil Rights: Race and the Image of American Democracy* (Princeton: Princeton University Press, 2011), 12, 79.

59. See, for instance, Lizabeth Cohen, *A Consumer's Republic* (New York: Vintage Books, 2003), and Charles McGovern, *Sold American* (Chapel Hill: University of North Carolina Press, 2006), among others.

60. May, *Homeward Bound*, 162.

61. Paul J. Harvey Jr., "Rome Yet Again," *Archaeology Magazine*, September 6, 2005, http://archive.archaeology.org/online/reviews/hborome/.

62. Alessandra Stanley, "HBO's Roman Holiday," *New York Times*, August 21, 2005, http://www.nytimes.com/2005/08/21/arts/television/21stan.html.

63. In a thoughtful essay on the series, Christopher Lockett has argued that the subplot with Pullo and Vorenus actually offers a "counternarrative" to the "historical epic more generally. The series works consistently toward subtle dislocations of unitary and monolithic power and historical agency, traditionally located within individuals such as Caesar. These disjunctions place *Rome* at odds with the standard Hollywood 'historical epic,' which tacitly subscribes to the Great Man theory of history: such depictions of history's defining moments and events pivoting on the actions of a handful of powerful, monumental people is a model of historical agency that *Rome* consistently and specifically depicts as illusory, rejecting unified, deterministic history in favour of a series of *accidental* histories" ("Accidental History: Mass Culture and HBO's *Rome*," *Journal of Popular Film and Television* 38, no. 3 [2010]: 104).

64. *Rome: The Complete First Season*, DVD (Los Angeles: HBO Entertainment in association with BBC, 2006).

65. Michael Apted, dir., Bruno Heller, John Milius, William J. MacDonald, creators, *Rome*, HBO, August 28, 2005–March 25, 2007 (HD Vision Studios, HBO, BBC); quotes from the series are my transcriptions.
66. Lockett, "Accidental History," 104.

3. ENCOUNTERING CONTRADICTION: REALITY HISTORY TV

1. Brian Fay, introduction to "Unconventional History," special issue of *History and Theory* 41, no. 4 (2002): 6.
2. Rebecca Schneider, *Performing Remains: Art and War in the Times of Theatrical Reenactment* (London: Routledge, 2011), 8.
3. Jacques Rancière, *The Politics of Aesthetics*, trans. Gabriel Rockhill (London: Continuum Books, 2004), 63.
4. Jill Bennett, *Empathic Vision: Affect, Trauma, and Contemporary Art* (Stanford: Stanford University Press, 2005), 69.
5. Rancière, *The Politics of Aesthetics*, 12–13.
6. Walter Benjamin, "The Work of Art: Second Version," trans. Edmund Jephcott and Harry Zohn, in *The Work of Art in the Age of Its Technological Reproducibility and Other Writings on Media*, ed. Michael W. Jennings, Brigid Doherty, and Thomas Y. Levin (Cambridge, Mass.: Harvard University Press, 2008), 23.
7. Iain McCalman and Paul Pickering, "From Realism to the Affective Turn," in *Historical Reenactment: From Realism to the Affective Turn*, ed. Iain McCalman and Paul A. Pickering (Houndmills, U.K.: Palgrave Macmillan, 2010), 1, 2, 6, 13.
8. Graeme Turner, *Ordinary People and the Media* (London: Sage, 2010) 2, 3, 34, 39, 42.
9. Bobbie Birleffi, Christopher Ragazzo, Ilana Trachman, Barnaby Coughlin, Ian Roberts, James Jansen, Raoul Germain, Don DiNicola, Stewart Lerman, and Stuert Smith, dirs., *Texas Ranch House*, PBS, May 1–4, 2006 (Wall to Wall Media, Thirteen/WNET New York, PBS Video); quotes from the series are my transcriptions.
10. Vanessa Agnew, "History's Affective Turn: Historical Reenactment and Its Work in the Present," *Rethinking History* 11, no. 3 (2007): 301.
11. Rebecca Schneider suggests that errors can function in this way in reenactment: "Error could be, in fact, *the way through* to success: the error of the past in the now was twin to the error of the now in the past" (*Performing Remains*, 53).
12. Alison Landsberg, *Prosthetic Memory: The Transformation of American Remembrance in the Age of Mass Culture* (New York: Columbia University Press, 2004), 129–39.
13. Alexander Cook, "The Use and Abuse of Historical Reenactment: Thoughts on Recent Trends in Public History," *Criticism* 46, no. 3 (2004): 487, 491.
14. Ibid., 492. Cook's concern here is another version of the problem enumerated by Vanessa Schwartz: that it is problematic to give our own experiences in the present evidentiary status regarding the past.
15. Alun Munslow has written extensively on conventional academic history writing as a genre unto itself. See, for instance, *Narrative and History* (London: Palgrave Macmillan, 2007).

16. Gilles Deleuze, "Image of Thought," in *Difference* and *Repetition*, trans. Paul Patton (New York: Columbia University Press, 1995), 138.

17. Catherine Gallagher, "War, Counterfactual History, and Alternate-History Novels," *Field Day Review* 3 (2007): 53.

18. Gavriel Rosenfeld, "Why Do We Ask 'What If'? Reflections on the Function of Alternate History," *History and Theory* 41, no. 4 (2002): 93.

19. Ibid., 103. In her essay on ABC's *Outback House,* Anja Schwarz suggests that such shows in Australia are preoccupied with imperial history and wind up attempting to right the wrongs of the past (" . . . Just as It Would Have Been in 1861': Stuttering Colonial Beginnings in ABC's *Outback House,*" in *Historical Reenactment,* ed. McCalman and Pickering, 18–38). She discusses this point in the context of counterfactual history and Niall Ferguson's work in particular. Schwarz argues that despite the fact that many historians dismiss his work because of his neoconservative agenda, Ferguson makes some useful claims that give back a sense of contingency and work against teleological accounts (31).

20. Nicolas Roether Brown, Maro Chermayeff, Kathryn Walker, Will Edwards, Andrew Ford, Kelly Korzan, and Simon Shaw, dirs., *Frontier House,* PBS, April 29–May 3, 2002 (Thirteen/WNET New York, PBS, Wall to Wall Television); quotations from the series are my transcriptions.

21. See Landsberg, *Prosthetic Memory,* 23–24, 120–21, 135–36.

22. Malgorzata Rymsza-Pawlowska, "*Frontier House*: Reality Television and the Historical Experience," *Film & History* 37, no. 1 (2007): 39. See also Leigh H. Edwards, "The Endless End of Frontier Mythology: PBS's *Frontier House* 2002," *Film & History* 37, no. 1 (2007): 29–34.

23. See, for instance, Jerome de Groot, "Empathy and Enfranchisement: Popular Histories," *Rethinking History* 10, no. 3 (2006): 391–413, and Iain McCalman, "The Little Ship of Horrors: Reenacting Extreme History," *Criticism* 46, no. 3 (2004): 477–86.

24. This experience, which shares something with the original but is of a lesser order of magnitude, is in some ways akin to what Rebecca Schneider has called "the error relative pain—of being *related,* but not *the thing itself*' (*Performing Remains,* 53).

25. Kristi Jacobson and Sally Aitken, dirs., *Colonial House,* PBS, May 17–25, 2004 (Thirteen/WNET New York, Wall to Wall Television, PBS Video); quotes from the series are my transcriptions.

4. DIGITAL TRANSLATIONS OF THE PAST: VIRTUAL HISTORY EXHIBITS

1. See Alison Landsberg, "Memory, Empathy, and the Politics of Identification," *International Journal of Politics, Culture, and Society* 22, no. 2 (2009): 221–29.

2. Deborah H. Gould, *Moving Politics: Emotion and ACT UP's Fight Against AIDS* (Chicago: University of Chicago Press, 2009), 3.

3. Alison Landsberg, *Prosthetic Memory: The Transformation of American Remembrance in the Age of Mass Culture* (New York: Columbia University Press, 2004), 147–55.

4. Walter Benjamin, "On Some Motifs in Baudelaire," in *Illuminations,* trans. Harry Zohn, ed. Hannah Arendt (New York: Schocken Books, 1968), 175.

5. On our fragmentary knowledge of the past, see the works of Hayden White, Alun Munslow, Robert Rosenstone, Keith Jenkins, and Frank Ankerschmidt.

6. Alun Munslow, *Narrative and History* (London: Palgrave Macmillan, 2007), 17.

7. Walter Benjamin, "The Task of the Translator," in *Illuminations*, 71, 76.

8. Ibid., 73, 78–79.

9. José María Rodríguez García considers in his essay "Literary Into Cultural Translation" the possibility of cultural translation, which is in some ways related to what I am describing. He writes, "The task ahead for the theorist of translation (I would not dare to speak for practitioners) is to seek a balance between methods that emphasize the untranslatability of cultures and methods that presuppose the convertibility of one into the other. The overview offered in these pages is but an invitation to the reader to think in that direction" ("Literary Into Cultural Translation," *Diacritics* 34, nos. 3–4 [2004]: 28).

10. Roy Rosenzweig and David Thelen, *The Presence of the Past: Popular Uses of History in American Life* (New York: Columbia University Press, 1998), 12.

11. Sheila Watson, "Myth, Memory, and the Senses in the Churchill Museum," in *Museum Materialities: Objects, Engagements, Interpretations*, ed. Sandra H. Dudley (London: Routledge, 2010), 220, 204, 220–21.

12. Vanessa Agnew, "History's Affective Turn: Historical Reenactment and Its Work in the Present," *Rethinking History* 11, no. 3 (2007): 299–312.

13. This question also applied to the experience of the families in *Frontier House*; when the Clune girls ventured out into the snow covered only with blankets to find the family's cow and milk it, they may not have been in any real danger, but they were to a certain extent at the mercy of the weather and subject to real frostbite.

14. Dominick LaCapra, *Writing History, Writing Trauma* (Baltimore: Johns Hopkins University Press, 2000), xi.

15. Lynne Teather, "A Museum Is a Museum Is a Museum . . . or Is It? Exploring Museology and the Web," April 1998, http://www.museumsandtheweb.com/mw98/papers/teather/teather_paper.html#I.%20Introduction.

16. Doug Worts and Kris Morrisey, "Technology, Communication, and Public Programming: Going Where Museums Have Rarely Gone," quoted in ibid.

17. Ross Parry and John Hopwood, "Virtual Reality and the 'Soft' Museum: A Call for Further Research," *Journal of Museum Ethnography*, no. 16 (March 2004): 73, 70.

18. Hilde Hein, "Assuming Responsibility: Lessons from Aesthetics," in *Museum Philosophy for the Twenty-First Century*, ed. Hugh H. Genoways (Lanham, Md.: Altamira Press, 2006), 3, 6.

19. Spencer R. Crew and James Sims, "Locating Authenticity: Fragments of a Dialogue," in *Exhibiting Cultures: The Poetics and Politics of Museum Display*, ed. Ivan Karp and Steven D. Lavine (Washington, D.C.: Smithsonian Institution Press, 1991), 159.

20. A primitive version of this kind of "virtual tour" would be a video of a camera moving through the actual exhibit. Such a video is available, for instance, on the website for Yad Vashem, the Holocaust memorial in Israel (http://www.yadvashem.org/yv/en/museum/virtual_tour.asp). See also Sylaiou Styliani, Liarokapis Fotis, Kotsakis Kosta, and Patias Petros, "Virtual Museums: A Survey and Some Issues for Consideration," *Journal of Cultural*

Heritage 10 (2009): 520–21. Although there is no official count of virtual museums, Styliani and colleagues assert that they number in the thousands.

21. See the Orchard House, Home of Louisa May Alcott, website, http://www.louisamay alcott.org/panoramas.html. It is worth noting that the furnished rooms, even at the actual site, are reconstructions.

22. Geoffrey Lewis, "Virtual Museum," *Encyclopaedia Britannica* online, http://www.britannica .com/eb/article-9000232, last updated September 24, 2013.

23. Werner Schweibenz, "The 'Virtual Museum': New Perspectives for Museums to Present Objects and Information Using the Internet as a Knowledge Base and Communication System," in *Knowledge Management und Kommunikationssysteme: Workflow Management, Multimedia, Knowledge Transfer. Proceedings des 6. Internationalen Symposiums für Informationswissenschaft (ISI '98) Prag, 3.–7. November 1998*, ed. Harald Zimmermann and Volker Schramm, Schriften zur Informationswissenschaft no. 34 (Konstanz, Germany: UKV. S., 1998), 185–200, http://is.uni-sb.de/projekte/sonstige/museum/virtual_museum _isi98#tea.

24. Smithsonian Natural History Museum, "Panoramic Virtual Tour," http://www.mnh.si .edu/vtp/1-desktop/.

25. Sistine Chapel website, http://www.vatican.va/various/cappelle/sistina_vr/index.html.

26. A selection of rooms from the Rijksmuseum can be visited and explored as part of a three-dimensional tour of Amsterdam. In this tour, you may move within the available rooms, but you have no access to the rest of the museum. See the museum website at http://www .amsterdam360.com/panos/rijksmuseum/.

27. Styliani et al., "Virtual Museums," 526.

28. Anne Frank House Museum website, http://www.annefrank.org/en/.

29. *The Secret Annex Online*, virtual exhibit at the Anne Frank House Museum website, n.d., http://www.annefrank.org/en/Subsites/Home/.

30. Stephen Borysewicz, "Networked Media: The Experience Is Closer Than You Think," in *The Virtual and the Real: Media in the Museum*, ed. Selma Thomas and Ann Mintz (Washington, D.C.: American Association of Museums, 1998), 110, 116, emphasis added.

31. Walter Benjamin, "The Work of Art: Second Version," trans. Edmund Jephcott and Harry Zohn, in *The Work of Art in the Age of Its Technological Reproducibility and Other Writings on Media*, ed. Michael W. Jennings, Brigid Doherty, and Thomas Y. Levin (Cambridge, Mass.: Harvard University Press, 2008), 40.

32. "About *The Secret Annex Online*," Anne Frank Museum website, n.d., http://www .annefrank.org/en/Subsites/Hme/More-info/.

33. Sandra H. Dudley, "Museum Materialities: Objects, Sense, and Feeling," in *Museum Materialities*, ed. Dudley, 8. Lynne Teather has also suggested that "most often the view of museums centres on 'things' or 'objects' as the essence of the museums' role and function, the beginning point of the collecting function at the heart of museums' role" ("A Museum Is a Museum Is a Museum").

34. Styliani et al., "Virtual Museums," 524.

35. Vivian Sobchack, "The Scene of the Screen: Envisioning Photographic, Cinematic, and Electronic 'Presence,'" in *Carnal Thoughts: Embodiment and Moving Image Culture* (Berkeley: University of California Press, 1994), 139.

36. Saul Friedländer, *The Years of Extermination*, vol. 2 of *Nazi Germany and the Jews, 1939–1945* (2007; reprint, New York: Harper Perennial, 2008), xxvi.

37. Laura Marks, *The Skin of the Film: Intercultural Cinema, Embodiment, and the Senses* (Durham: Duke University Press, 2000), 153.

38. Ibid., xvii.

39. Although Anne Frank's diary was addressed to Kitty, her words in this context, here spoken rather than written, speak directly to us.

40. Elizabeth Edwards suggests, "Perhaps the most powerful sensory form is the entanglement with sound, the human voice. Photographs are spoken about and spoken to—the emotional impact articulated through forms of vocalization" ("Photographs and History: Emotion and Materiality," in *Museum Materialities*, ed. Dudley, 25).

41. Ibid., 32, citation omitted.

42. "What Is *Second Life*?" *Second Life* website, n.d., http://secondlife.com/whatis/?lang=en-US.

43. The *Witnessing History* exhibit can be accessed more directly at the Kristallnacht page on the USHMM website, https://ushmm.org/museum/exhibit/focus/kristallnacht/; all quotes are my transcriptions from the exhibit.

44. David Klevan, digital learning strategist at USHMM, managed the development of the project.

45. Karl M. Kapp and Tony O'Driscoll, "Learning from Experience," in *Learning in 3D: Adding a New Dimension to Enterprise Learning and Collaboration* (San Francisco: Pfeiffer, 2010), 143.

46. Ibid., 145.

47. Ibid.

48. These edited interviews of survivors of Kristallnacht can be accessed on YouTube at http://www.youtube.com/playlist?list=PL68049C833F2565DD. They were edited down from interviews that typically lasted forty-five to ninety minutes each.

49. On intellectual and emotional engagement, see Landsberg, *Prosthetic Memory*, and Edward T. Linenthal, *Preserving Memory: The Struggle to Create America's Holocaust Museum* (New York: Columbia University Press, 2001). This point is crucial to Saul Friedländer's work *The Years of Extermination* as well.

50. Kapp and O'Driscoll, "Learning from Experience," 144.

51. Styliani et al., "Virtual Museums," 525.

52. Testimony of Susan Strauss Taube.

53. Testimony of Susan Warsinger.

54. Testimony of Johanna (Gerechter) Neumann.

55. Kapp and O'Driscoll, "Learning from Experience," 149.

56. Quoted in ibid., 150.

57. Ibid., 149.

58. The Embodying Empathy project is directed by Struan Sinclair at the Department of English, Film, and Theatre Media Lab at the University of Manitoba. The affiliated researchers are Jim Young, Andrew Woolford, Katherine Starzyk, and Adam Muller.

59. Quotes in this paragraph and the next come from the Embodying Empathy website, http://embodyingempathy.ca/projects.html.

BIBLIOGRAPHY

"About *Mad Men*." AMC website, n.d. http://www.amctv.com/shows/mad-men/about.

Agnew, Vanessa. "History's Affective Turn: Historical Reenactment and Its Work in the Present." *Rethinking History* 11, no. 3 (2007): 299–312.

Ahmed, Sara. *The Cultural Politics of Emotion*. New York: Routledge, 2013.

——. "Happy Objects." In *The Affect Theory Reader*, edited by Melissa Gregg and Gregory J. Seigworth, 29–51. Durham: Duke University Press, 2010.

——. *The Promise of Happiness*. Durham: Duke University Press, 2010.

Altman, Rick. *Sound Theory, Sound Practice*. New York: Routledge, 1992.

Ankersmit, F. R. *Sublime Historical Experience*. Stanford: Stanford University Press, 2005.

Anne Frank House Museum. "About *The Secret Annex Online*." Museum website, http://www.annefrank.org/en/Subsites/Home/More-info/.

——. *The Secret Annex Online*. Virtual exhibit on the museum website. http://www.annefrank.org/en/Subsites/Home/.

Apted, Michael, dir.; Bruno Heller, John Milius, and William J. MacDonald, creators. *Rome*. HBO, August 28, 2005–March 25, 2007. HD Vision Studios, HBO, BBC.

Barker, Jennifer. *The Tactile Eye: Touch and the Cinematic Experience*. Berkeley: University of California Press, 2009.

Barra, Allen. "The Man Who Made *Deadwood*: The Creator of the Immensely Popular New Western Discusses What Makes It Truly New—an Interview with David Milch." *American Heritage Magazine* 57 (June–July 2006), http://www.americanheritage.com/content/man-who-made-%C2%91deadwood%C2%92.

Baudry, Jean-Louis. "Ideological Effects of the Basic Cinematographic Apparatus." *Film Quarterly* 28, no. 2 (1974–1975): 39–47.

Benjamin, Walter. "On Some Motifs in Baudelaire." In *Illuminations*, translated by Harry Zohn, edited by Hannah Arendt, 155–200. New York: Schocken Books, 1968.

——. "The Task of the Translator." In *Illuminations*, translated by Harry Zohn, edited by Hannah Arendt, 69–82. New York: Schocken Books, 1968.

——. "Theory of Distraction." Translated by Howard Eiland. In *The Work of Art in the Age of Its Technological Reproducibility and Other Writings on Media*, edited by Michael W. Jennings, Brigid Doherty, and Thomas Y. Levin, 56–57. Cambridge, Mass.: Harvard University Press, 2008.

——. "Theses on the Philosophy of History." In *Illuminations*, translated by Harry Zohn, edited by Hannah Arendt, 253–64. New York: Schocken Books, 1968.

——. "The Work of Art: Second Version." Translated by Edmund Jephcott and Harry Zohn. In *The Work of Art in the Age of Its Technological Reproducibility and Other Writings on Media*, edited by Michael W. Jennings, Brigid Doherty, and Thomas Y. Levin, 19–55. Cambridge, Mass.: Harvard University Press, 2008.

Bennett, Jill. *Empathic Vision: Affect, Trauma, and Contemporary Art*. Stanford: Stanford University Press, 2005.

Berenstein, Rhoda. "Spectatorship as Drag: The Act of Viewing and Classic Horror Cinema." In *Viewing Positions: Ways of Seeing Film*, edited by Linda Williams, 231–70. New Brunswick, N.J.: Rutgers University Press, 1995.

Bingham, Dennis. "The Life and Times of the Biopic." In *A Companion to the Historical Film*, edited by Robert Rosenstone and Constantin Parvalescu, 233–54. Malden, Mass.: Wiley-Blackwell, 2013.

Birleffi, Bobbie, Christopher Ragazzo, Ilana Trachman, Barnaby Coughlin, Ian Roberts, James Jansen, Raoul Germain, Don DiNicola, Stewart Lerman, and Stuert Smith, dirs. *Texas Ranch House*. PBS, May 1–4, 2006. Wall to Wall Media, Thirteen/WNET New York, PBS Video.

Black, Dustin Lance. *Milk*. Film script. IMSDb, n.d. http://www.imsdb.com/scripts/Milk.html.

Borysewicz, Stephen. "Networked Media: The Experience Is Closer Than You Think." In *The Virtual and the Real: Media in the Museum*, edited by Selma Thomas and Ann Mintz, 103–16. Washington, D.C.: American Association of Museums, 1998.

Brecht, Berthold. *Brecht on Theatre: The Development of an Aesthetic*. New York: Hill and Wang, 1964.

Brennan, Teresa. *The Transmission of Affect*. Ithaca: Cornell University Press, 2004.

Bronski, Michael. "*Milk*." *Cineaste* 34, no. 2 (2009): 71–73.

Brown, Nicolas Roether, Maro Chermayeff, Kathryn Walker, Will Edwards, Andrew Ford, Kelly Korzan, and Simon Shaw, dirs. *Frontier House*. PBS, April 29–May 3, 2002. Thirteen/WNET New York, PBS Video, Channel Four, Wall to Wall Television.

Burgoyne, Robert. *Film Nation*. Minneapolis: University of Minnesota Press, 2010.

——. *The Hollywood Historical Film*. Malden, Mass.: Wiley-Blackwell, 2008.

Burns, James. "*Milk*." *Journal of American History* 96, no. 1 (2009): 318–20.

Butler, Jeremy G. " 'Smoke Gets in Your Eyes': Historicizing Visual Style in *Mad Men*." In *Mad Men*, edited by Gary R. Edgerton, 55–71. London: I. B. Taurus, 2011.

Cartwright, Lisa. *Moral Spectatorship: Technologies of Voice and Affect in Postwar Representations of the Child*. Durham: Duke University Press, 2008.

Chion, Michael. *Audio-Vision: Sound on Screen*. Translated by Claudia Gorbman. New York: Columbia University Press, 1990.

Clooney, George, dir. *Good Night and Good Luck*. Dallas: 2929 Entertainment, 2005.

Clover, Carol J. *Men, Women, and Chain Saws: Gender in the Modern Horror Film*. Princeton: Princeton University Press, 1992.

Cohen, Lizabeth. *A Consumer's Republic*. New York: Vintage Books, 2003.

Collingwood, R. G. *The Idea of History*. Oxford: Oxford University Press, 1956.

Comolli, Jean-Louis. "Historical Fiction: A Body Too Much." *Screen* 19, no. 2 (1978): 41–54.

Comolli, Jean-Luc and Jean Narboni. "Cinema/Ideology/Criticism." In *Film, Theory, and Criticism*, 7th ed., edited by Leo Braudy and Marshall Cohen, 686–93. Oxford: Oxford University Press, 2008.

Cook, Alexander. "The Use and Abuse of Historical Reenactment: Thoughts on Recent Trends in Public History." *Criticism* 46, no. 3 (2004): 487–96.

Coole, Diana and Samantha Frost. Introduction to *New Materialisms: Ontology, Agency, and Politics*, edited by Diana Coole and Samantha Frost, 1–43. Durham: Duke University Press, 2010.

"Costume Drama." *Wikipedia*, n.d. http://en.wikipedia.org/wiki/Costume_drama.

Crafton, Donald. "Pie and Chase: Gag, Spectacle, and Narrative in Slapstick Comedy." In *The Cinema of Attractions Reloaded*, edited by Wanda Strauven, 355–64. Amsterdam: Amsterdam University Press, 2007.

Creeber, Glen. *Serial Television: Big Drama on the Small Screen*. London: BFI, 2004.

Crew, Spencer R. and James Sims. "Locating Authenticity: Fragments of a Dialogue." In *Exhibiting Cultures: The Poetics and Politics of Museum Display*, edited by Ivan Karp and Steven D. Lavine, 159–75. Washington, D.C.: Smithsonian Institution Press, 1991.

Davis, Natalie Zemon. *Slaves on Screen: Film and Historical Vision*. Cambridge, Mass.: Harvard University Press, 2000.

De Groot, Jerome. *Consuming History: Historians and Heritage in Contemporary Popular Culture*. London: Routledge, 2009.

——. "Empathy and Enfranchisement: Popular Histories." *Rethinking History* 10, no. 3 (2006): 391–413.

——. " 'Perpetually Dividing and Suturing the Past and Present': *Mad Men* and the Illusions of History." *Rethinking History* 15, no. 2 (2011): 269–85.

Deleuze, Gilles. "Image of Thought." In *Difference and Repetition*, translated by Paul Patton, 129–67. New York: Columbia University Press, 1995.

De Mille, Cecil B. *The Autobiography of Cecil B. De Mille*. Edited by Donald Hayne. Englewood Cliffs, N.J.: Prentice-Hall, 1959.

Dhoest, Alexander. "History in Popular Television Drama: The Flemish Past in *Wij, Heren van Zichem*." In *Televising History: Mediating the Past in Postwar Europe*, edited by Erin Bell and Ann Gray, 179–190. Houndmills, U.K.: Palgrave Macmillan, 2010.

Dudley, Sandra H. "Museum Materialities: Objects, Sense, and Feeling." In *Museum Materialities: Objects, Engagements, Interpretations,* edited by Sandra H. Dudley, 1–17. London: Routledge, 2010.

Dudziak, Mary. *Cold War Civil Rights: Race and the Image of American Democracy*. Princeton: Princeton University Press, 2011.

Edgerton, Gary R. "Introduction: A Brief History of HBO." In *The Essential HBO Reader*, edited by Gary R. Edgerton and Jeffrey P. Jones, 1–20. Lexington: University Press of Kentucky, 2008.

———. "Introduction: Television as Historian: A Different Kind of History Altogether." In *Television Histories: Shaping Collective Memories in the Media Age*, edited by Gary R. Edgerton and Peter C. Rollins, 1–19. Lexington: University Press of Kentucky, 2001.

———. "Introduction: When Our Parents Became Us." In *Mad Men*, edited by Gary R. Edgerton, xxi–xxxvi. London: I. B. Taurus, 2011.

Edwards, Elizabeth. "Photographs and History: Emotion and Materiality." In *Museum Materialities: Objects, Engagements, Interpretations*, edited by Sandra H. Dudley, 21–38. London: Routledge, 2010.

Edwards, Leigh H. "The Endless End of Frontier Mythology: PBS's *Frontier House* 2002." *Film & History* 37, no. 1 (2007): 29–34.

Fay, Brian. Introduction to "Unconventional History." Special issue of *History and Theory* 41, no. 4 (2002): 1–6.

Federal Communications Commission. *The Public and Broadcasting*. Revised July 2008. http://www.fcc.gov/guides/public-and-broadcasting-july-2008#OBJECTIONABLE.

Film and Theatre Media Lab, University of Manitoba. "Embodying Empathy." http://embodyingempathy.ca/projects.html.

Franklin, Nancy. "Dead On: David Milch Explores the Dakota Territory." *The New Yorker*, June 12, 2006. http://www.newyorker.com/archive/2006/06/12/060612crte_television.

Friedländer, Saul. *The Years of Extermination*. Vol. 2 of *Nazi Germany and the Jews, 1939–1945*. 2007. Reprint. New York: Harper Perennial, 2008.

Gallagher, Catherine. "War, Counterfactual History, and Alternate-History Novels." *Field Day Review* 3 (2007): 52–65.

García, José María Rodríguez. "Literary Into Cultural Translation." *Diacritics* 34, nos. 3–4 (2004): 2–30.

Geluradi, John. "Dan White's Motive More About Betrayal Than Homophobia." *SFWeekly*, January 30, 2008. http://www.sfweekly.com/2008-01-30/news/white-in-milk/.

George, Terry, dir. *Hotel Rwanda*. Hollywood: United Artists, 1994.

Gould, Deborah H. *Moving Politics: Emotion and ACT UP's Fight Against AIDS*. Chicago: University of Chicago Press, 2009.

Gray, Ann and Erin Bell. *History on Television*. London: Routledge, 2013.

———, eds. *Televising History: Mediating the Past in Postwar Europe*. Houndmills, U.K.: Palgrave Macmillan, 2010.

Gregg, Melissa and Gregory Seigworth. "An Inventory of Shimmers." In *The Affect Theory Reader*, edited by Melissa Gregg and Gregory J. Seigworth, 1–25. Durham: Duke University Press, 2010.

Griffith, D. W. "Five Dollar 'Movies' Prophesied." *The Editor*, April 24, 1915.

Grossberg, Lawrence. *We Gotta Get Out of this Place*. New York: Routledge, 1992.

Gumbrecht, Hans Ulrich. *The Production of Presence: What Meaning Cannot Convey*. Stanford: Stanford University Press, 2003.

Handler, Richard and Eric Gable. *The New History in an Old Museum: Creating the Past at Colonial Williamsburg*. Durham: Duke University Press, 1997.

Hansen, Miriam. "Pleasure, Ambivalence, Identification: Valentino and Female Spectatorship." *Cinema Journal* 25, no. 4 (1986): 6–32.

———. "'With Skin and Hair': Kracauer's Theory of Film, Marseilles 1940." *Critical Inquiry* 19, no. 3 (1993): 437–69.

Haralovich, Mary Beth. "Women on the Verge of the Second Wave." In *Mad Men,* edited by Gary R. Edgerton, 159–76. London: I. B. Taurus, 2011.

Harvey, Paul J., Jr. "Rome Yet Again." *Archaeology Magazine,* September 6, 2005. http://archive .archaeology.org/online/reviews/hborome/.

Hein, Hilde. "Assuming Responsibility: Lessons from Aesthetics." In *Museum Philosophy for the Twenty-First Century,* edited by Hugh H. Genoways, 1–9. Lanham, Md.: Altamira Press, 2006.

Hilmes, Michelle. "Is There a Field Called Sound Culture Studies? And Does It Matter?" *American Quarterly* 57 (2005): 249–59.

Hunt, Tristram. "The Time Bandits: Television History Is Now More About a Self-Indulgent Search for Our Identity Than an Attempt to Explain the Past and Its Modern Meaning." *The Guardian,* September 9, 2007. http://www.theguardian.com/media/2007/sep/10/monday mediasection.television1.

Jacobson, Kristi and Sally Aitken, dirs. *Colonial House.* PBS, May 17–25, 2004. Thirteen/WNET New York, Wall to Wall Television, PBS Video.

Jameson, Fredric. *The Political Unconscious: Narrative as a Socially Symbolic Act.* Ithaca: Cornell University Press, 1982.

Jordanova, Ludmilla. *History in Practice.* London: Arnold, 2000.

Kaplan, E. Ann. *Trauma Culture: The Politics of Terror and Loss in Media and Literature.* New Brunswick, N.J.: Rutgers University Press, 2005.

Kapp, Karl M. and Tony O'Driscoll. "Learning from Experience." In *Learning in 3D: Adding a New Dimension to Enterprise Learning and Collaboration,* 119–202. San Francisco: Pfeiffer, 2010.

Kracauer, Siegfried. *From Caligari to Hitler.* Princeton: Princeton University Press, 2004.

LaCapra, Dominick. *Writing History, Writing Trauma.* Baltimore: Johns Hopkins University Press, 2000.

Landsberg, Alison. "Memory, Empathy, and the Politics of Identification." *International Journal of Politics, Culture, and Society* 22, no. 2 (2009): 221–29.

———. *Prosthetic Memory: The Transformation of American Remembrance in the Age of Mass Culture.* New York: Columbia University Press, 2004.

Lang, Robert. "History, Ideology, Narrative Form." In *The Birth of Nation,* edited by Robert Lang, 3–24. New Brunswick, N.J.: Rutgers University Press, 1994.

Lewis, Geoffrey. "Virtual Museum." *Encyclopaedia Britannica* online. http://www.britannica .com/eb/article-9000232. Last updated September 24, 2013.

Linenthal, Edward T. *Preserving Memory: The Struggle to Create America's Holocaust Museum.* New York: Columbia University Press, 2001.

Lockett, Christopher. "Accidental History: Mass Culture and HBO's *Rome*." *Journal of Popular Film and Television* 38, no. 3 (2010): 102–12.

MacCabe, Janet. "Myth Maketh the Woman." In *Reading* Deadwood: *A Western to Swear By,* edited by David Lavery, 59–77. London: I. B. Taurus, 2006.

Marks, Laura. *The Skin of the Film: Intercultural Cinema, Embodiment, and the Senses.* Durham: Duke University Press, 2000.

Massumi, Brian. "The Autonomy of Affect." *Cultural Critique*, no. 31 (Autumn 1995): 83–109.

——. *Parables of the Virtual: Movement, Affect, Sensation.* Durham: Duke University Press, 2002.

——. *Semblance and Event: Activist Philosophy and the Occurrent Arts.* Cambridge, Mass.: MIT Press, 2011.

May, Elaine Tyler. *Homeward Bound.* New York: Basic Books, 1998.

McCalman, Iain. "The Little Ship of Horrors: Reenacting Extreme History." *Criticism* 46, no. 3 (2004): 477–86.

McCalman, Iain and Paul Pickering. "From Realism to the Affective Turn." In *Historical Reenactment: From Realism to the Affective Turn*, edited by Iain McCalman and Paul A. Pickering, 1–17. Houndmills, U.K.: Palgrave Macmillan, 2010.

McGovern, Charles. *Sold American.* Chapel Hill: University of North Carolina Press, 2006.

McKinley, Jesse. "'Deadwood' Gets a New Lease on Life." *New York Times*, June 11, 2006. http://www.nytimes.com/2006/06/11/arts/television/11mcki.html?_r=1&scp=1&sq=deadwood&st=cse.

Metz, Christian. *The Imaginary Signifier: Psychoanalysis and the Camera.* Translated by Celia Britton, Annwyl Williams, Ben Brewster, and Alfred Guzzetti. Bloomington: Indiana University Press, 1982.

Milch, David, creator. *Deadwood.* HBO, March 21, 2004–August 27, 2006. Roscoe Productions.

——. "The Real Deadwood." n.d. http://www.hbo.com/deadwood/behind/therealdeadwood.shtml. Accessed June 24, 2009, but site no longer accessible.

Munslow, Alun. Editorial. *Rethinking History* 1, no. 1 (1997): 1–20.

——. *The Future of History.* New York: Routledge, 2010.

——. *Narrative and History.* London: Palgrave Macmillan, 2007.

Münsterberg, Hugo. *The Film: A Psychological Study.* 1916. Reprint. New York: Dover, 1970.

Newcomb, Horace. "Learning to Live with Television in *Mad Men*." In *Mad Men*, edited by Gary R. Edgerton, 101–114. London: I. B. Taurus, 2011.

Parry, Ross and John Hopwood. "Virtual Reality and the 'Soft' Museum: A Call for Further Research." *Journal of Museum Ethnography*, no. 16 (March 2004): 69–78.

Perlman, Allison. "The Strange Career of *Mad Men*: Race, Paratexts, and Civil Rights Memory." In *Mad Men*, edited by Gary R. Edgerton, 209–25. London: I. B. Taurus, 2011.

Plantinga, Carl. *Moving Viewers: American Film and the Spectator's Experience.* Berkeley: University of California Press, 2009.

Rancière, Jacques. *The Politics of Aesthetics.* Translated by Gabriel Rockhill. London: Continuum, 2004.

Rath, Richard Cullen. *How Early America Sounded.* Ithaca: Cornell University Press, 2003.

Rose, Charlie. "A Discussion of the Television Series *Mad Men* with Matthew Weiner, Jon Hamm, and John Slattery." *Charlie Rose*, PBS, July 28, 2008. http://www.charlierose.com/guest/view/6417.

Rosenfeld, Gavriel. "Why Do We Ask 'What If'? Reflections on the Function of Alternate History." *History and Theory* 41, no. 4 (2002): 90–103.

Rosenstone, Robert. "The History Film as a Mode of Historical Thought." In *A Companion to the Historical Film*, edited by Robert Rosenstone and Constantin Parvalescu, 71–87. Malden, Mass.: Wiley-Blackwell, 2013.

——. "History in Images/History in Words: Reflections on the Possibility of Really Putting History Onto Film." *American Historical Review* 93, no. 5 (1988): 1173–85.

——. *Visions of the Past*. Cambridge, Mass.: Harvard University Press, 1995.

Rosenstone, Robert and Constantin Parvalescu. Introduction to *A Companion to the Historical Film*, edited by Robert Rosenstone and Constantin Parvalescu, 1–8. Malden, Mass.: Wiley-Blackwell, 2013.

Rosenzweig, Roy and David Thelen. *The Presence of the Past: Popular Uses of History in American Life*. New York: Columbia University Press, 1998.

Rymsza-Pawlowska, Malgorzata. "*Frontier House*: Reality Television and the Historical Experience." *Film & History* 37, no. 1 (2007): 35–42.

Samuel, Raphael. *Theatres of Memory*. London: Verso, 1996.

Schneider, Rebecca. *Performing Remains: Art and War in the Times of Theatrical Reenactment*. London: Routledge, 2011.

Schwarz, Anja. "'. . . Just as It Would Have Been in 1861': Stuttering Colonial Beginnings in ABC's *Outback House*." In *Historical Reenactment: From Realism to the Affective Turn*, edited by Iain McCalman and Paul A. Pickering, 18–38. Houndmills, U.K.: Palgrave Macmillan, 2010.

Schweibenz, Werner. "The 'Virtual Museum': New Perspectives for Museums to Present Objects and Information Using the Internet as a Knowledge Base and Communication System." In *Knowledge Management und Kommunikationssysteme: Workflow Management, Multimedia, Knowledge Transfer. Proceedings des 6. Internationalen Symposiums für Informationswissenschaft (ISI '98), Prag, 3.–7. November 1998*, edited by Harald H. Zimmermann and Volker Schramm, 185–200, Schriften zur Informationswissenschaft no. 34. Konstanz, Germany: UKV. S., 1998. http://is.uni-sb.de/projekte/sonstige/museum/virtual_museum_isi98#tea.

Scott, A. O. "News in Black, White, and Shades of Gray." *New York Times*, September 23, 2005. http://www.nytimes.com/2005/09/23/movies/23luck.html?_r=0.

Scott, Joan. "Experience." In *Feminists Theorize the Political*, edited by Judith Butler and Joan Scott, 22–40. New York: Routledge, 1992.

Shittu, Fatimah. "Imperialism: What You Won't See in *Hotel Rwanda*." Uhurunews.com, March–April 2005. http://uhurunews.com/story?resource_name=imperialism-what-you-wont-see-in-hotel-rwanda.

Sobchack, Vivian. *The Address of the Eye: A Phenomenology of Film Experience*. Princeton: Princeton University Press, 1991.

——. "The Scene of the Screen: Envisioning Photographic, Cinematic, and Electronic 'Presence.'" In *Carnal Thoughts: Embodiment and Moving Image Culture*, 135–62. Berkeley: University of California Press, 1994.

——. "What My Fingers Knew: The Cinesthetic Subject, or Vision in the Flesh." In *Carnal Thoughts: Embodiment and Moving Image Culture*, 53–84. Berkeley: University of California Press, 1994.

Sorlin, Pierre. "Television and Our Understanding of History: A Distant Conversation." In *Screening the Past: Film and the Representation of History*, edited by Tony Barta, 205–20. New York: Praeger, 1998.

Spinoza, Baruch. *Ethics: On the Correction of Understanding*. Translated by Andrew Boyle. London: Everyman's Library, 1959.

Stanley, Alessandra. "The Code of the West as Hard as a Gunfighter's Eye." *New York Times*, March 19, 2004. http://www.nytimes.com/2004/03/19/movies/tv-weekend-the-code-of -the-west-as-hard-as-a-gunfighter-s-eye.html

——. "HBO's Roman Holiday." *New York Times*, August 21, 2005. http://www.nytimes .com/2005/08/21/arts/television/21stan.html.

Styliani, Sylaiou, Liarokapis Fotis, Kotsakis Kosta, and Patias Petros. "Virtual Museums: A Survey and Some Issues for Consideration." *Journal of Cultural Heritage* 10 (2009): 520–28.

Tashiro, C. S. *Pretty Pictures: Production Design and the History Film*. Austin: University of Texas Press, 1998.

Taussig, Michael. *Mimesis and Alterity*. New York: Routledge, 1993.

Teather, Lynne. "A Museum Is a Museum Is a Museum . . . or Is It? Exploring Museology and the Web." April 1998. http://www.museumsandtheweb.com/mw98/papers/teather/teather_ paper.html#I.%20Introduction.

Toplin, Brent. *Reel History*. Lawrence: University Press of Kansas, 2002.

Turner, Graeme. *Ordinary People and the Media*. London: Sage, 2010.

United States Holocaust Memorial Museum. *Witnessing History: Kristallnacht—the November 1938 Pogroms*. Virtual exhibit on *Second Life*. Accessed through https://ushmm.org/museum/ exhibit/focus/kristallnacht/.

Van Sant, Gus, dir. *Milk*. New York: Axon Films, 2008.

Vertov, Dziga. *Kino-Eye: The Writings of Dziga Vertov*. Translated by Kevin O'Brien. Edited by Annette Michelson. Berkeley: University of California Press, 1984.

Watson, Sheila. "Myth, Memory, and the Senses in the Churchill Museum." In *Museum Materialities: Objects, Engagements, Interpretations*, edited by Sandra H. Dudley, 204–23. London: Routledge, 2010.

Weiner, Matthew, creator. *Mad Men*. AMC, July 19, 2007–2015. Weiner Bros.

——. "Part 2: The Making of *Mad Men*, Season 1, Episode 3." AMC website, n.d. http://www .amctv.com/mad-men/videos/the-making-of-mad-men-part-2.

Wells, Amy. "It Is as It Was: Inside *Mad Men*." Season 1, episode 11. AMC website, n.d. http:// www.amctv.com/mad-men/videos/it-is-as-it-was.

"What Is Second Life?" *Second Life* website. http://secondlife.com/whatis/?lang=en-US.

Williams, Linda. Introduction to *Viewing Positions: Ways of Seeing Film*, edited by Linda Williams, 1–20. New Brunswick, N.J.: Rutgers University Press, 1995.

Williams, Raymond. *Marxism and Literature*. New York: Oxford University Press, 1978.

INDEX

Cronkite, Walter, 46, 89, *90*
Cuban Missile Crisis, 86, 88

Daniels, Jeff, 57
Davis, Natalie Zemon, 187n11
Deadwood (HBO TV series, 2004–2006),
 22, 69–70, 85, 104, 145; as costume drama,
 188n23; empathetic engagement with the
 past and, 70–71; historical setting of, 71;
 language and sound used in, 72–84, *76*,
 109, 189n39; mode of address in, 106, 109
de Groot, Jerome, 11, 19, 62–63, 189n41
Deleuze, Gilles, 15, 38, 106, 119, 121
DeMille, Cecil B., 25–26, 33
Dhoest, Alexander, 67
diegesis/diegetic world, 11–12, 33, 35; charac-
 ters watching television in, 87; distance
 from, 37; mediation and, 40; point-of-
 view shots and, 31–32; sounds in, 74–75;
 viewers forced out of, 80; voice-over
 narration in, 49
Dillahunt, Garrett, 71
"discursive turn," 17
distance, 29, 33, 148; historical knowledge
 production and, 43; in *Hotel Rwanda*, 52,
 54; proximity in oscillation with, 106, 153;
 sense of distance from past, 28. *See also*
 alienation; mediation
"distribution of the sensible" (Rancière), 12,
 13, 114, 120
docudramas, 62, 71
documentary films, 39, 62
Dodge, Col. Richard Irving, 144
Downey, Robert, Jr., 56
Dudley, Sarah, 160
Dudziak, Mary, 101

Edgerton, Gary, 64, 68, 189n44
editing, film, 31, 33
Edwardian Country House (TV series, 2002),
 116
Edwards, Elizabeth, 164–65, 195n40
Eisenstein, Sergei, 15, 38

emanation speech, 82–83
Embodying Empathy project (University of
 Manitoba Media Lab), 23, 174–76, *175*,
 196n58
emotion, 35, 81
Empathetic Vision (Bennett), 66
empathy, 65–66, 93, 149, 176; empathetic en-
 gagement with the past, 70–71; empathic
 unsettlement, 153; political action and, 148
encounter, 132–33, 138, 160; cognitive disso-
 nance produced by, 127, 130; as embodied
 contradiction, 133; moments of, 124–25;
 principle of, 120–21; staging of, 36–38
entertainment, 1, 69
Epstein, Robert, 39, 40
Essential HBO Reader, The, 68
everyday life, 86, 104, 105–8, 116; moments
 of encounter in, 124–25; religious beliefs
 and, 135
experiential mode, 6, 7, 8, 16, 143

fascism, 13
Fay, Brian, 111, 112
Federal Communications Commission, 68
Feinstein, Dianne, 45
Feminine Mystique, The (Friedan), 95, 190n52
feminism, 94
Ferguson, Niall, 192n19
film, 13, 20; bodily engagement with view-
 ers, 30, 33–36; classical Hollywood
 cinema, 14–15, 70; documentary, 62, 71;
 experiential mode and, 23, 147; histori-
 cal fiction, 10; history films, 29, 40, 179,
 184n9, 186n37; as ideological apparatus,
 32, 184n16; materiality of, 162, 163–64; as
 multisensory experience, 74; objectivity
 and, 2; phenomenology of, 34, 185n22
Finkelstein, Maura, 137–38, 141
flashback, 26, 41
form, 11–16, 113–14
frame, breaking of, 112, 126, 145
Franco, James, 40
Frank, Anne, 158–59, 165, 176, 195n39

past and, 3, 6–7, 18–19; cinema as replacement for history books, 1; complexity of the past, 119; counterfactual, 192n19; "dumbed down," 119; epistemological basis of, 11; "factual history," 62, 68, 187n4; form of, 11–16; generic conventions of cinema/television and, 20, 29, 112, 115; Great Man theory of, 107, 190n63; historical engagement, 6, 7, 8, 23; images and narratives in mass culture and, 2–3; politics of affective history, 16–21; as reenactment, 3–10; sense of distance from past and, 27; sublime historical experience, 9. *See also* alternate history

impact on communication and education, 61; live news disseminated by, 87; "long form" serial drama, 67, 69–70, 73, 93; modes of address in, 177; reality TV, 7, 115–16. *See also* reality history TV

"Television and Our Understanding of History" (Sorlin), 61

Texas Ranch House (PBS TV series, 2006), 111, 116–17, 137–44, *143*, 145

theatrical speech, 82

Thelen, David, 6, 19, 152, 181n12

"Theory of Distraction" (Benjamin), 147

"Theses on the Philosophy of History" (Benjamin), 21

Times of Harvey Milk, The (Epstein, 1984), 39, 40, 41

Tisdale, Danny, 135

transferential space, 122

translation, 150–52, 153, 174, 193n9

trauma, 9, 66, 114, 117

Trauma Culture (Kaplan), 34

trauma narratives, 34

truth: historical truth as contradiction, 133; object truth of the past, 153; period truth, 28, 64; truth claims, 4, 21, 71

Turner, Graeme, 115–16

"Unconventional History" (*History and Theory* issue), 111

United States Holocaust Memorial Museum (USHMM), 23, 118, 149, 166–67

Van Pels family, 157, 158, 165

Van Sant, Gus, 38, 39

Vertov, Dziga, 15, 38

videotape, 52, *53*

virtual history exhibits, 10

virtual spaces, 147, 148, 155

vision, 37, 74

Visions of the Past (Rosenstone), 63

visual pleasure, 55

voice-overs, 49, 117, 120; in *Colonial House*, 130, 131, 132; debunking of myths and,

122, 124; in *Frontier House*, 124, 125; in museum exhibits, 155, 157–58, 159; in *Texas Ranch House*, 138–39, 141, 144

Voorhees, John, 130, 131

Voorhees, Michelle, 131, 134

voyeurism, 52, 81, 94

Wall to Wall Video, 116

Wampanoag people, 133

war on terror, 57

Watson, Sheila, 152

Web 2.0, 116

websites, 20, 23, 147–48, 179

Weigert, Robin, 71

Weiner, Matt, 84, 85, 91, 92, 94, 190n52

Wells, Amy, 92

White, Dan, 39, 40, 186n36

White, Hayden, 11

Who Do You Think You Are? (BBC One TV series), 62, 116

Wij, Heren van Zichen (BRT series, 1969), 67

Williams, Raymond, 12

Williamsburg, colonial, 93, 151

Wilson, Woodrow, 25

Witnessing History: Kristallnacht—the November 1938 Pogroms (USHMM virtual exhibit), 23, 149–50, 170–72, 176; destruction rendered graphically in, *171, 172, 173*; distance between visitors and actual event, 173–74; reporter avatar, 167–69, *168*; *Second Life* as host for, 165–68; testimonies in, 169–70, 171–72; visitor comments, 147, 173

women's movement, 40

Woolford, Andrew, 196n58

Worts, Douglas, 154

Wyers, Bethany, 130, 132, 134

Wyers, Jeff, 130, 131, 134

Yad Vashem, 193n20

Years of Extermination, The (Friedländer), 8

Young, James, 196n58